Hollywood Beach Beauties

Holly

DEY ST.
An Imprint of WILLIAM MORROW

wood
Beach Beauties

Sea Sirens, Sun Goddesses,
and Summer Style
1930–1970

David Wills

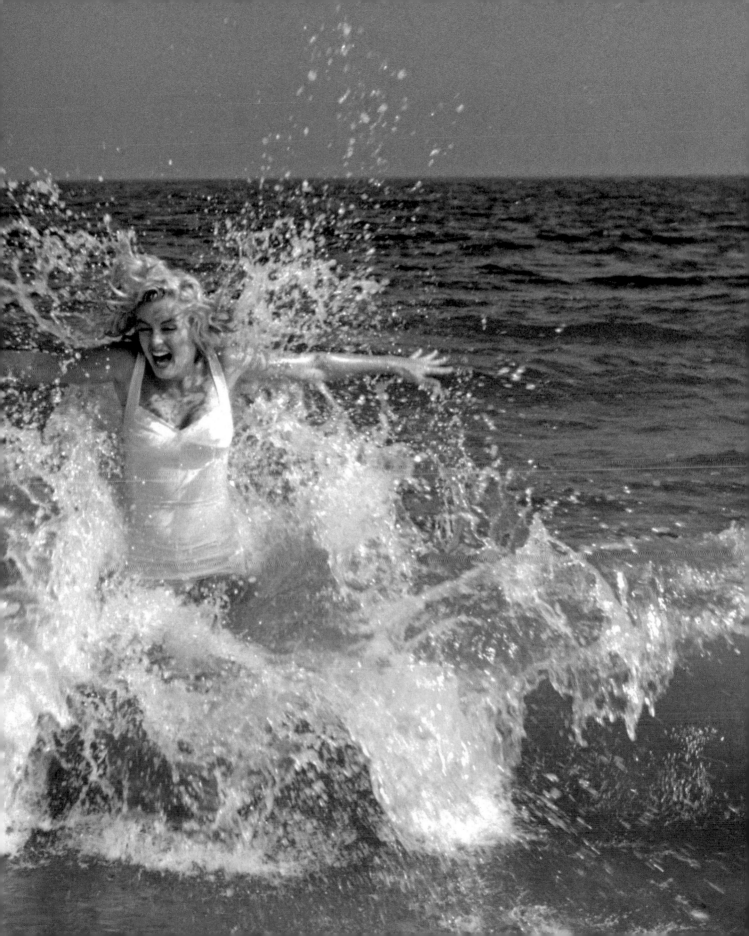

INTRODUCTION

"The most daring attire to appear on American beaches to date. Scanty swimsuits are designed to give the girls a maximum of vitamin D and the boys an eyeful."

The photography magazine *Click*, in an issue published in 1944, did a bit of editorializing regarding the shrinking American woman's bathing suit. The suit in question was a very modest, by today's standards, two-piece designed by Tina Leser.

Magazine and newspaper editors could not have foreseen that the shrinkage would continue, exposing ever more female flesh, poolside and surf side. Less than two decades later, futurist designer Rudi Gernreich, based in Los Angeles, impulsively declared that swimwear would evolve quickly: "Bosoms will be uncovered within five years." As a result, the fashion editor of *Life,* Sally Kirkland, asked him to submit a swimsuit design for a feature she had in mind on future fashion. "It was my prediction," Gernreich acknowledged with some trepidation. "For the sake of history, I didn't want Pucci to do it first."

The initial design, a bosom-baring, high-waisted sarong, struck Kirkland as lacking boldness. It uncovered, yes, but it didn't

innovate. Gernreich's final solution was a simple maillot, minus the bra—two narrow straps rose between the breasts and over the shoulder to form a complimentary "V" in the back. The suit itself was not cut high over the leg, a nod to tradition, and from behind it recalled 1930s Hollywood glamour. But Kirkland got her statement: the breast exposure was complete, a future revealed.

A photo shoot was arranged for Montego Bay in the Bahamas with five models. But on-site, they all refused to wear the suit, leaving the photographer to scramble up a local prostitute to pose from the back in what Gernreich called "the monokini," and what the rest of the world would refer to as "the topless swimsuit." Gernreich had no plans to produce his monokini for the market until he met with Diana Vreeland at *Vogue*. His muse-in-chief, Peggy Moffitt, modeled the suit for DV, who was intrigued, making one of her grand pronouncements: "If there's a picture of it, it's an actuality. You must make it."

William Claxton had already photographed Moffitt in the sample suit in black, the resulting pictures to be carefully released to just a very few publications. *Life* accepted the photo of Moffitt with her arms covering her breasts. *WWD* editor Carol Bjorkman published the "full monty": Moffitt's chest totally exposed in the soon-to-be notorious swimsuit.

The studio photos ramped up the urgency to make the bathing suit available in stores, and three thousand were produced in 1964,

mostly for the European market. Since there was virtually no public place to wear the garment legally in the U.S., the inventory was soon marked down. The only sightings of the topless suit occurred in June, when exotic dancer Carol Doda wore one to the Condor nightclub in San Francisco—and made the front page—and in Chicago, where nineteen-year-old model Toni Lee Shelley was arrested in July for indecent exposure on the "Windy City" strand. Further headlines were made when the Vatican denounced the suit's display and purchase, much less its wear on public beaches.

Peggy Moffitt had a denouncement of her own: the photograph in *Life* was "dirty." Pictured with her arms hiding her breasts, she considered the pose "a tease, a prudish come-on." She preferred the full exposure of the *WWD* image—honest and unashamed— calling it "a political statement. [The suit] was not meant to be worn in public." A flashpoint of discussion at the time, Gernreich's topless creation gave another jolt to the sexual revolution, lining up behind the honest sensuality of Marilyn Monroe and the frank sexuality of Hugh Hefner's *Playboy* magazine. The controversy ignited a thousand debates in print, in public, in private, about something yet to be specifically designated as "feminism," pro and con. The suit was either exploitive and a morally corrupt garment, or its wearing was an act of self-determination and a call for equal rights. The noncombative Gernreich continued to state the issue quite simply, "[It was time] for freedom in fashion as well as in every other facet

of life. [Women] drop their bikini tops already, so it seemed like the next natural step."

But beauty being in the beholder's eye, Claxton's portraits of Moffitt were either degenerate or fashion forward, a shocking scandal or liberating art. They were Hollywood-born and bred—as was the suit itself—and now exude a cool distance: the female form unveiled in a moment in time. Hollywood remained through the 1970s the purveyor of popular, aspirational imagery, on the screen, on the red carpet, in the media, and here, at play in the waves and the sand. The women—actresses, models, starlets, dilettantes, and social mavens—have followed the sun, in an international, frequently exotic, show of flesh and fantasy, glamorously remote or charmingly accessible: beauty on the beach.

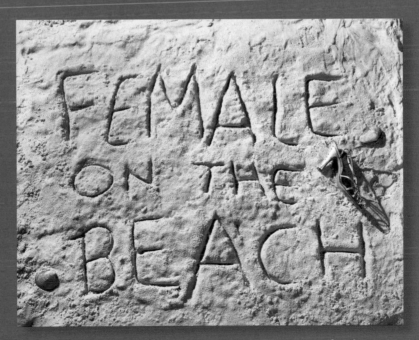

Female on the Beach (1955) starring Joan Crawford.

THE THIRTIES

"The most beautiful star in the world, tisn't Garbo
Tisn't Dietrich, but a sweet trick
Who can make me believe it's a beautiful world . . . "
LYRIC BY LORENZ HART

Lolita Dolores Martine Asunsolo Lopez Negrette—in fewer syllables, Dolores Del Rio—in the early to mid-1930s, was often hailed as "the most beautiful woman in Hollywood." Before the Hays Office (established in 1930 as the self-censorship authority) clamped down on content and presentation, Del Rio, in *Bird of Paradise* (1932), had her moment in the nude in the ocean off Santa Catalina Island, swimming in tandem through the murk and the bubbles with Joel McCrea. (The planned location shoot in Hawaii had to be abandoned due to constant storms.) That same year, in *Tarzan of the Jungle*, Maureen O'Sullivan as Jane joined Johnny Weissmuller's Tarzan for a naked frolic in a rainforest pool, in Silver Springs, Florida. When Joseph Breen was appointed head of the commission, such risqué, yet beautiful, scenes ceased to be considered, much less put on film. In continental Europe, less reactionary about sex and nudity, Hedy Lamarr took to the water au naturel in *Ecstasy* (1933), and was summoned to Hollywood by Louis B. Mayer.

A few years later, in 1936, Edith Head designed the costumes for Dorothy Lamour in *The Jungle Princess*, cleverly putting together varying styles of bathing suits and sarongs "with just enough draping and coverage to count as proper garments" to satisfy Hays Office restrictions on how many swimsuit/lingerie scenes would be allowed in any one film. Lamour became known as "the sarong girl," continuing to wear the cover-up in other tropical movie adventures and in the *Road* pictures with Bob Hope and Bing Crosby.

From the early 1920s, Coco Chanel had reengineered the summer experience by first introducing "couture" sportswear: sailor sweaters, nautical trousers, and beach pajamas. She then applied her way with wool jersey to swimwear, cut high above the knee, low at the bosom, and dispensing with sleeves. But wool jersey, heavy when wet, was shapeless until dry, sometimes permanently. Hollywood came to the rescue, Mabs of Hollywood, that is, a girdle manufacturer. Mabs took its girdle fabric, a silk and elastic blend with a satiny finish, and made the first bathing suits of sleek and lustrous Lastex. The suits were instantly popular with the Hollywood elite, the petite-figured ones—Jean Harlow at 5'2", Joan Crawford at 5'3", Norma Shearer at 5'1"—especially, finding them flattering and easy to wear. Marlene Dietrich (5'3") ordered twelve, one in each color.

What would become the big three in West Coast swimwear—Catalina, Cole, and Jantzen—began as knitting mills, looking to expand into new wholesale territory by manufacturing knit swimsuits.

In Oregon, Carl Jantzen took credit for coining the term "swimsuit" to replace "bathing costume," and in 1915 began to employ rib-stitch wool, with a drawstring, for a better-fitting suit. In 1921, ads began appearing in *Life* and *Vogue* that featured the Jantzen "diving girl," the label's symbol, always in a red swimsuit. Through the 30s, the company marketed its innovations with catchy designations like "The Molded-Fit," "the Shouldaire," and the "Double-Dare," which sported a cutout on each upper thigh. Loretta Young and Ginger Rogers lent their names and figures to Jantzen advertising.

In Southern California, in 1928, Pacific Knitting Mills, with Mary Ann DeWeese as designer, launched Catalina Swimwear. The brand aligned itself closely with Hollywood cachet by arranging with Warner Bros. to have its chief costume designer (and Bette Davis' favorite) Orry-Kelly come up with a yearly collection for Catalina, wool jersey knit at first. Orry-Kelly also employed Lastex, now sought after for its fit and light weight, but also known for its short shelf life; the elastic element in the fabric tended to pull apart in salt water unless vigorously rinsed. In addition to Orry-Kelly, Catalina, on occasion, enlisted other Hollywood designers—Travis Banton, Milo Anderson, and later, Edith Head—to lend even more movie mystique to the label.

Silent film star Fred Cole took over his parents' knitting mill, and, in 1936, installed Margit Fellegi as designer for his label Cole of California. Cole had already been responsible for what he

called the first line of fashion swimsuits, and the "Prohibition Suit," a knit number with a more miserly cut. Cole also featured Lastex, but referred to his version as "Matletex." Fred never left his movie career entirely behind, insisting that Cole of California was all about Hollywood and glamour.

Studio glamour portraiture reached a zenith of technique and artistry in the late 1930s. The women, and some of the men, were painstakingly lit and strictly posed for maximum star-power effect. The photographers—Laszlo Willinger (MGM), Frank Powolny (Fox), Bill Walling (Paramount, Universal), Clarence S. Bull (MGM), and Bob Coburn (RKO, UA, Columbia)—were kept busy creating elegant promotional art. A few, like Horst P. Horst and George Hoyningen-Huene, also worked for *Vogue* and *Harper's Bazaar,* stimulating a cross pollination between New York and Hollywood. Eric Carpenter, a photographer at MGM, lamented the "irritation and restriction" involved in the requirement to submit all stills to the Hays Office: "They were out of our hands. You were very limited by the studio's image of itself. The retouchers were the real artists in my opinion. They had about 22 of them working at MGM alone. They helped make the reality a dream."

Outside the studio walls, the stars were often sent to Santa Monica Beach for some photographed fun in the sun. Bette Davis, Joan Blondell, and Joan Crawford, in their wool jersey tank suits, casually posed before Marion Davies' big beach house—a spot

for Hollywood players to play. The house, right on the strand, was designed by Julia Morgan, the first lady of Los Angeles architecture at the time. The mansion, in the vintage photos, looks like it belongs more to the Hamptons on New York's Long Island, but without the hedgerows, sea grass, and sand dunes. There was one cardinal rule the studios imposed on photographers and stars: the swimsuit must *never* get wet, not even damp, the resulting "cling" quite taboo. The one-piece jersey suits, though not overtly sexy, were helpful in disguising figure flaws.

Other "beach" photos were studio-bound, with imported sand and potted palms to simulate a day at the shore. Props were more vital in the studio than on location to aid the atmospherics; heavy umbrellas, big beach balls, and picnic baskets shared the frame. For a holiday portrait, the actress might interact with a giant starred and striped firecracker. Unless barefoot, the ladies slipped on footwear that was more shoe than sandal, and endured the harsh spotlights subbing for the summer sun. A hothouse beach, with minimal effort to convince, featuring Lana Turner, with studio-perfect coif, makeup, and bathing suit, was thought to be better than no beach at all.

(OPPOSITE) Bette Davis makes a bid for bombshell status, in rare cheesecake publicity for her role as Ruth Wescott in the 1932 pre-Code crime melodrama *Three on a Match*.

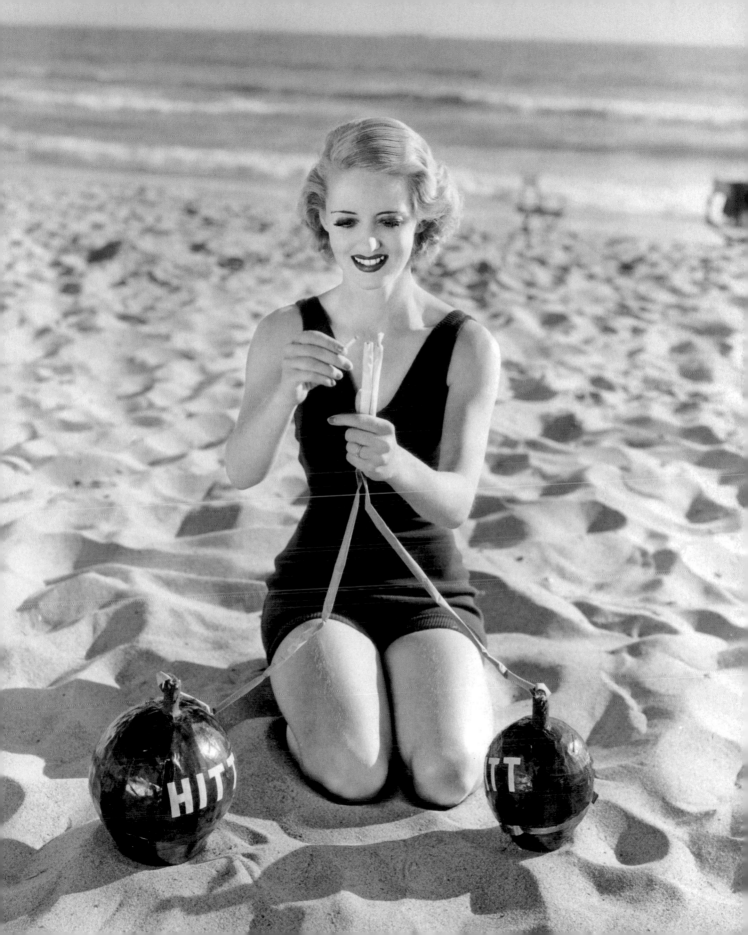

A soaring dance to spring by burlesque artiste
Sally Rand, on the beaches of St. Petersburg,
Florida, 1934.

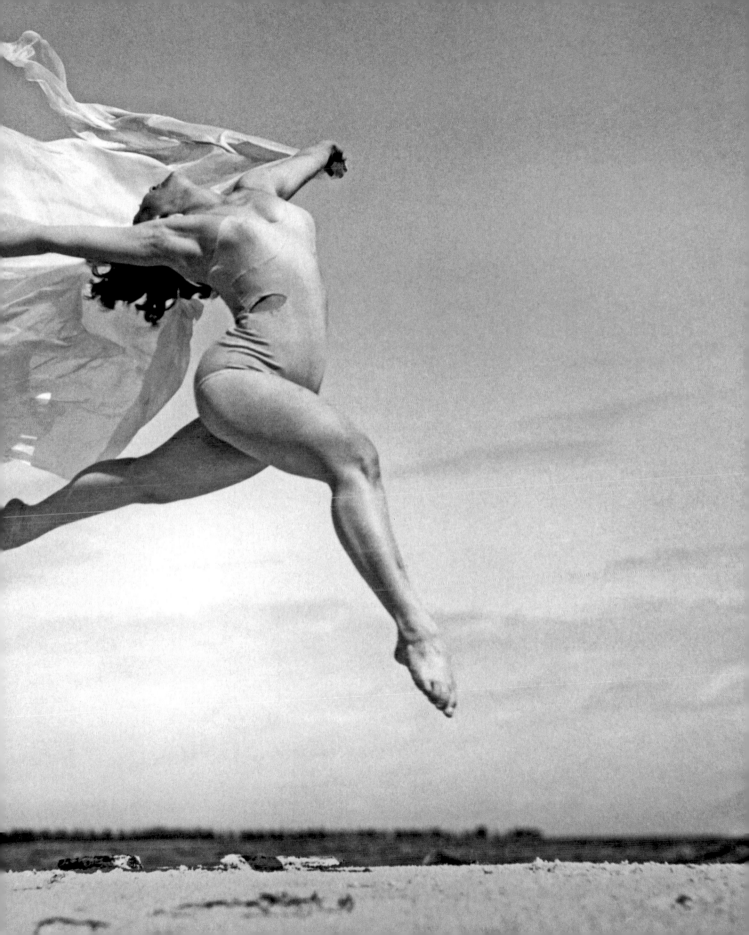

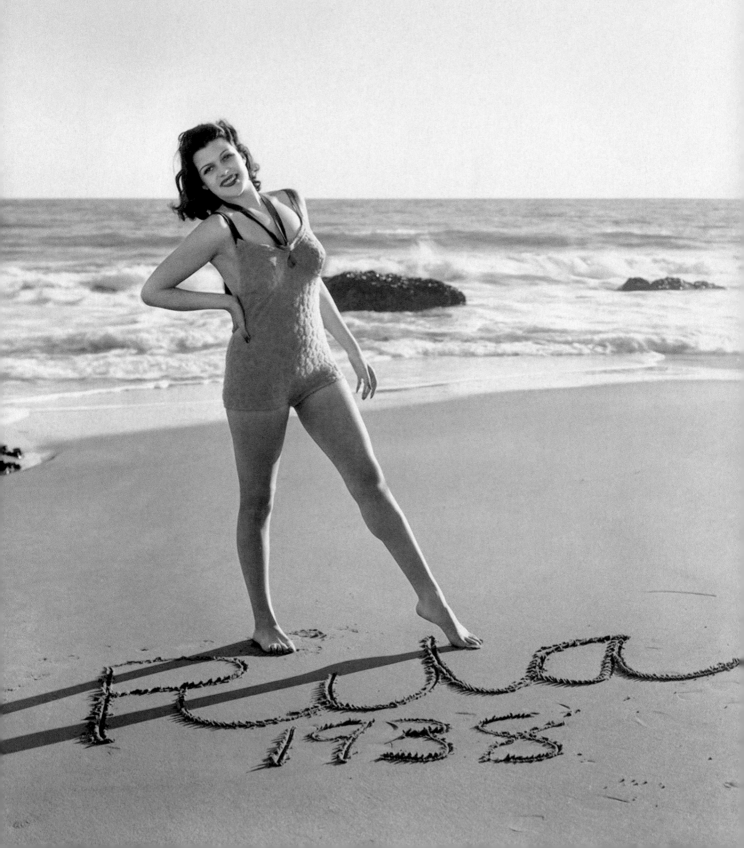

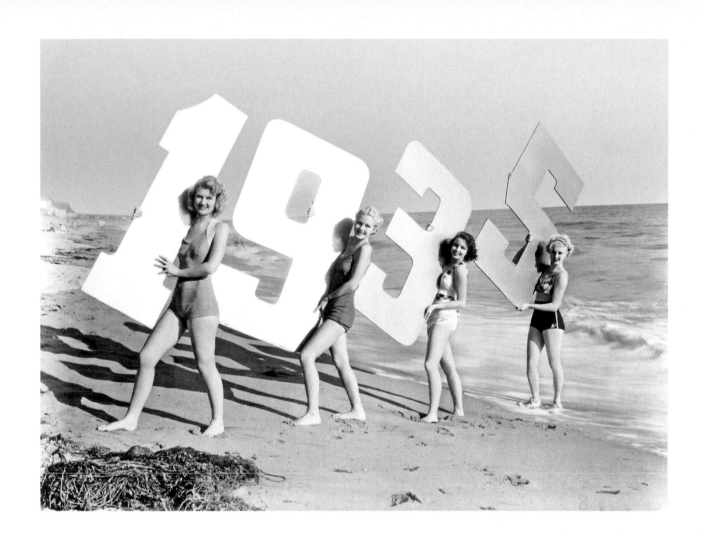

IT'S A DATE!: (OPPOSITE) Rita Hayworth, 1938.
(ABOVE) Chorus girls from Busby Berkeley's *Gold Diggers of 1935*.

Glamour is simply what you'd expect to see in a beautiful woman — mesmerizing—the kind you can never approach in real life but can dream of on the screen. We gave them that Aphrodite figure you think you saw on the screen.

WILLIAM WALLING JR., Studio photographer at Universal and Paramount in the 30s & 40s.

Norma Shearer, late 1930s.

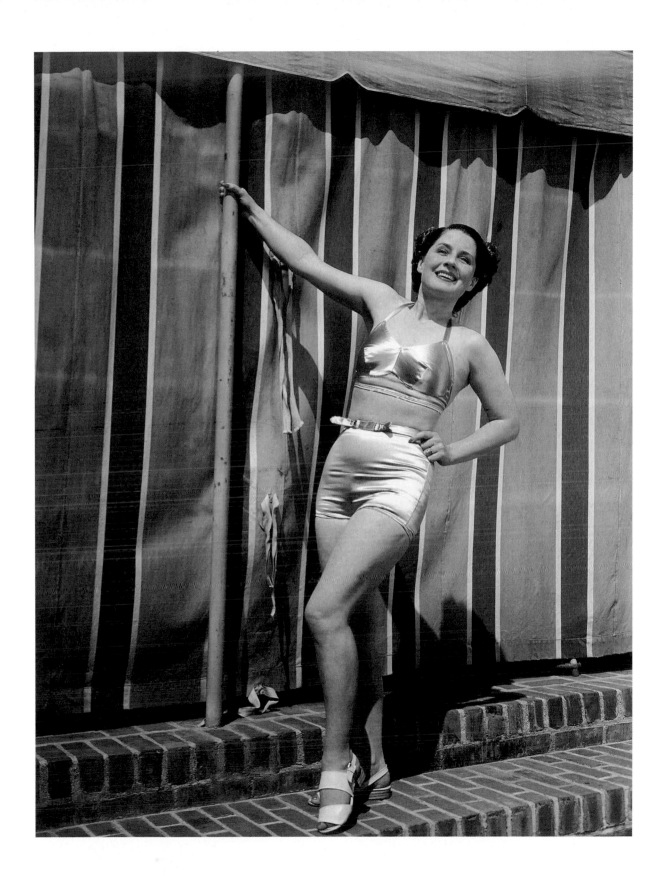

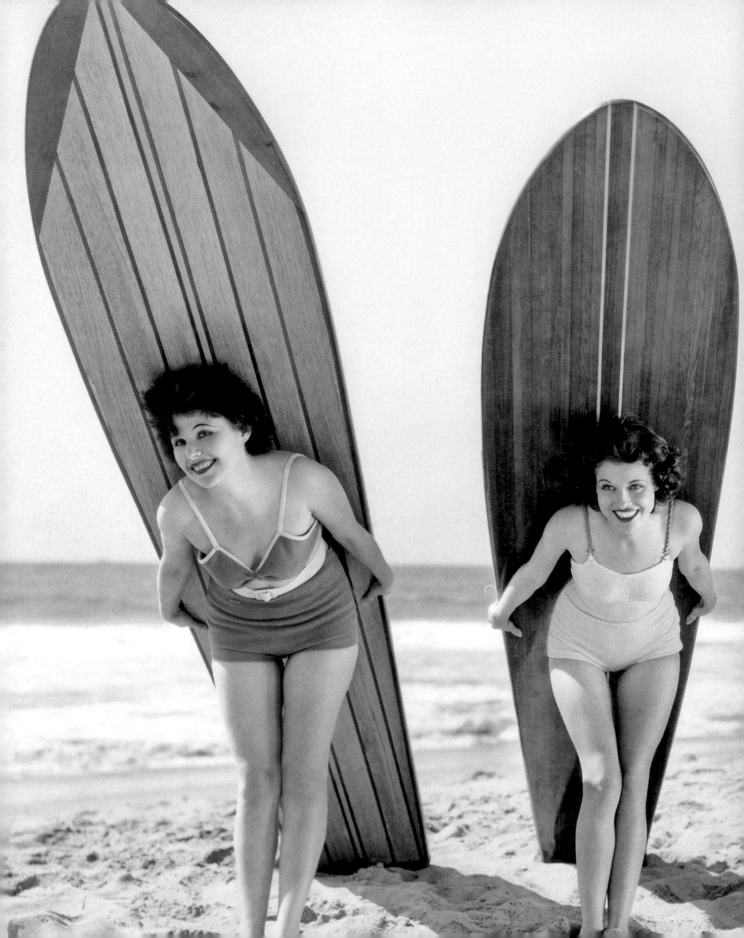

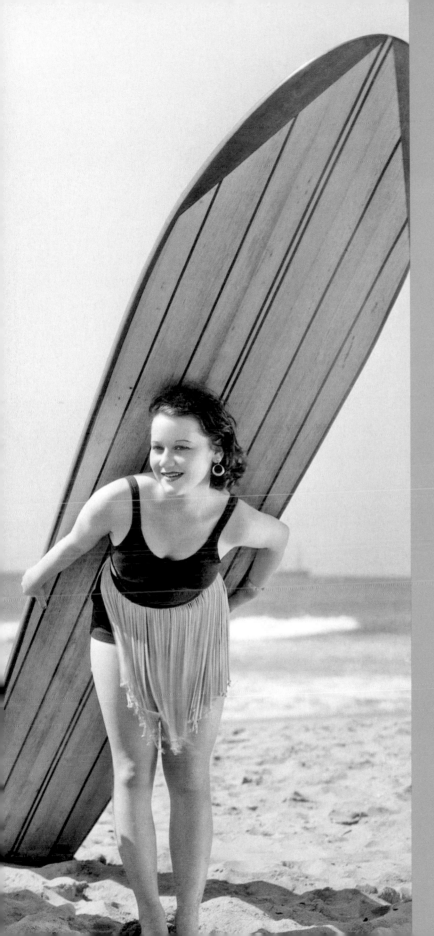

Rose Vespro, Marion Shelton, and Irma Richardson in *Down to Their Last Yacht* (1934).

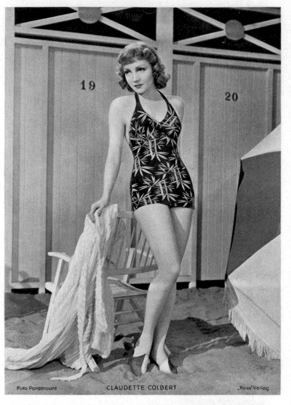

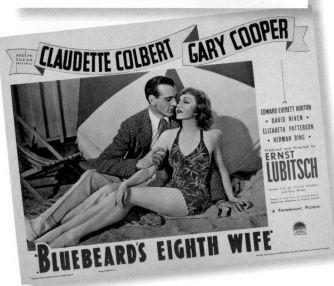

CHIC BY THE SEA: (TOP) Promotional postcard of Claudette Colbert, circa 1938. (BOTTOM) Lobby card featuring Colbert and Gary Cooper in *Bluebeard's Eighth Wife* (1938). (RIGHT) Constance Bennett in *Topper Takes a Trip* (1938).

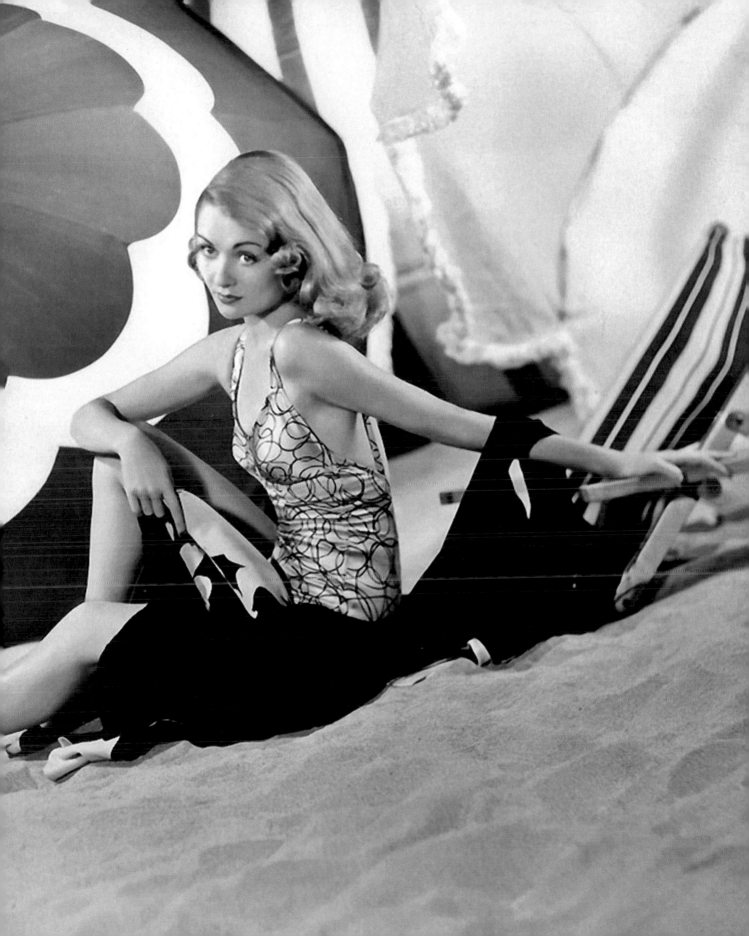

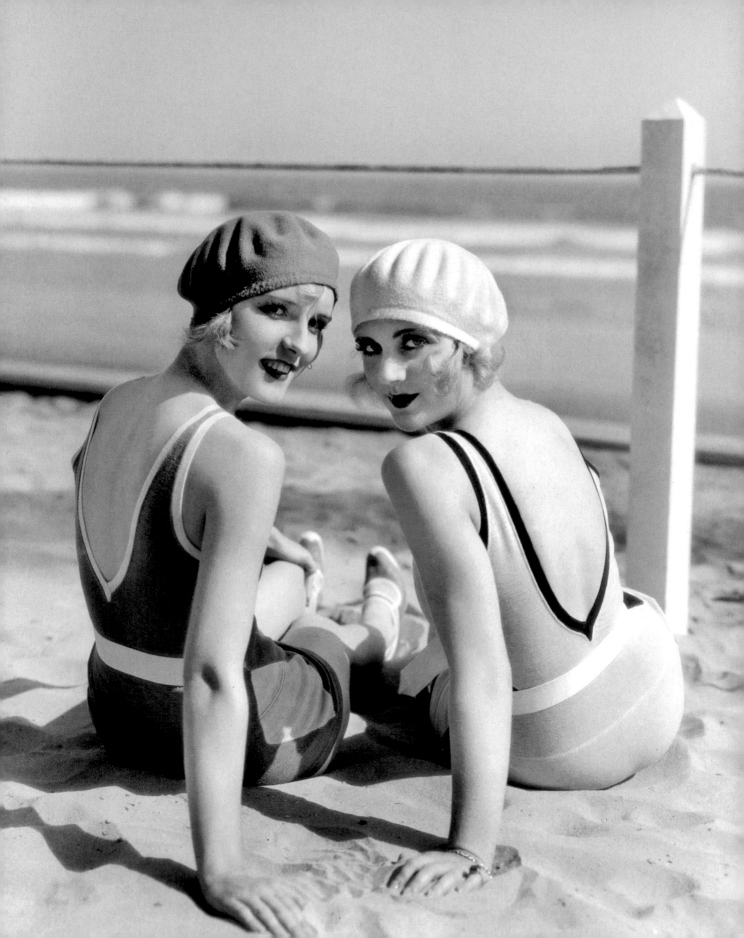

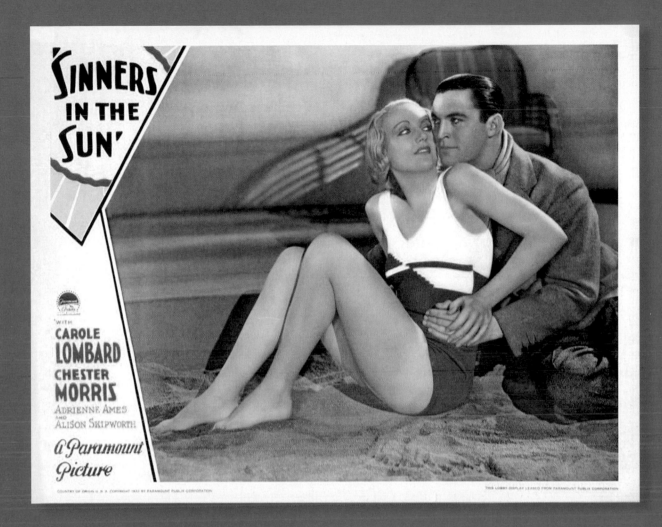

FRIENDS AND LOVERS: (OPPOSITE) Diane Ellis and Carole Lombard in *High Voltage* (1930). (ABOVE) Lobby card featuring Lombard and Chester Morris in *Sinners in the Sun* (1932).

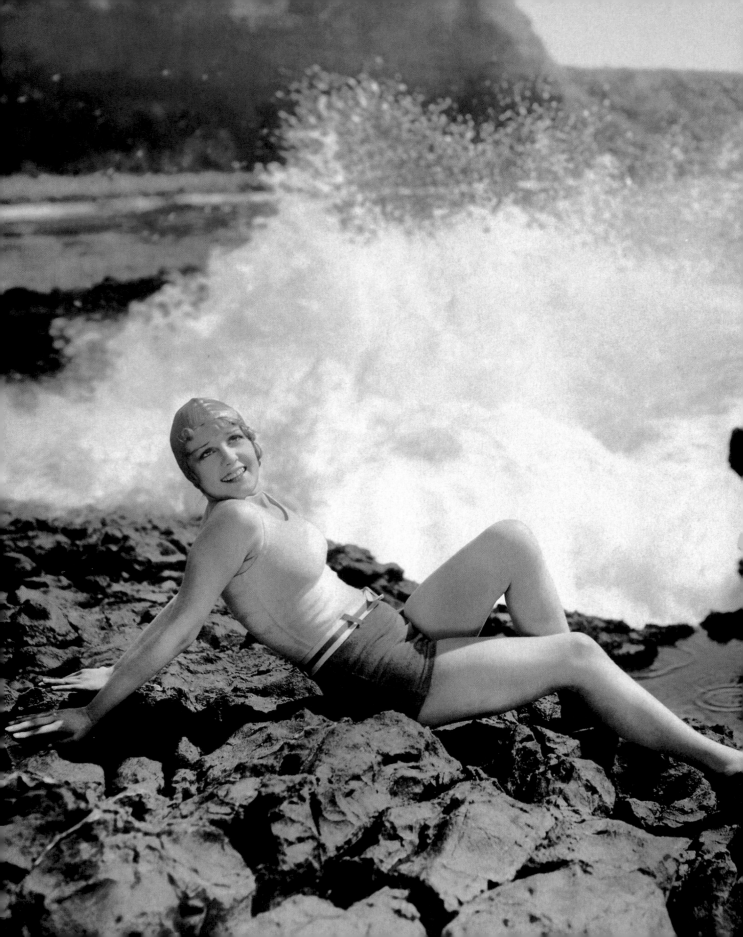

Anita Page, Laguna Beach, 1930s.

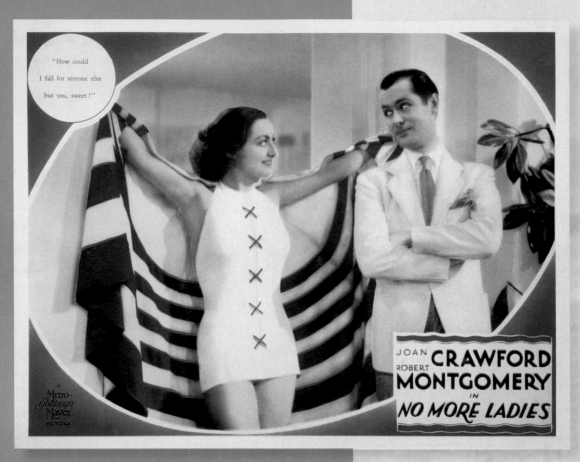

"How could I fall for anyone else but you, sweet?"

Metro-Goldwyn-Mayer PICTURES

JOAN **CRAWFORD**
ROBERT **MONTGOMERY**
IN
NO MORE LADIES

(ABOVE) Lobby card featuring Joan Crawford and Robert Montgomery in *No More Ladies* (1935). (RIGHT) Newlyweds Crawford and Douglas Fairbanks Jr., with their dog, relax on Catalina Island, 1930.

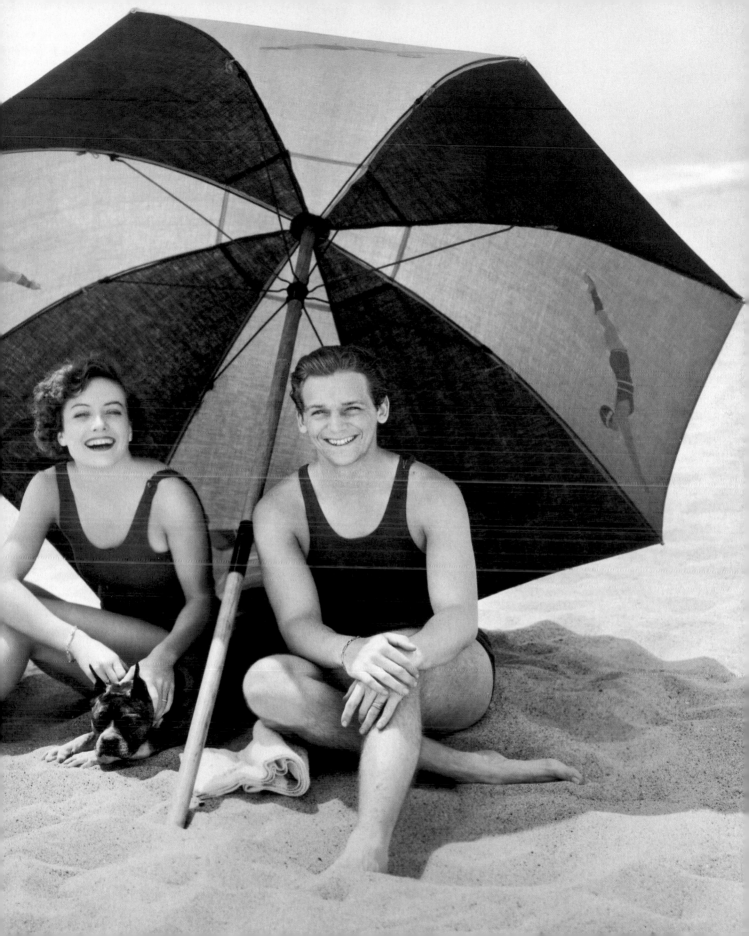

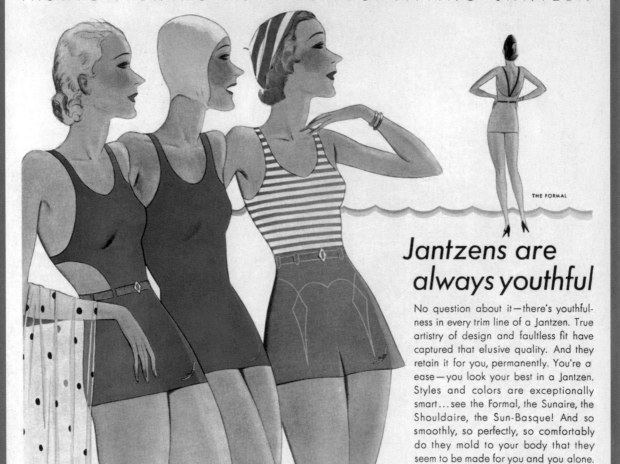

FASHION SWIMS IN A PERFECT-FITTING JANTZEN

THE FORMAL

Jantzens are always youthful

No question about it—there's youthful-ness in every trim line of a Jantzen. True artistry of design and faultless fit have captured that elusive quality. And they retain it for you, permanently. You're a ease—you look your best in a Jantzen. Styles and colors are exceptionally smart...see the Formal, the Sunaire, the Shouldaire, the Sun-Basque! And so smoothly, so perfectly, so comfortably do they mold to your body that they seem to be made for you and you alone. Jantzen quality is the highest and prices are the lowest in Jantzen history.

You'll always find the famous Red Diving Girl emblem on the label. Jantzen Knitting Mills, Portland, Oregon; Vancouver, Canada; London, England; Sydney, Australia.

Jantzen

The suit that put style in swimming

LEFT TO RIGHT
THE SUNAIRE
THE SHOULDAIRE
THE SUN-BASQUE

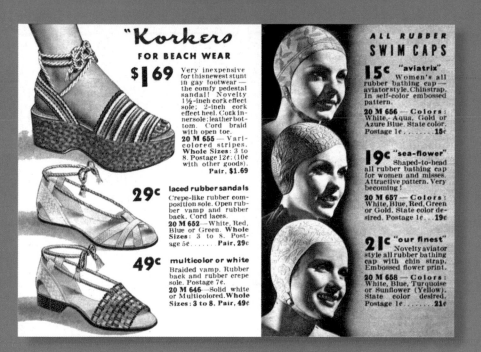

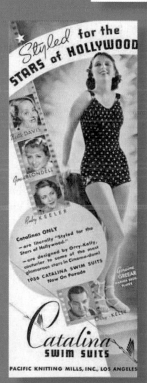

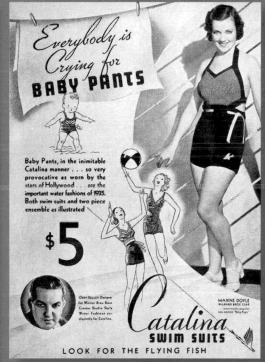

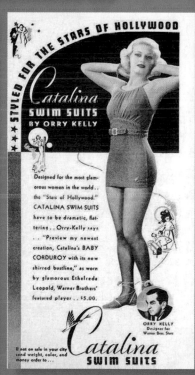

(OPPOSITE) Advertisement for Jantzen swimsuits, 1932. (TOP) Advertisement for "Korkers" beach shoes and swim caps, 1938. (ABOVE LEFT TO RIGHT) In 1936, Australian-born Hollywood costume designer Orry-Kelly tried his hand at water fashions, as seen in these advertisements for Catalina Swim Suits.

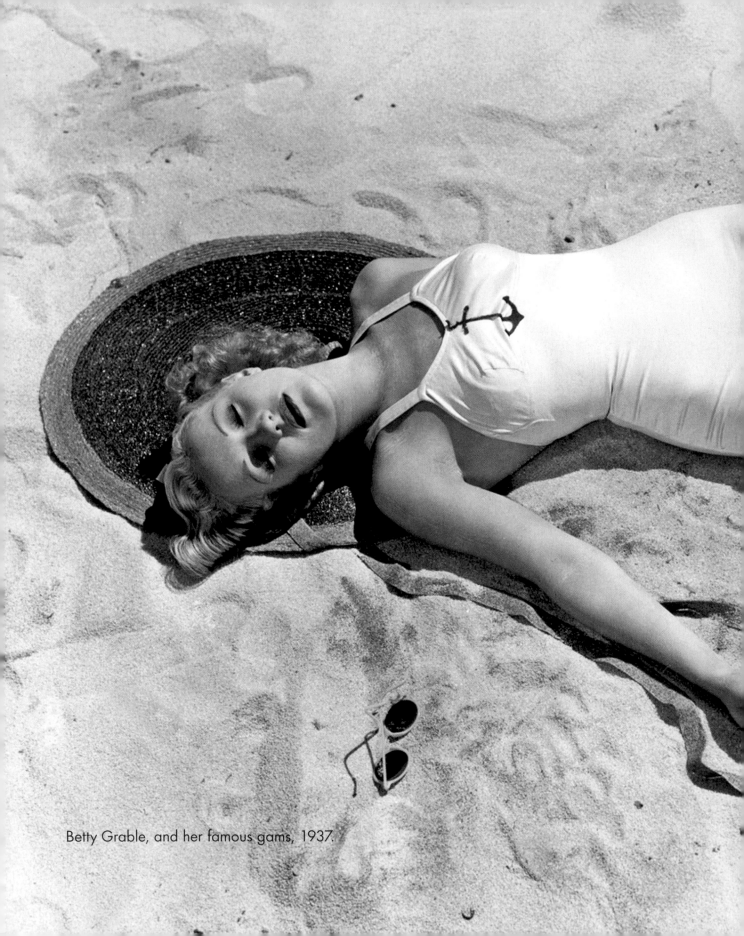

Betty Grable, and her famous gams, 1937.

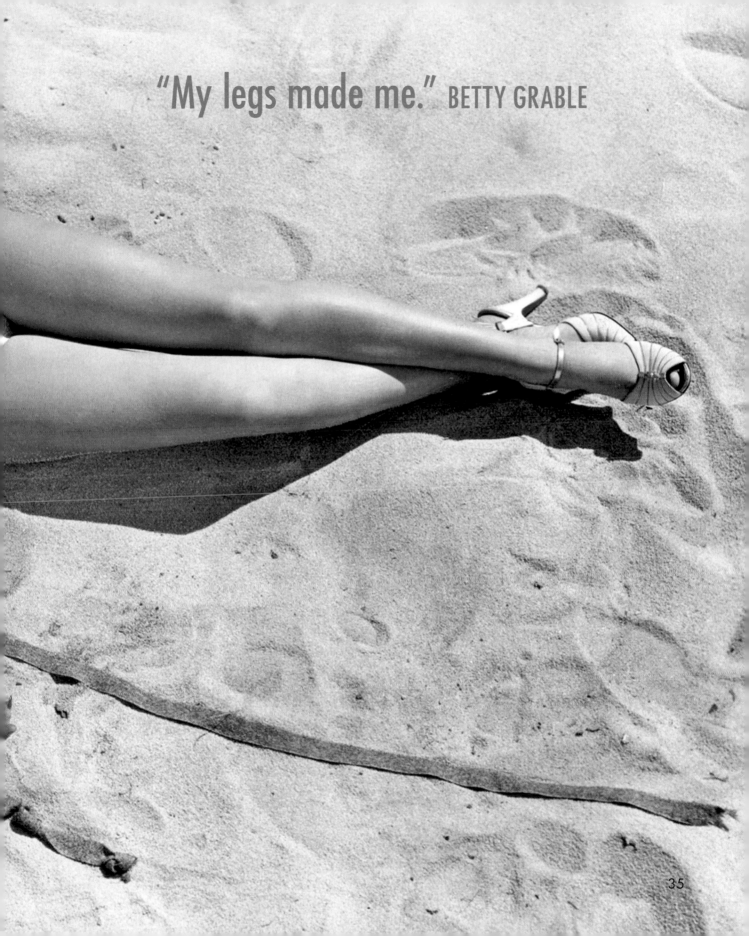

"My legs made me." BETTY GRABLE

35

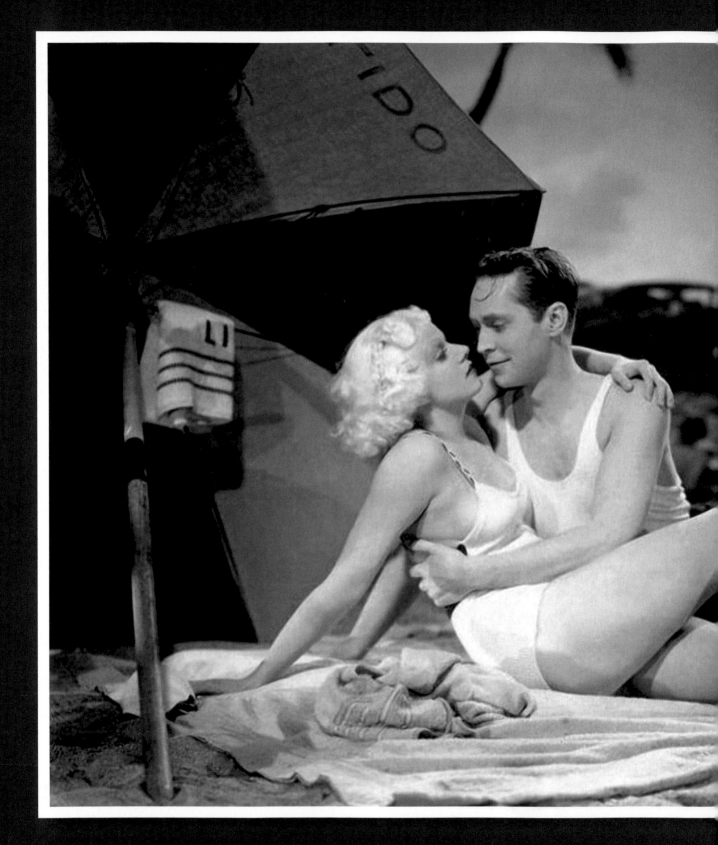

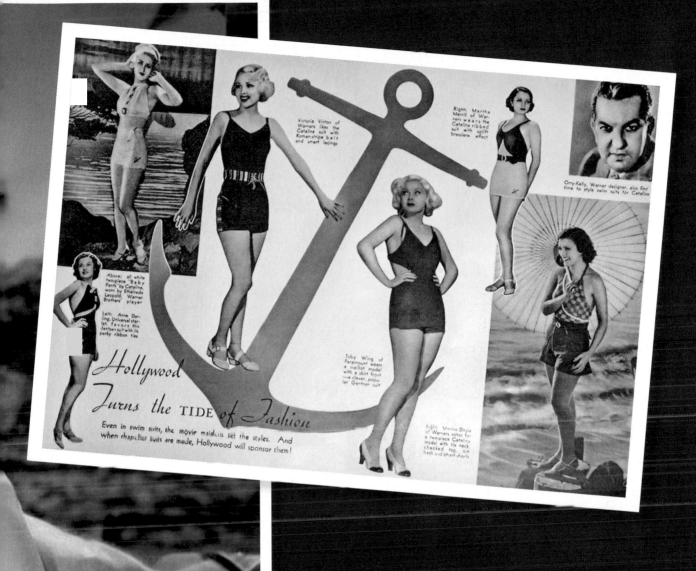

Hollywood

Turns the TIDE *of Fashion*

Even in swim suits, the movie maidens set the styles. And when chapelier suits are made, Hollywood will sponsor them!

(ABOVE) Fan magazine article from 1935 featuring Hollywood costume designer Orry-Kelly's collaboration with Catalina Swim Suits. (LEFT) Jean Harlow and Franchot Tone, feeling the heat, in *The Girl from Missouri* (1934).

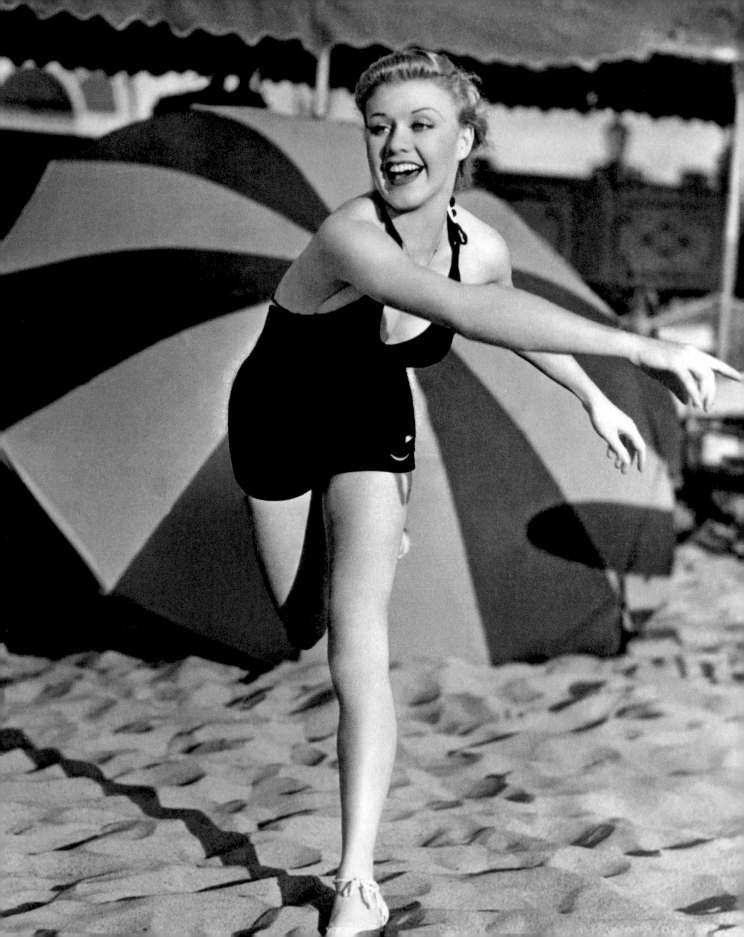

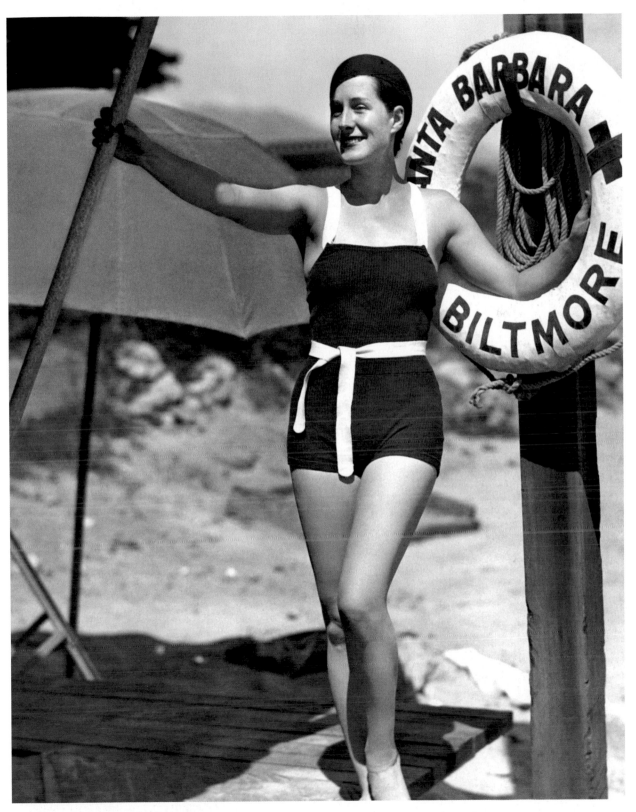

(ABOVE) Norma Shearer, in repose, at the Biltmore Hotel, Santa Barbara, May 25, 1932.
(OPPOSITE) Ginger Rogers, in motion, 1934.

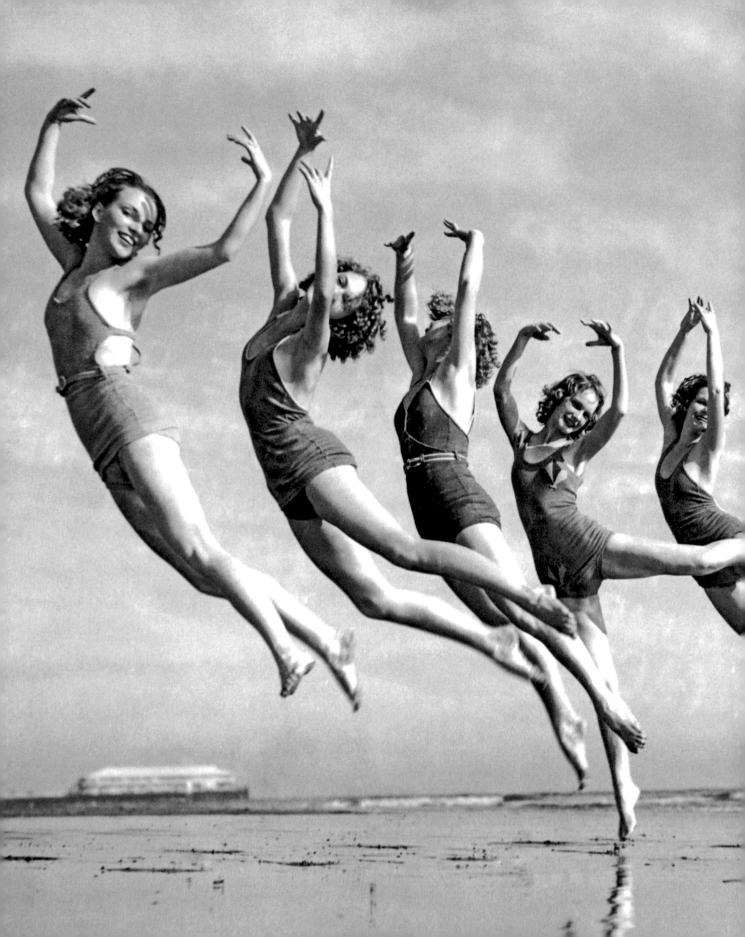

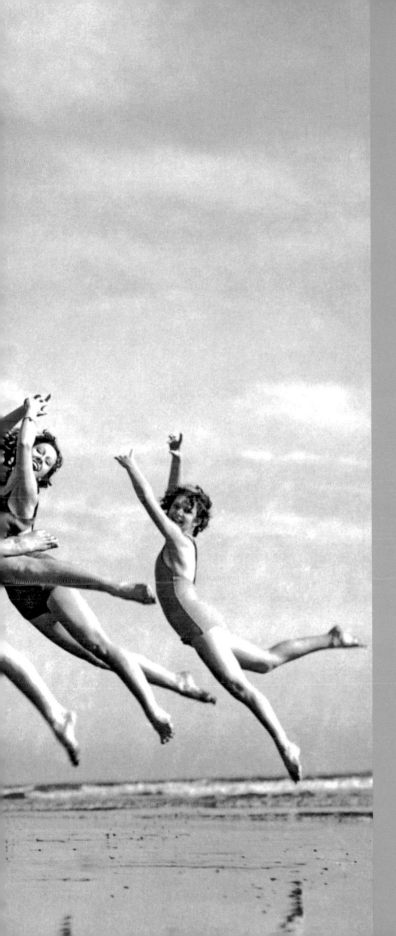

Dancers trained by Lillian Newman
stage a *pas de sept,* Long Beach, California,
March 16, 1934.

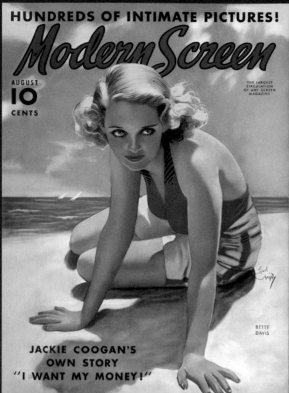

(ABOVE) Bette Davis on the cover of *Modern Screen*, August 1938. (RIGHT) Bette Davis, not rocking the boat, in a hilariously trompe l'oeil composition for *Three on a Match* (1932).
(OPPOSITE) Joan Blondell and Davis between takes on the set of *Three on a Match* (1932).

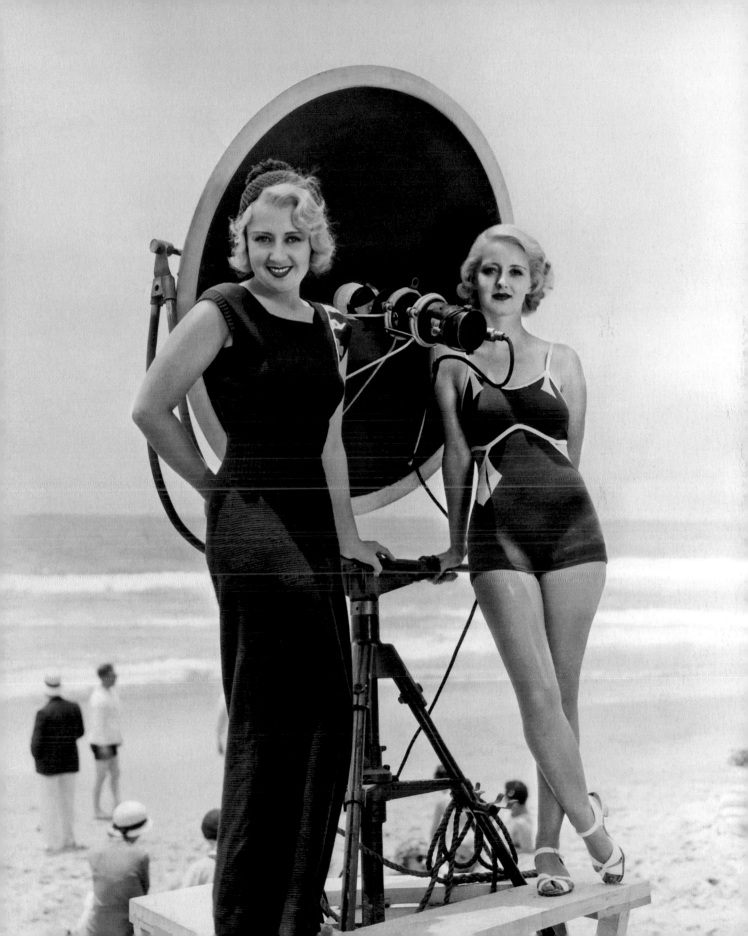

THE FORTIES

"If you try, you'll find me, where the sky meets the sea.
Here am I, your special island. Come to me, come to me."

LYRIC BY OSCAR HAMMERSTEIN

The war in the Pacific inspired a thousand pinups as morale boosters for the troops all over the world. Betty Grable, with her "one-million-dollar legs," and Rita Hayworth—"the goddess of love of the Twentieth Century"—donned Lastex swimwear or lacy lingerie for the pleasure of the boys in service, and the boys at home. Ava Gardner ("the world's most beautiful animal") joined the pinup brigade as well, later in the decade, posing languidly in the studio, athletically on the beach.

The swimwear makers, in an effort to stand out in the crowded market, attempted to cultivate an in-house style in their advertising, with the help of the illustrators—and there were many at the time— who could individualize and romanticize their products. The full-color ads that were placed in *Vogue, Harper's Bazaar, Life, Look,* and *The Saturday Evening Post,* were signed by talents such as Willard Cox, Frank Clark, and Lewis Baumer. The inexpensive movie magazines made do with plain-wrap, black-and-white illustrations. Jantzen employed a roster of commercial artists: Pete Hawley,

McClelland Barclay, and George Petty—famous as the creator of the "Petty Girl." The pinup master, Alberto Vargas, also worked with Jantzen, dreaming up his dream girls, radiant in sexy boned and wired suits, their shapely legs stretching to two-thirds of an ad page.

Christian Dior's postwar "New Look" had an effect on American swimwear. The corseting, girdling, boning, wiring, and seaming associated with the uplifted and wasp-waisted dresses, translated into the very constructed look of bathing suits in the late 1940s and into the 1950s. But another evolution had already begun. For the Dolores Del Rio picture *In Caliente* (1935), Orry-Kelly dared the censors with the two-piece suit—the first onscreen—he designed for her; it was white, skirted, one-shouldered, and bared the actress's tummy above the navel. The wartime restrictions on materials encouraged the popularity of the suit, as it used significantly less fabric than the classic maillot, even though the gap between top and bottom was just a matter of three to four inches. These few inches of skin, however, were much appreciated by connoisseurs of the female form.

Another excuse to show some extra inches of skin would be to film a fantasy about a mermaid, who would wear the equivalent of a two-piece: an embellished bra top with a spangled and scaled fish tail. For *Mr. Peabody and the Mermaid* (1948), Ann Blyth plays half of the title roles, winning the love of a married man on holiday in the Caribbean. An advantage to the situation: Blyth was

petite, actually short, and the length of her mermaid's tail would substantially elongate her figure, as she posed on the rocks. The movie company went on location, but not to the Caribbean: the crucial ocean and shore scenes were filmed at Weeki Wachee Springs in Florida.

It was an American woman, sportswear designer Claire McCardell, who first offered, in 1935, the two-piece in the marketplace. Like Chanel, she was known for her wool jersey separates, but McCardell's were said to have a very "American look": spirited, surprising, more than a little dashing. She devised the first tube top, the first unitard, and her swimsuits were a bit experimental, involving, among other effects, neoclassic draping and loincloth gathering.

Specializing in resort and cruise wear, Tina Leser moved her business from Honolulu to Manhattan, but still incorporated her ethnic sensibilities into her work by way of sarongs; harem, dhoti, and toreador pants; and hand-painted Hawaiian prints. Leser developed a celebrity clientele which included Joan Crawford, Joan Fontaine, and Paulette Goddard.

Designer of beach and play clothes, Carolyn Schnurer worked mostly with varieties of cotton fabrications rather than the elasticized synthetics. She was a world traveler, seeking inspiration globally, to design for the label Burt Schnurer Cabana. One scintillating image took Schnurer to the next level. Photographer Toni Frissell—a rare

woman behind the camera—captured model Dovima, oiled and glamorously exhausted in the tropical heat, and wearing a soft dotted cotton bandeau bikini, perhaps Schnurer's first. Shot at Montego Bay in Jamaica, the black-and-white photo was published in *Harper's Bazaar* in May 1947. The accompanying caption to the Frissell image advised, "One wonderful way to take the sun . . . completely covered with 'sutra' lotion to filter out the burning rays. . . ."

Sun tanning had become serious business by the late 1940s. From the 1920s on, it was no longer considered déclassé. A tanned face, neck, arms, and hands had been signifiers of the lower classes, those who had to work outdoors for their livelihoods. The 1920s flipped the script; Coco Chanel returned to Paris from Deauville in the south of France with a very attractive, healthy glow. The story may be true, and since then a beautiful tan has been an indication of wealth, leisure time, and resort living. Sunbathing's dangerous consequences were unknown decades ago. The big concerns were the painful burning and the subsequent premature aging of the skin, even with all the oils and creams and lotions.

More skin exposure, more attractive tan lines, and heightened sensuality were the catalysts for ever briefer swimwear. In 1946, in Paris, couture designer Jacques Heim unveiled his tiny two-piece design to an interested press corps. But when Louis Réard, a civil engineer and design dilettante, showed off his version at the Molitor spa pool just weeks later, the news raced round the world. Booking

a model to wear his invention proved impossible, so he recruited an exotic dancer, Martine Bernardini, to fill out his four triangles of cloth, and called it "the bikini," after the group of little atolls in the South Pacific where atomic testing had recently taken place.

Réard was expecting explosive effects on contemporary swimwear, and on the culture at large, and spoke of it as "smaller than the smallest swimsuit. A bikini is not a bikini unless it can be pulled through a wedding ring."

For the true "itsy bitsy" bikini to successfully cross the pond and appear on American beaches, another ten to twelve years would be necessary. Diana Vreeland stated that "The eye must travel," and in transit, must adjust.

(OPPOSITE) Ava Gardner, 1944. Photo by Clarence Sinclair Bull.

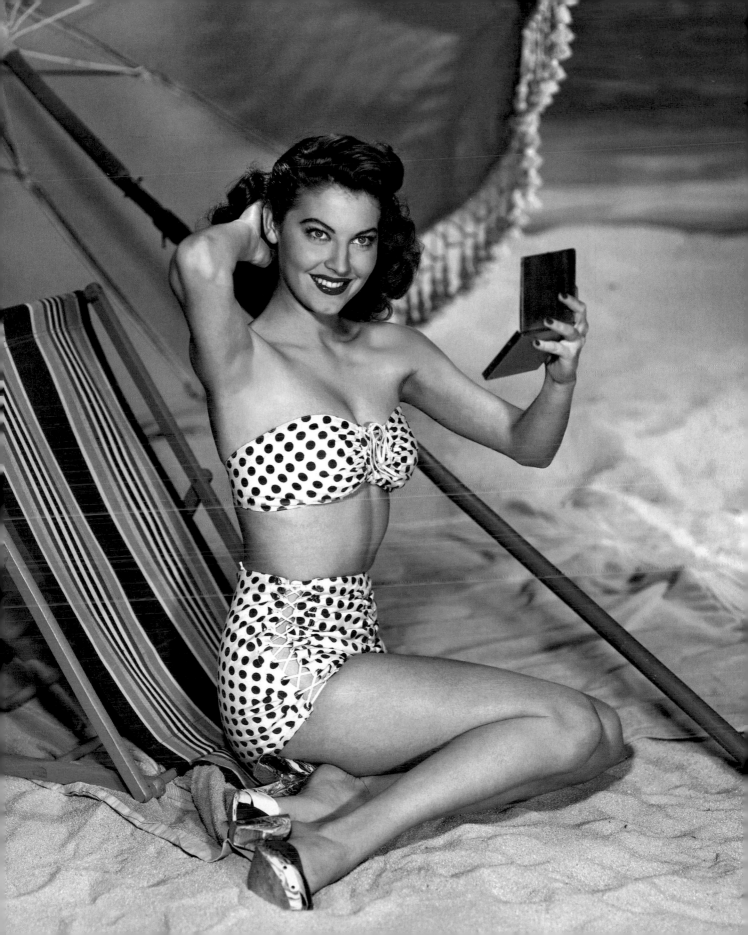

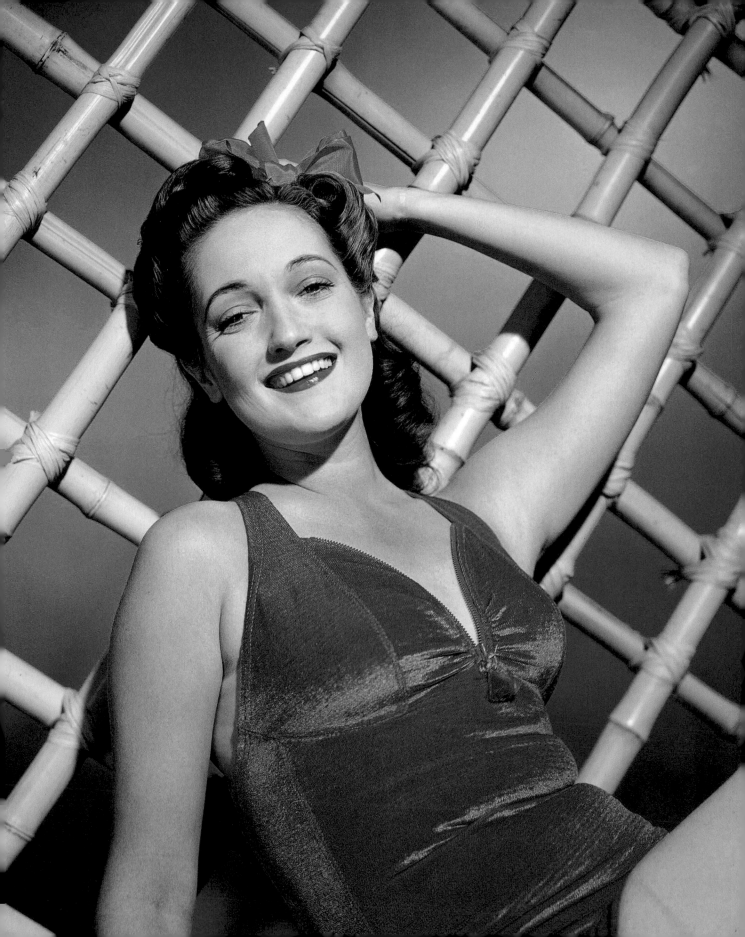

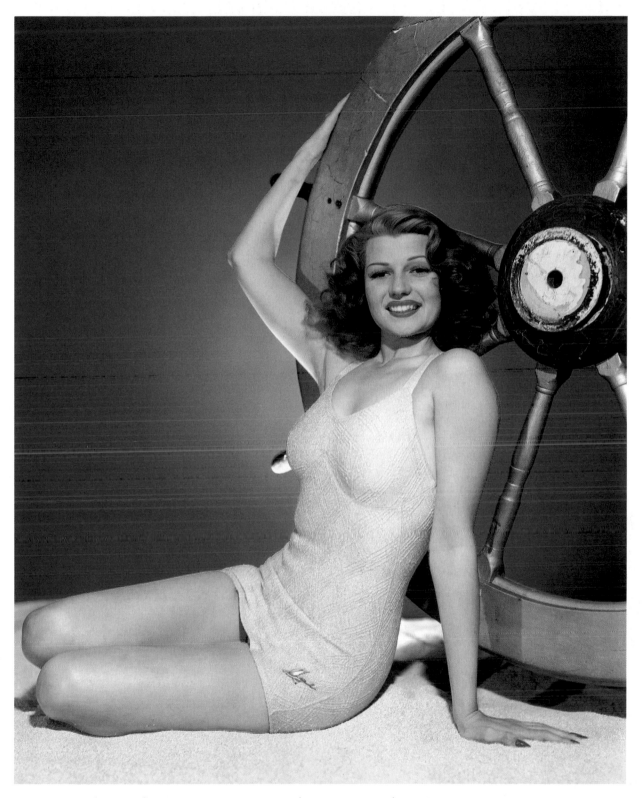

(ABOVE) Rita Hayworth, 1942. (OPPOSITE) Dorothy Lamour, early 1940s.

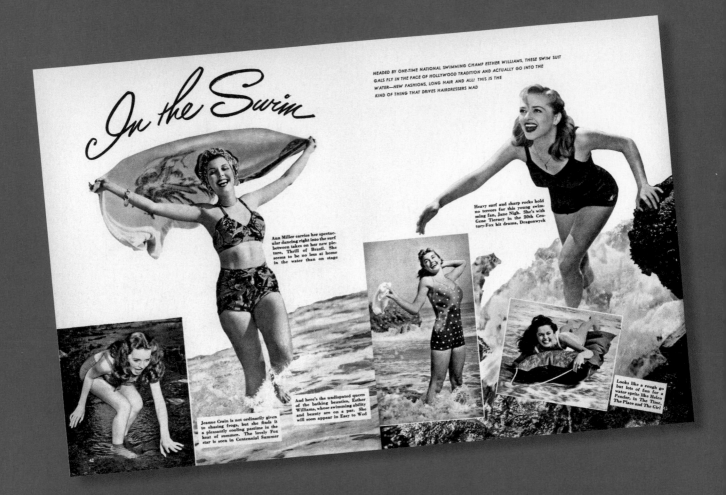

In the Swim

Ann Miller carries her spectacular dancing right into the surf between takes on her new picture, Thrill of Brazil. She seems to be no less at home in the water than on stage

Heavy surf and sharp rocks hold no terrors for this young swimming fan, Jane Nigh. She's with Gene Tierney in the 20th Century-Fox hit drama, Dragonwyck

And here's the undisputed queen of the bathing beauties, Esther Williams, whose swimming ability and beauty are on a par. She will soon appear in Easy to Wed

Jeanne Crain is not ordinarily given to chasing frogs, but she finds it a pleasantly cooling pastime in the heat of summer. The lovely Fox star is seen in Centennial Summer

Looks like a rough go but lots of fun for a water sprite like Helen Pender, in The Time, The Place and The Girl

"Curve: the loveliest distance between two points."

MAE WEST

(ABOVE) Article from *Motion Picture* magazine, July 1946.
(OPPOSITE) Alexis Smith, 1941.

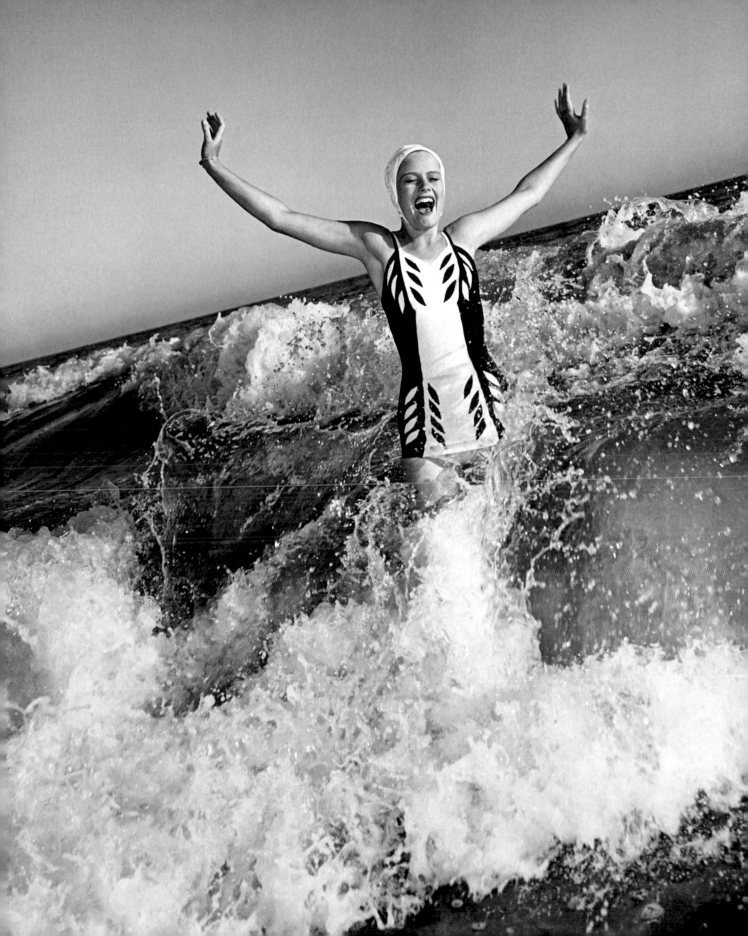

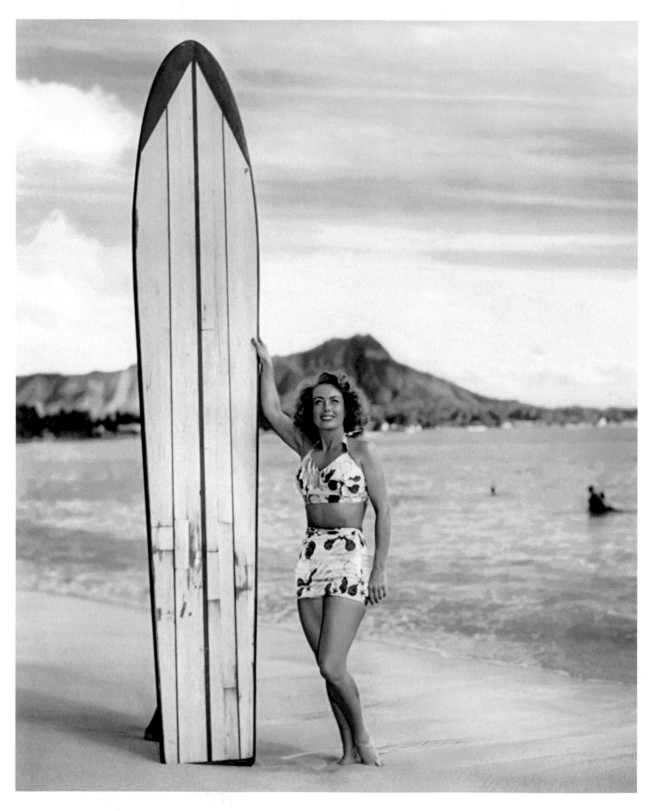

THE LONG AND THE SHORT OF IT: (ABOVE) Joan Crawford on Waikiki Beach, Hawaii, 1949.
(OPPOSITE) Starlet, 1940s.

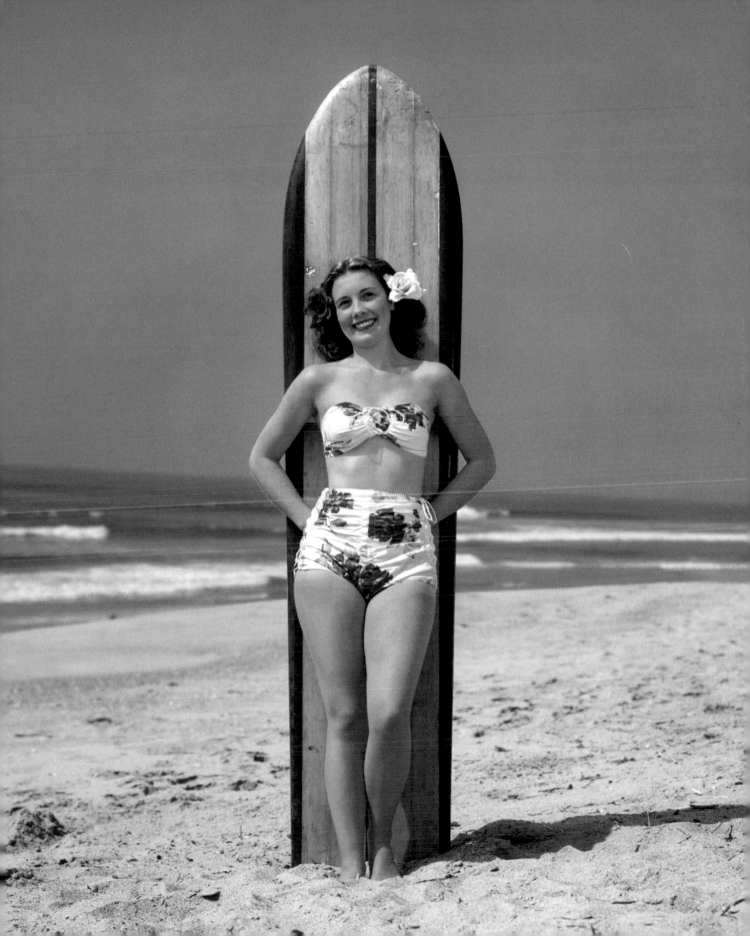

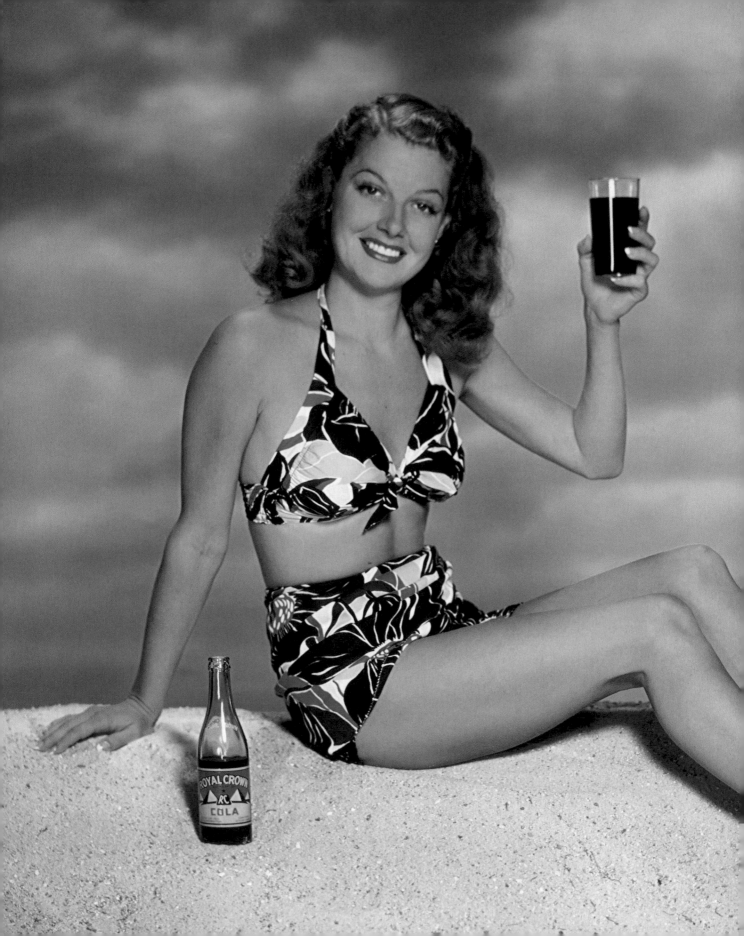

Ann Sheridan endorsing Royal Crown Cola,
late 1940s.

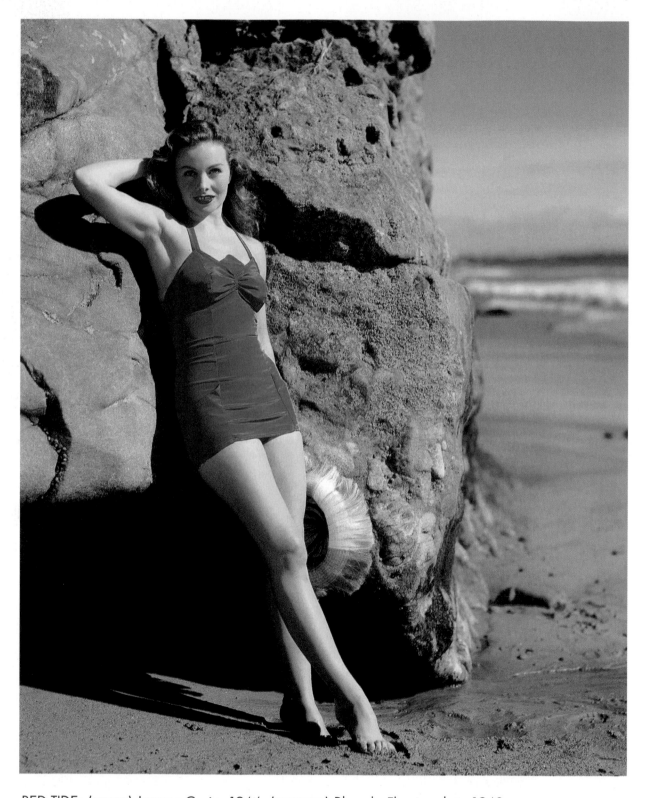

RED TIDE: (ABOVE) Jeanne Crain, 1944. (OPPOSITE) Rhonda Fleming, late 1940s.

(OVERLEAF) SECOND SKIN: Carmen Miranda, unleashing her inner animal, at her beach house in 1948.

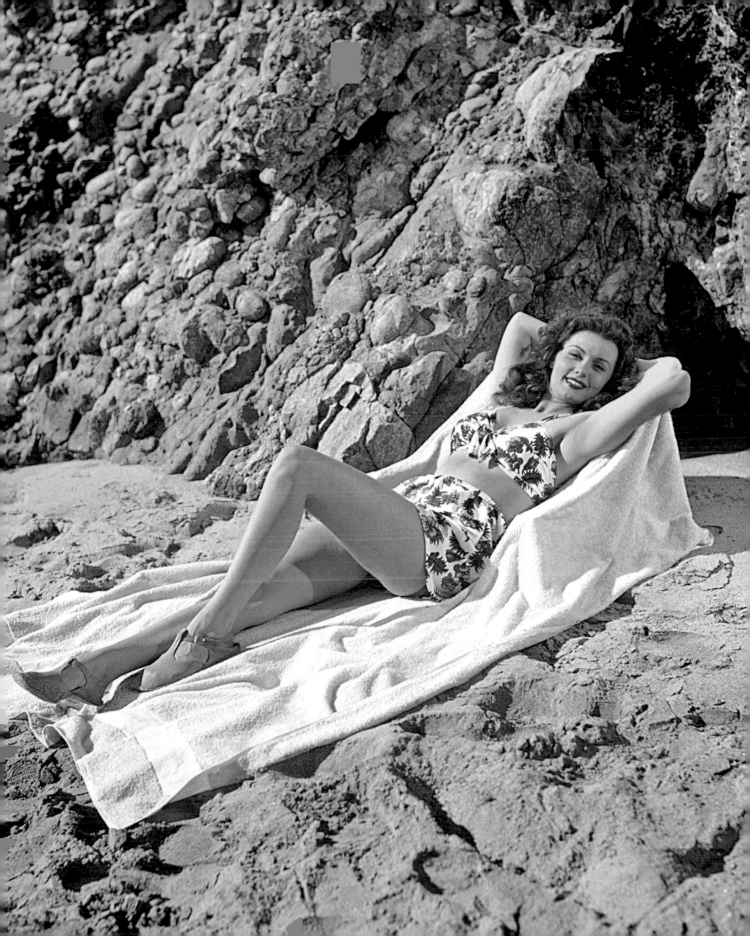

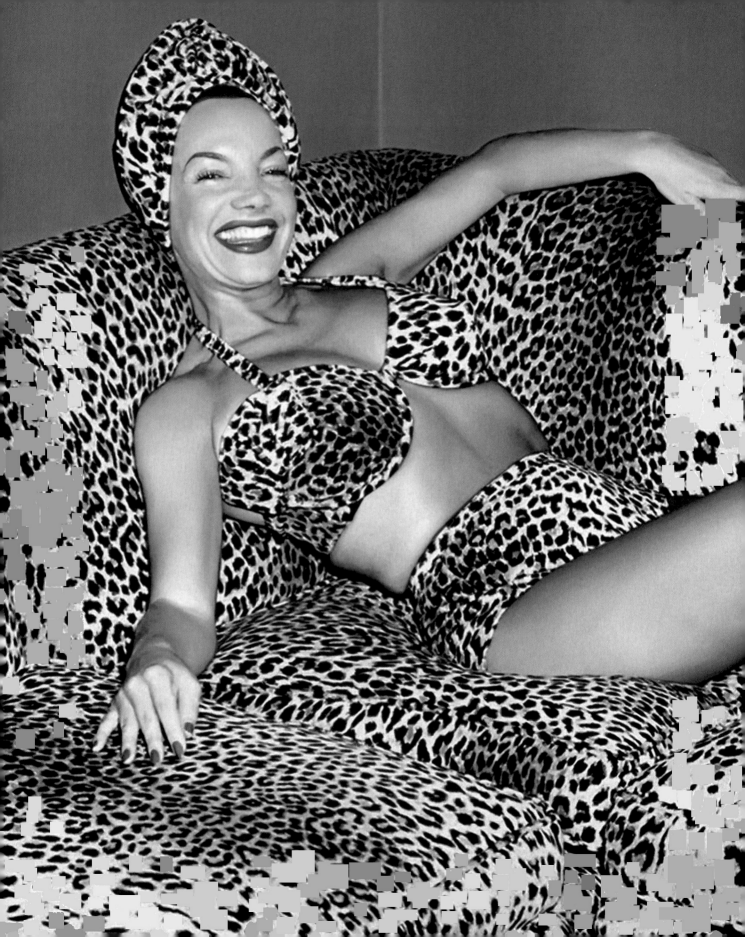

"Look at me and tell me I don't have Brazil in every curve of my body." CARMEN MIRANDA

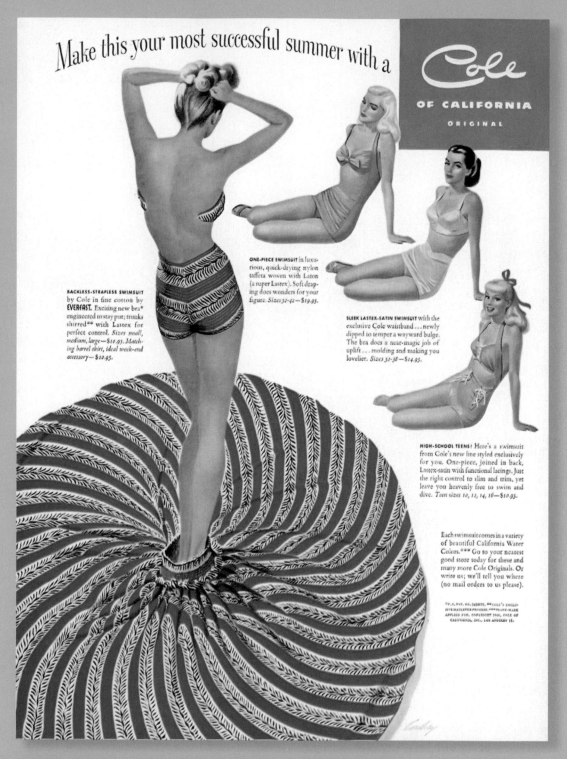

(ABOVE) Advertisement for Cole of California, 1948. (OPPOSITE, CLOCKWISE FROM TOP LEFT) Advertisements for Sea Molds by Flexees, late 1940s; Jantzen Swim Suits, illustrated by Pete Hawley, 1949; Cole of California, 1942; and Shepherd Knitwear, featuring Martha O'Driscoll, 1946.

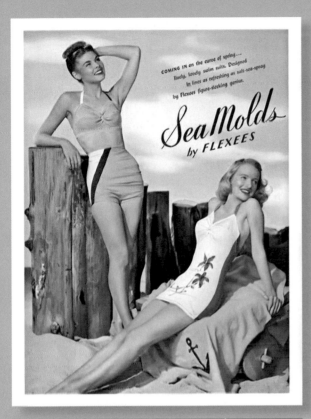

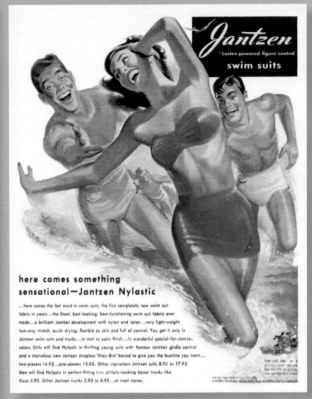

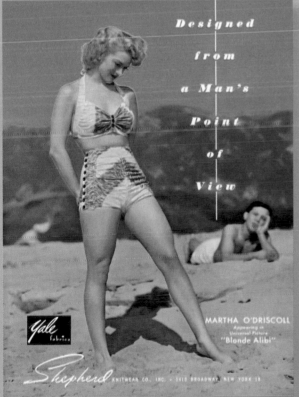

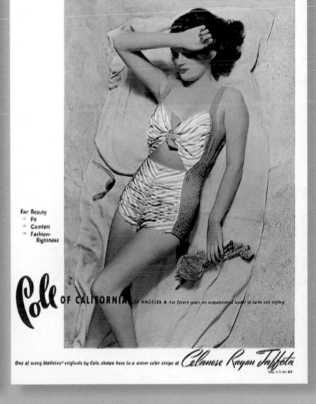

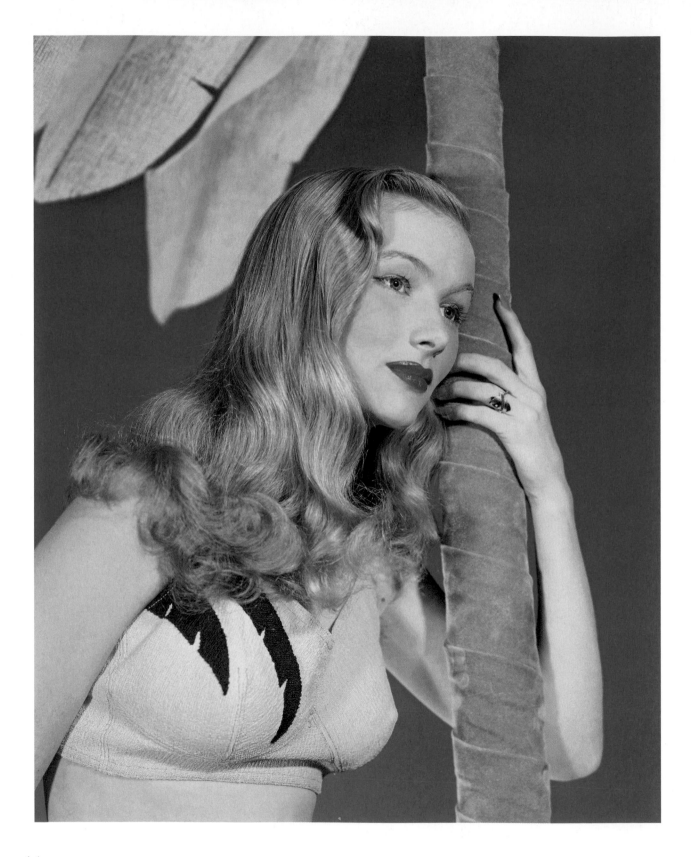

"I will have one of the cleanest obits of any actress. I never did cheesecake like Ann Sheridan and Betty Grable. I just used my hair."

VERONICA LAKE

Veronica Lake, 1942. Photo by Eugene Robert Richee.

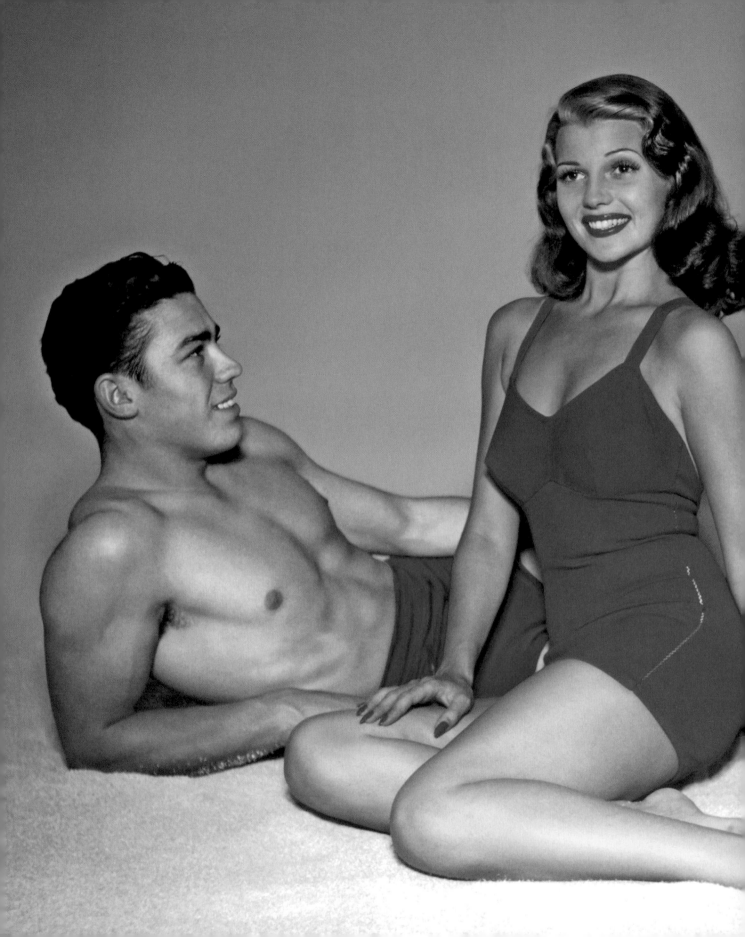

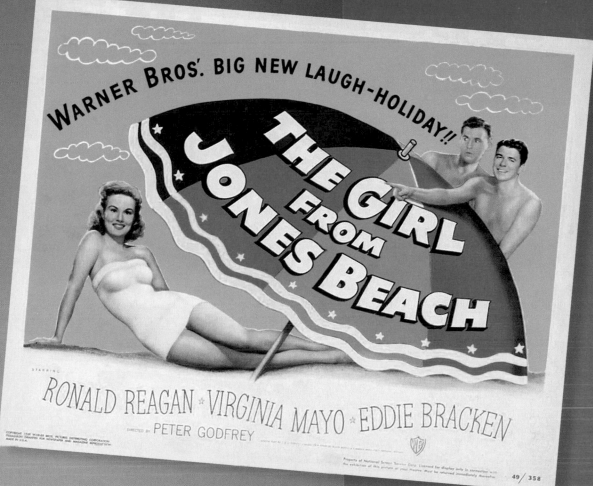

WARNER BROS'. BIG NEW LAUGH-HOLIDAY!!

THE GIRL FROM JONES BEACH

STARRING
RONALD REAGAN · VIRGINIA MAYO · EDDIE BRACKEN
DIRECTED BY PETER GODFREY

49/358

(ABOVE) Lobby card featuring Virginia Mayo, Ronald Reagan, and Eddie Bracken in *The Girl from Jones Beach* (1949). (LEFT) Rita Hayworth and her brother, Vernon Cansino, early 1940s.

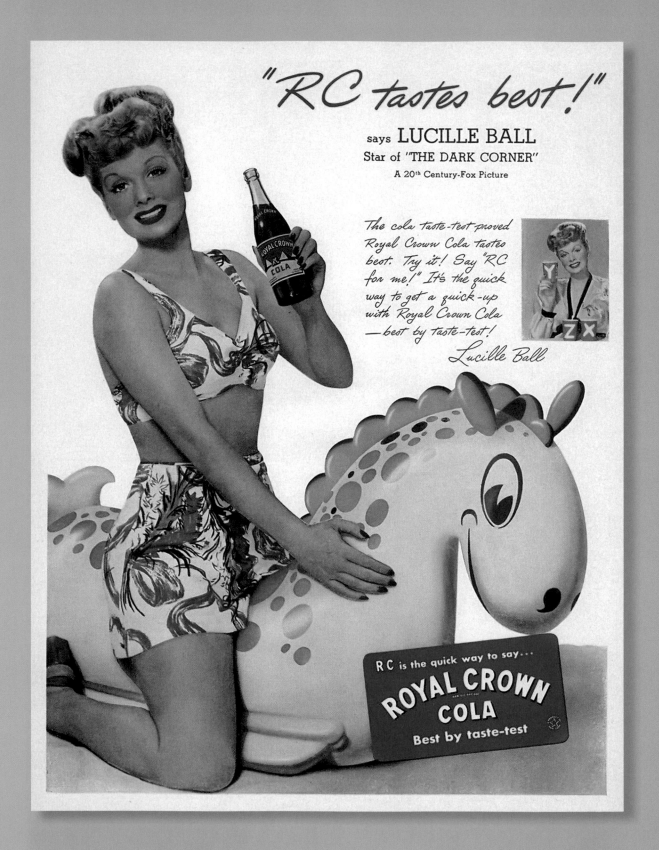

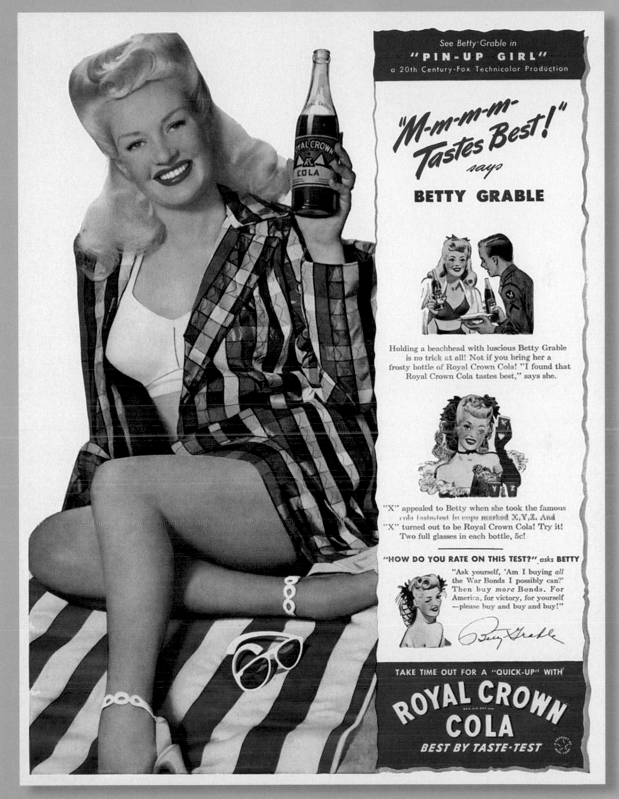

CROWNING GLORIES: (ABOVE) Betty Grable for Royal Crown Cola, 1944.
(OPPOSITE) Lucille Ball for Royal Crown, 1946.

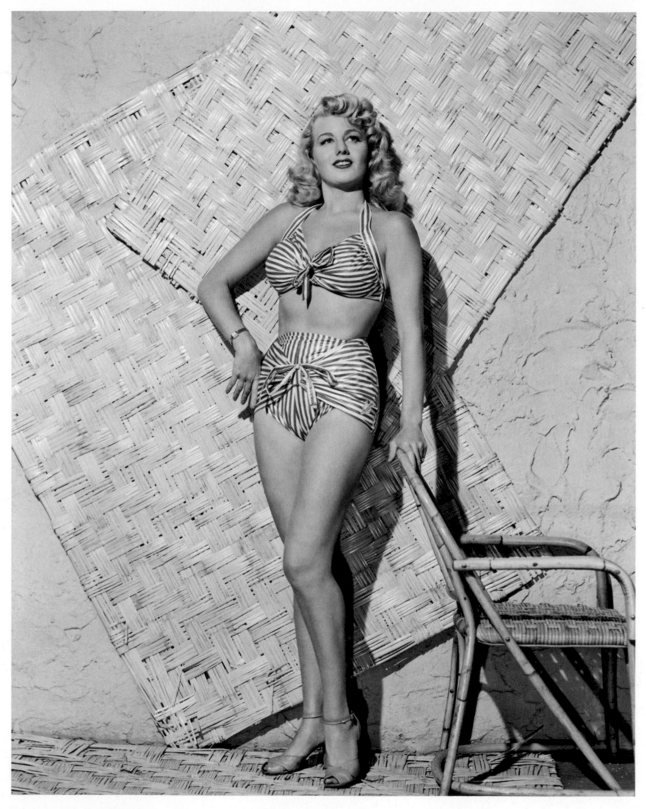

(ABOVE) Shelley Winters, 1947. (OPPOSITE) Yvonne De Carlo, late 1940s.

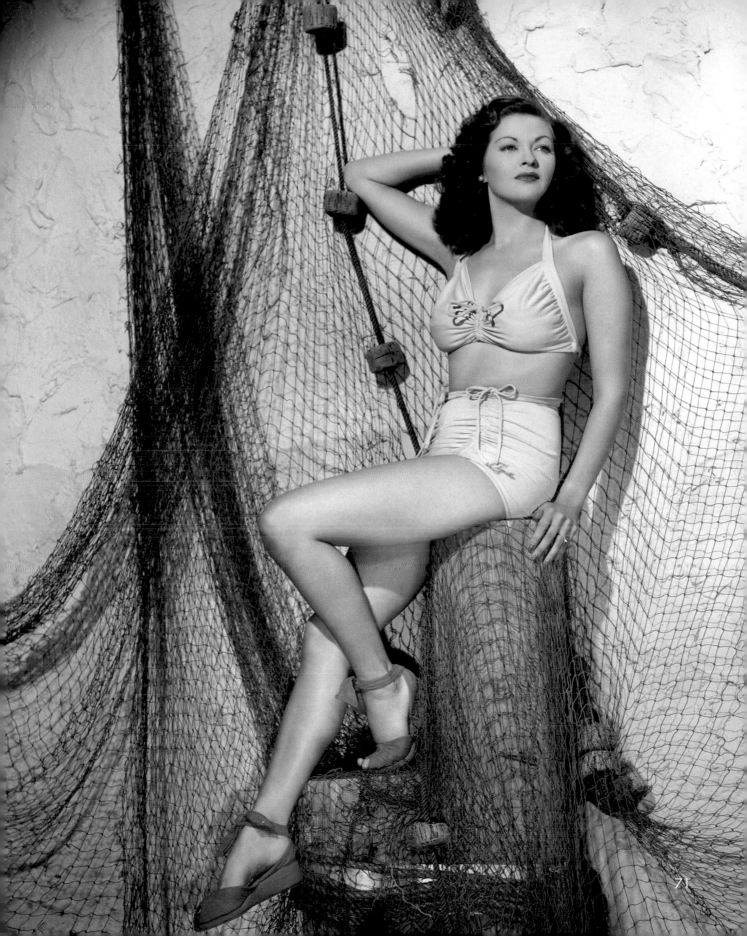

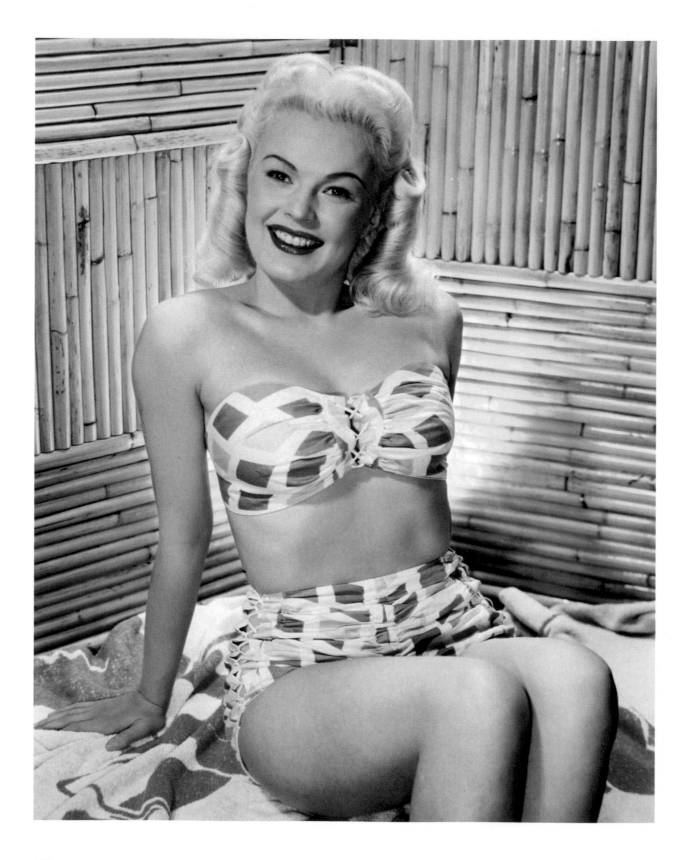

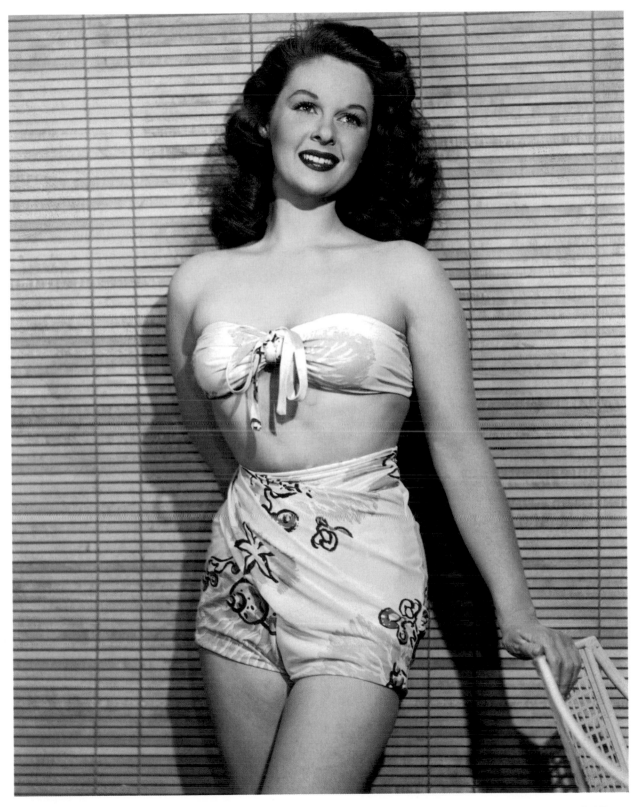

BANDEAU AND BAMBOO: (ABOVE) Susan Hayward, circa 1944. (OPPOSITE) June Haver, 1945.

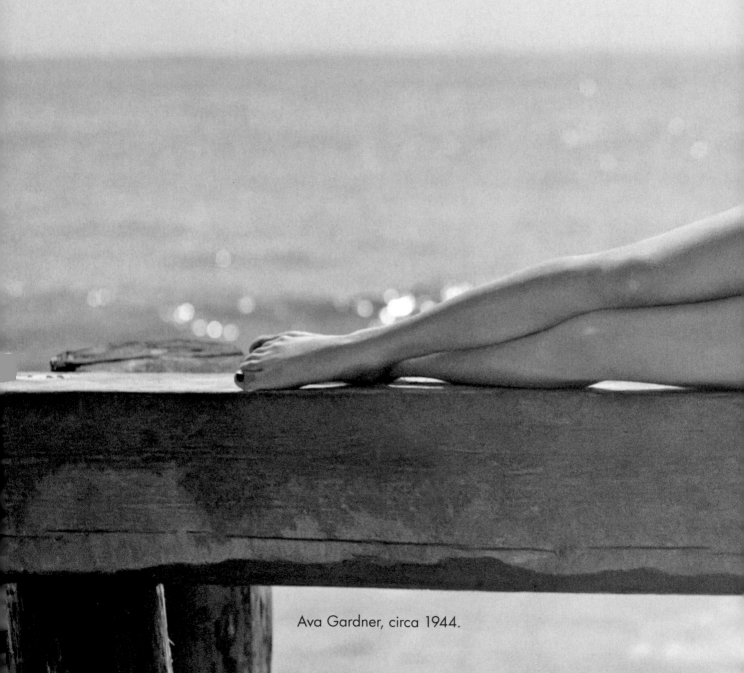

"Doing nothing feels like floating on warm water to me. Delightful, perfect . . ."

AVA GARDNER

Ava Gardner, circa 1944.

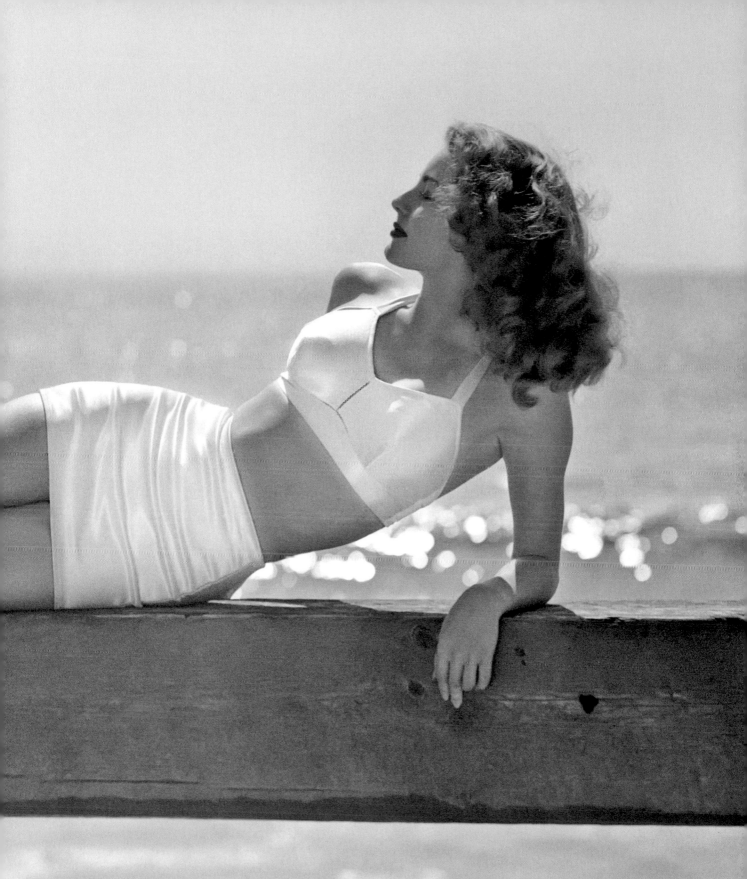

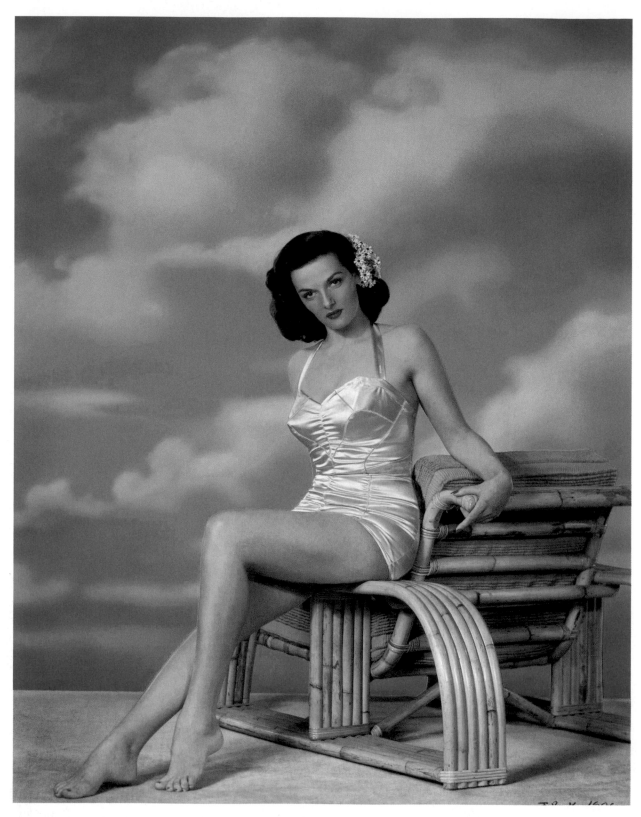

DOUBLE YOUR PLEASURE: (ABOVE) Jane Russell in a Lastex swimsuit, 1948.
(OPPOSITE) Russell in 1946.

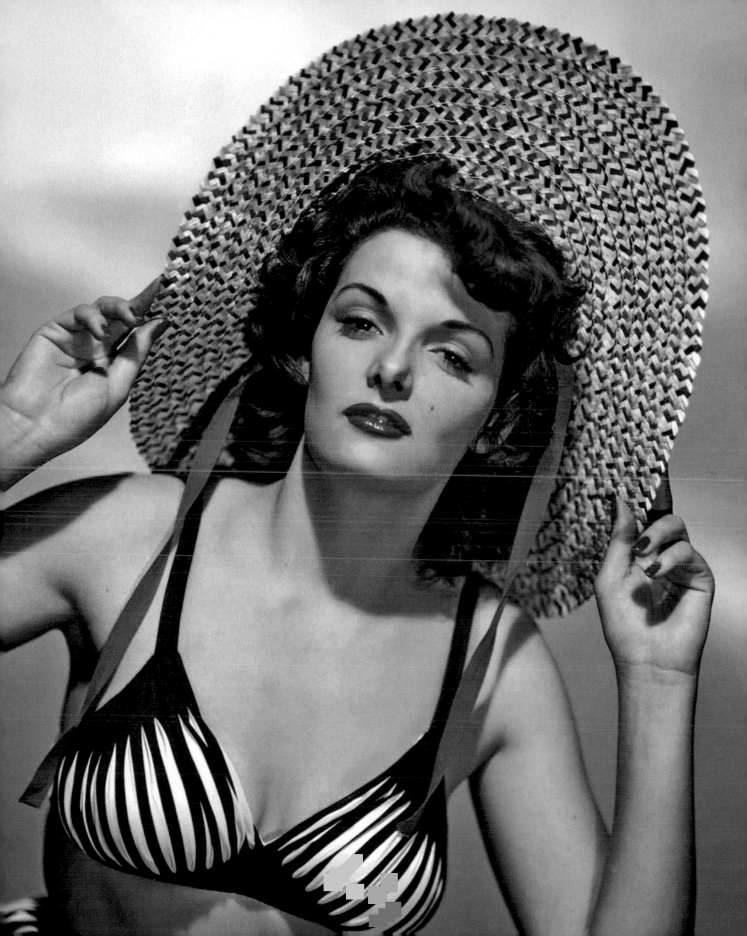

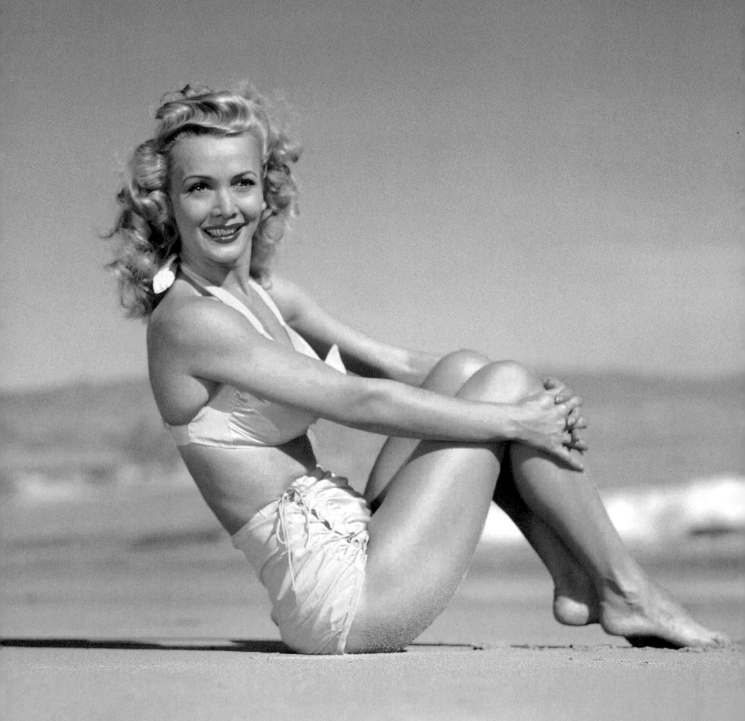

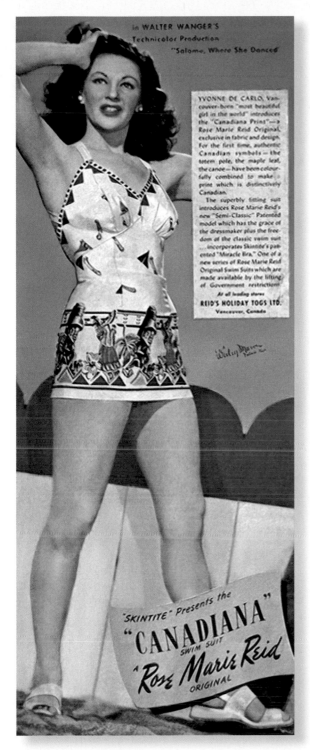

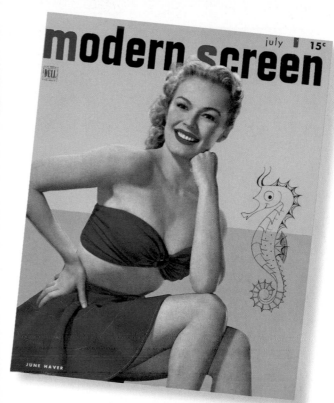

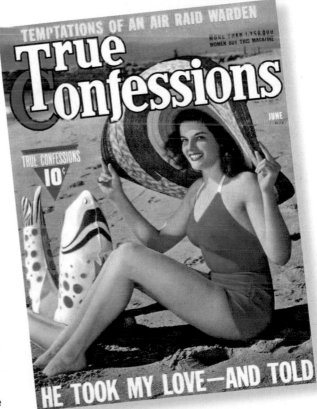

(TOP LEFT) Yvonne De Carlo in an advertisement for designer Rose Marie Reid, 1945. (TOP RIGHT) June Haver on the cover of *Modern Screen*, July 1948. (BOTTOM RIGHT) Jane Russell, *True Confessions*, June 1942. (OPPOSITE) Carole Landis, 1943.

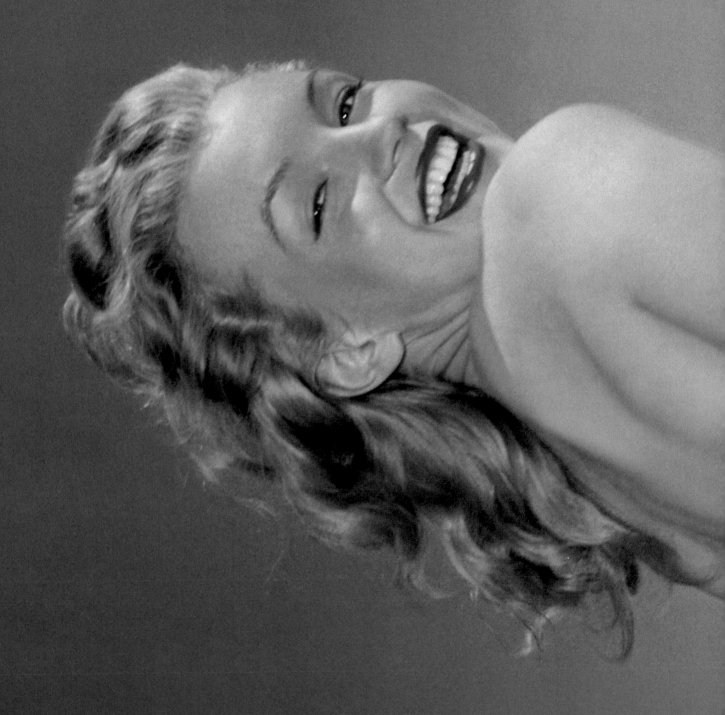

Marilyn Monroe, not quite on the brink of superstardom, as a young model in 1947.

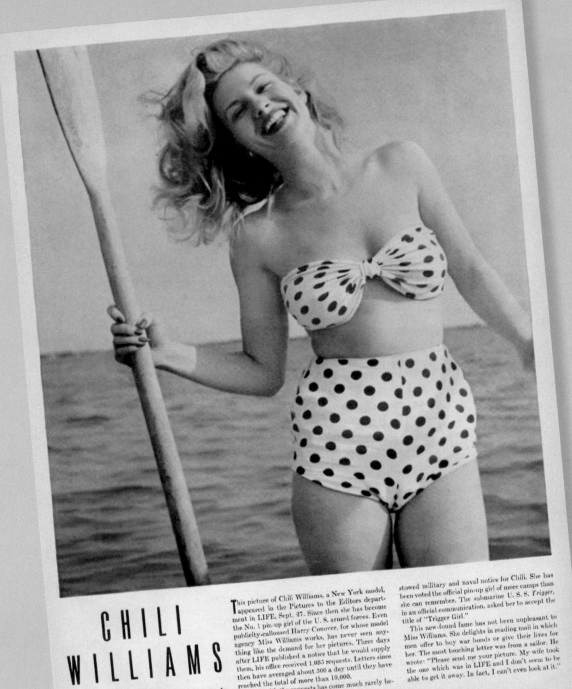

CHILI WILLIAMS

Her picture reprinted by request

This picture of Chili Williams, a New York model, appeared in the Pictures to the Editors department in LIFE, Sept. 27. Since then she has become the No. 1 pin-up girl of the U. S. armed forces. Even publicity-calloused Harry Conover, for whose model agency Miss Williams works, has never seen anything like the demand for her pictures. Three days after LIFE published a notice that he would supply them, his office received 1,035 requests. Letters since then have averaged about 500 a day until they have reached the total of more than 10,000.

Along with the requests has come much rarely bestowed military and naval notice for Chili. She has been voted the official pin-up girl of more camps than she can remember. The submarine U. S. S. *Trigger*, in an official communication, asked her to accept the title of "Trigger Girl."

This new-found fame has not been unpleasant to Miss Williams. She delights in reading mail in which men offer to buy war bonds or give their lives for her. The most touching letter was from a sailor. He wrote: "Please send me your picture. My wife took the one which was in LIFE and I don't seem to be able to get it away. In fact, I can't even look at it."

(ABOVE) Popular World War II pinup Chili Williams, nicknamed "The Polka-Dot Girl," featured in an article for *Life* magazine, November 22, 1943. (OPPOSITE) Lana Turner as Cora Smith in *The Postman Always Rings Twice* (1946).

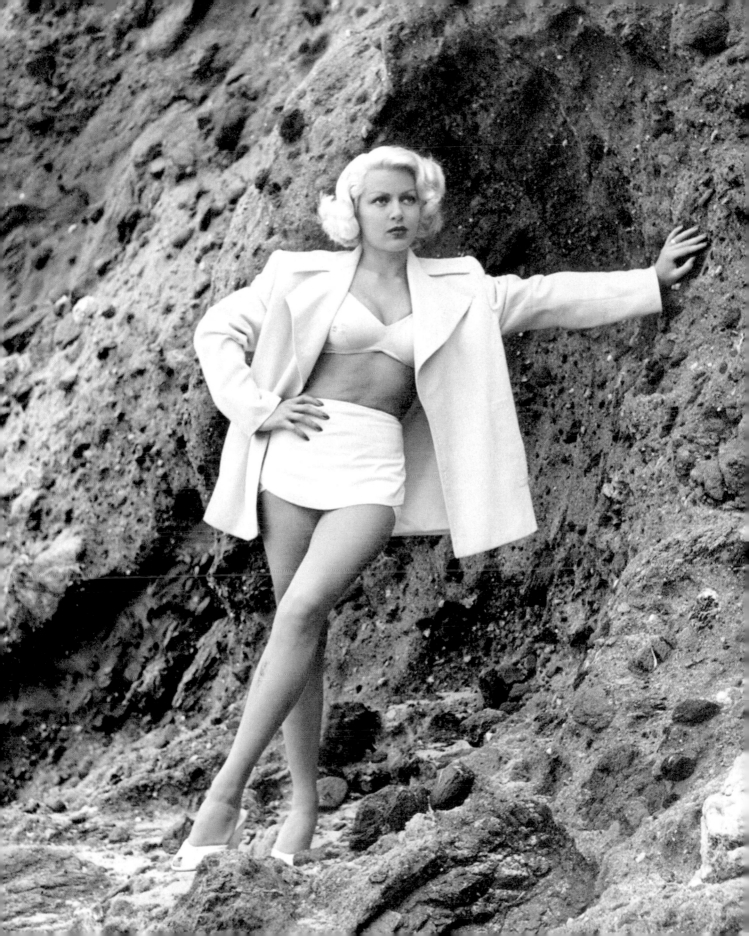

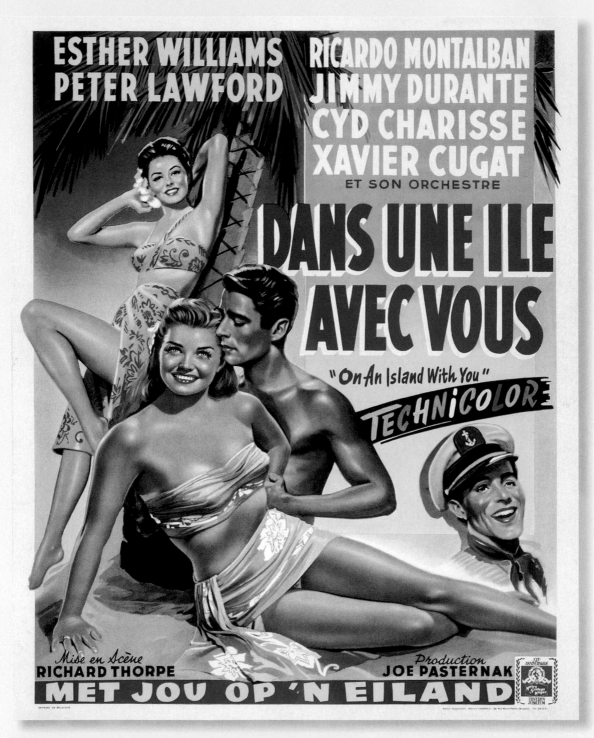

MILLION DOLLAR MERMAID: Champion swimmer Esther Williams captivated cinema audiences with her aquatic spectacles in blazing Technicolor, including *Bathing Beauty* (1944), *Neptune's Daughter* (1949), and *Dangerous When Wet* (1953). (ABOVE) Belgian movie poster featuring Williams with Peter Lawford in *On an Island with You* (1948).

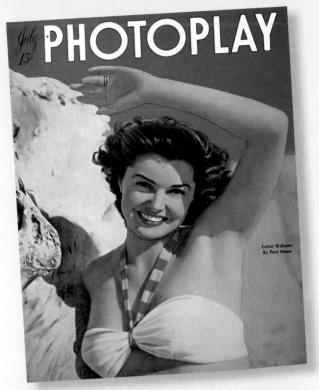

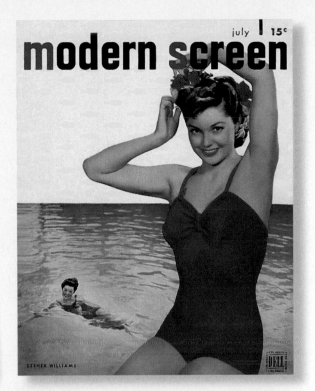

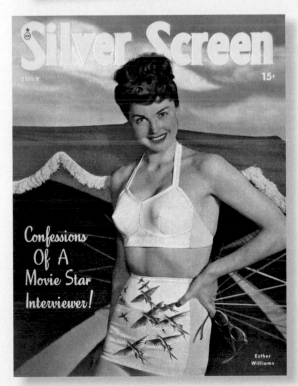

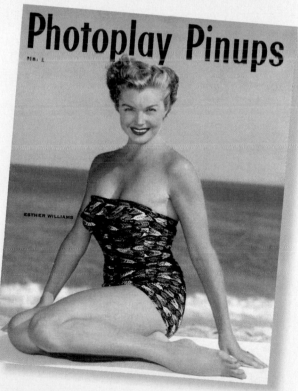

(CLOCKWISE FROM TOP LEFT) Williams on the cover of *Photoplay*, July 1947; *Modern Screen*, July 1947; *Photoplay Pinups*, late 1940s; and *Silver Screen*, July 1947.

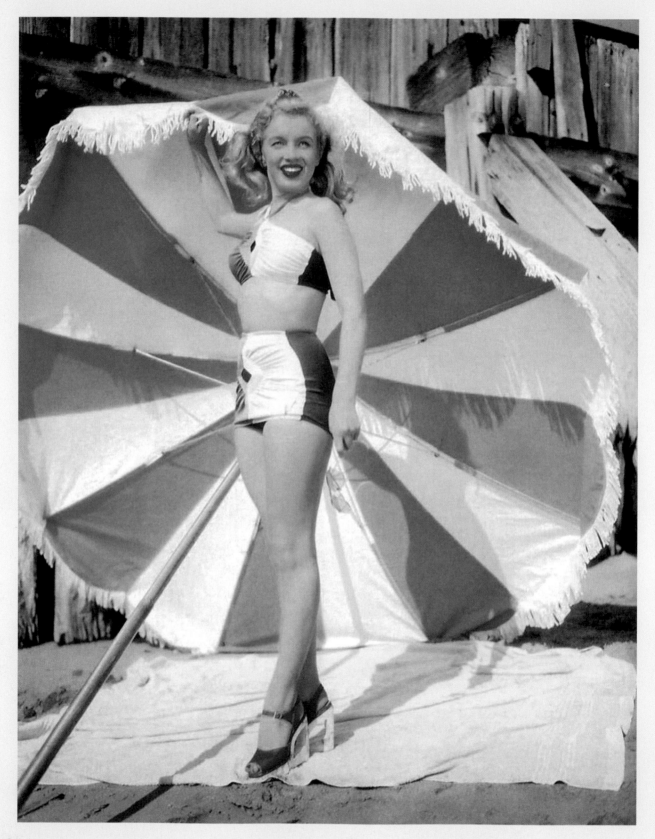

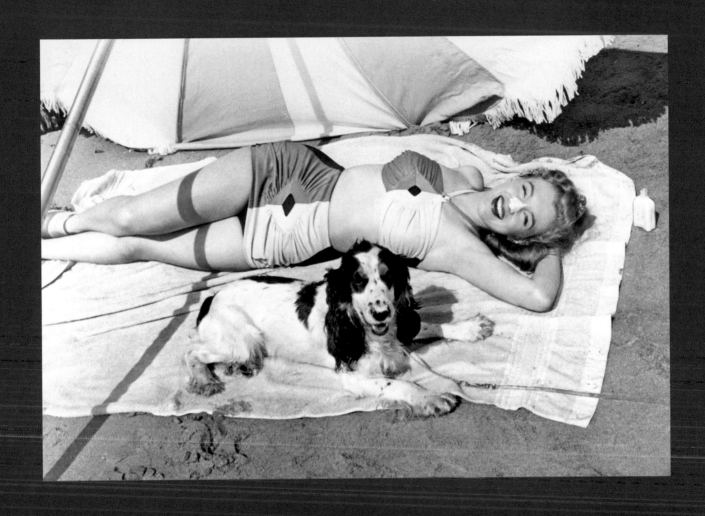

MINT CHOCOLATE CHIP: (ABOVE AND OPPOSITE) Marilyn Monroe, circa 1947.

"The two-piece swimsuit was born in the wartime years, out of fabric-saving necessity. . . . The unspoken but golden rule was that the navel should always be covered. This was to prove the crucial difference between the two-piece and the bikini . . . [which] the major swimwear brands in the USA avoided like the hot potato it was for some time. A staid conservatism still existed at the center of American society . . . which contradicted the strong, sexy image of Hollywood that was evident in every small-town cinema."

SARAH KENNEDY, Author and fashion journalist.

Gene Tierney, 1945.

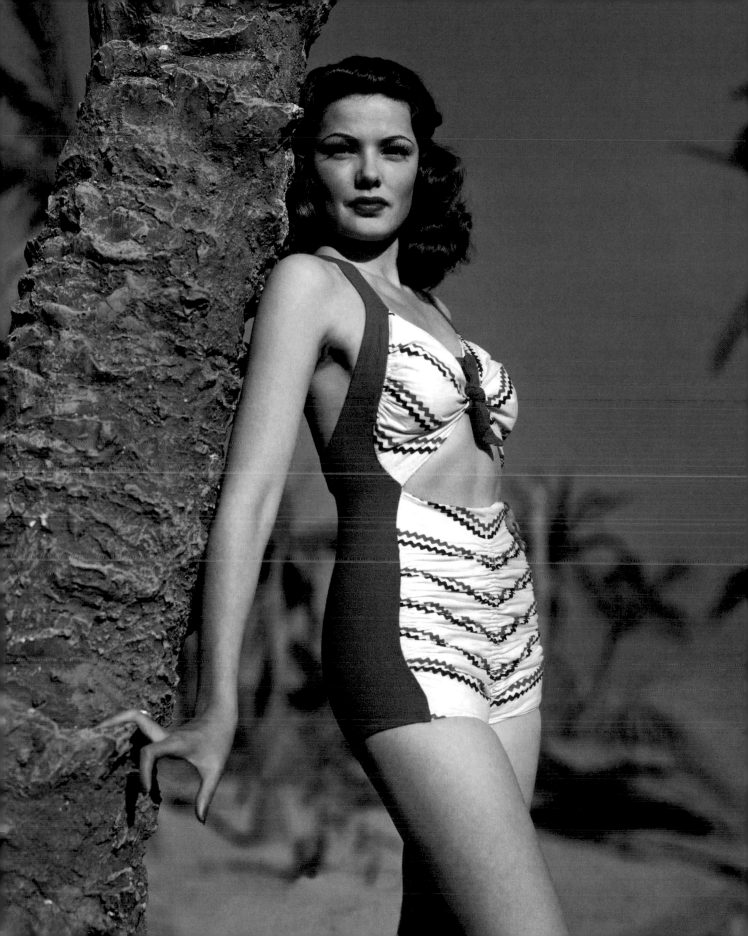

THE FIFTIES

"Under the boardwalk, down by the sea, yeah
On a blanket with my baby is where I'll be."

LYRIC BY JERRY LIEBER & MIKE STOLLER—RECORDED BY THE DRIFTERS

Atlantic City's landmark planked promenade became world famous
as the Miss America pageant grew in size and influence from
its origins as the "Fall Frolic" in 1920, through its first nationally
televised competition in 1954. The contestants' one-piece swimsuits
shrank in size and fit, but the ladies were not permitted to wear two-
piece suits until 1997.

The Miss Universe beauty contest began quite modestly as the
International Pageant of Pulchritude in 1920, in Galveston, Texas,
and was transported as a double promotion for the city of Long
Beach, California, and Catalina Swimwear in 1952. The Universe
organization went looking for a larger global presence and left the
coastal city for more lucrative associations. Long Beach struggled
to replace its signature event with the Miss International Beauty
contest, also with sponsorship and bathing suits from Catalina,
in 1960, but failed to catch on and folded before the turn of the
decade. Controversy has dogged the pageants for years, the
Miss America competition, especially, finding it difficult to justify a

swimsuit element as part of its "scholarship pageant."

The beauty competitions, although thoroughly objectifying females, steered clear of the inevitable for years: the acceptance of the bikini by young American women, even though the outcry was loud and clear, as in this *Modern Girl* editorial from 1957, " . . . it is inconceivable that any girl with tact and decency would ever wear such a thing." A foreign film, with its French star, shook the firm ground on which conservatives stood. Roger Vadim's 1956 picture, . . . *And God Created Woman*, presented Brigitte Bardot seducing a coastal village on the Riviera, and movie audiences everywhere, in her provocative little French-cut bikinis. The *New York Times* film critic Bosley Crowther filed his review on October 22, 1957: "The location is the quaint town of St. Tropez, with its mellow, pastel-colored houses against the blue of the Mediterranean Sea. And the outstanding feature of the scenery is invariably Mlle. Bardot. She is a thing of mobile contours—a phenomenon you have to see to believe."

Bardot started a trend for simple gingham which, in record time, was cut and stitched into a truckload of bikinis, intriguingly combining into one sexy item—the homespun and the heat. Marilyn Monroe segued from her one-piece halters into various revealing bikini styles and colors, as did Jayne Mansfield, Mamie Van Doren, and Diana Dors.

The annual film festival at Cannes had been Bardot's coming out

party a few years earlier where she was followed by the press and photographers along la Croissette and onto *la plage,* effortlessly garnering front-page publicity, in her brief swimwear. Sophia Loren made several junkets to the festival through the 1950s, promoting her films. In 1957, *Boy on a Dolphin* was released, in which Loren appeared, a dripping-wet modern goddess, aboard a ship anchored off the Greek Islands in the Aegean Sea: Mykonos, Delos and Santorini.

Back in the States, Esther Williams continued her run of waterlogged epics into the 1950s—she seemed much less recognizable out of her bathing suit. Fred Cole persuaded her to lend her name to a yearly minicollection of swimsuits, mostly strapless one-pieces. Cole also sought out Christian Dior to design a collection for 1955. The couturier at first declined, claiming he knew little about swimwear and its accessories, but Cole took the hard line, "You're a designer, aren't you? So design."

Another California designer, although originally from Vancouver, Rose Marie Reid cultivated a Hollywood clientele. Rita Hayworth had worn Reid's glamorous and glittering lamé suit in promotional photos for *Gilda* in 1947. Reid introduced dress-sizing to swimwear, and sought to perfect the inner brassiere, incorporate tummy-tuck panels, and stay-down legs, advising her customers, "What you really need is a new suit for sunning, last year's for swimming and an extra one just for fun." Reid provided the swimwear for the

starlets of *Gidget* (1959) and *Where the Boys Are* (1960), making a play for younger shoppers. Many of these suits were two-piece, amply structured through the chest and cut well above the navel. When it came to the bikini, Rose Marie Reid drew the line, selling her interest in the company in 1963 rather than collude in any further reveal of the female anatomy.

The ultra-curvaceous Hollywood figure, the ideal of the 1950s, in addition to those mentioned above, was embodied by Rhonda Fleming, Arlene Dahl, and Joan Collins. In 1951, Collins made her feature film debut, although uncredited, in a movie called *Bikini Baby.* She made the biggest "splash" in movies when scantily clad or minimally swimsuited. Bettie Page, also blessed with a merry-widow physique, was too curvy and fleshly to be a standard model type, and so began a career of posing very provocatively for a certain audience. On a visit to Miami, she encountered the photographer Bunny Yeager—model-attractive herself. The two created a portfolio of images, more sensual and sophisticated than the work Page had done previously; she posed for Yeager in a leopard-skin onesie, on a secluded beach, two lovely cheetahs at her feet.

In Miami Beach, the neighborhood of South Beach was in decline, its Deco and Streamline Moderne hotels, shops, and apartment buildings not treasured as they are today. Visitors to Miami gathered at the big new hotels lining the harbor. Honolulu

was experiencing a tourist boom; Diamond Head, Waikiki, Waimea, and the Royal Hawaiian Hotel were becoming the symbols of the fascination for the tropics and the tropical. The television series *Hawaiian Eye* exploited this trend, in glorious black-and-white, as well as the growing enthusiasm for Hawaiian surf culture. Cuba, especially its capital Havana, savored its reputation as a close-by resort, until the political realignment of 1959.

A metaphor: in *Suddenly, Last Summer* (1959), Elizabeth Taylor as Catherine, very bronze-skinned in a sun-white one-piece swimsuit, on a rocky cliff above a beach on the coast of Catalonia, Spain, witnesses the demise of her friend Sebastian at the hands of a gang of local urchins. In like fashion, the 1960s came swimming up to the shore, devoured whole the previous decade, and coughed up a whole new scene.

(OPPOSITE) Mother and daughter day at the beach, mid-1950s.

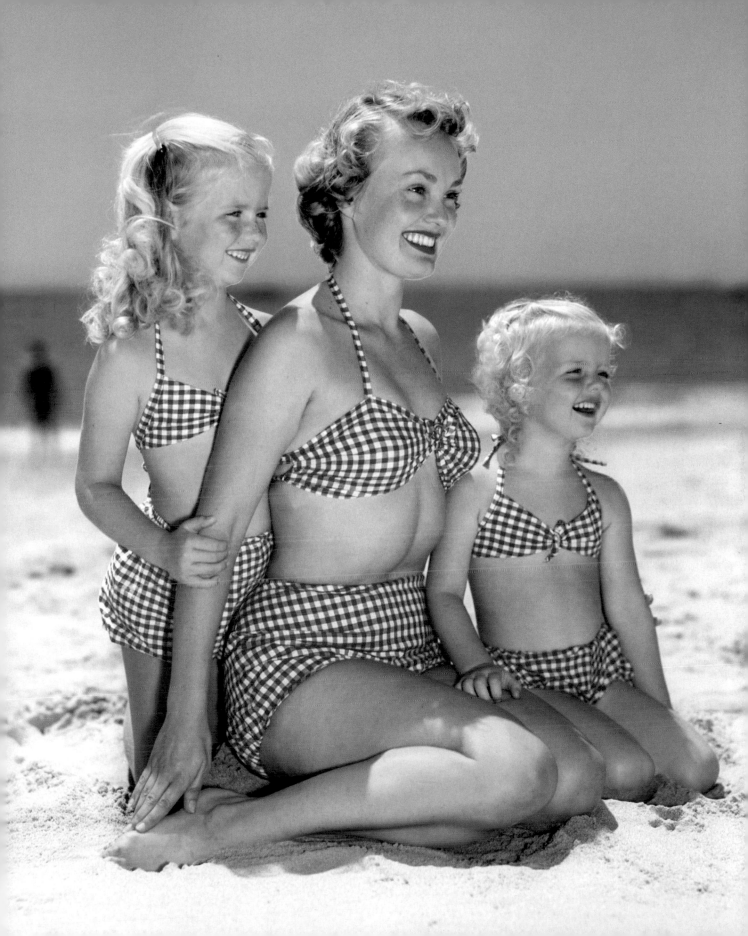

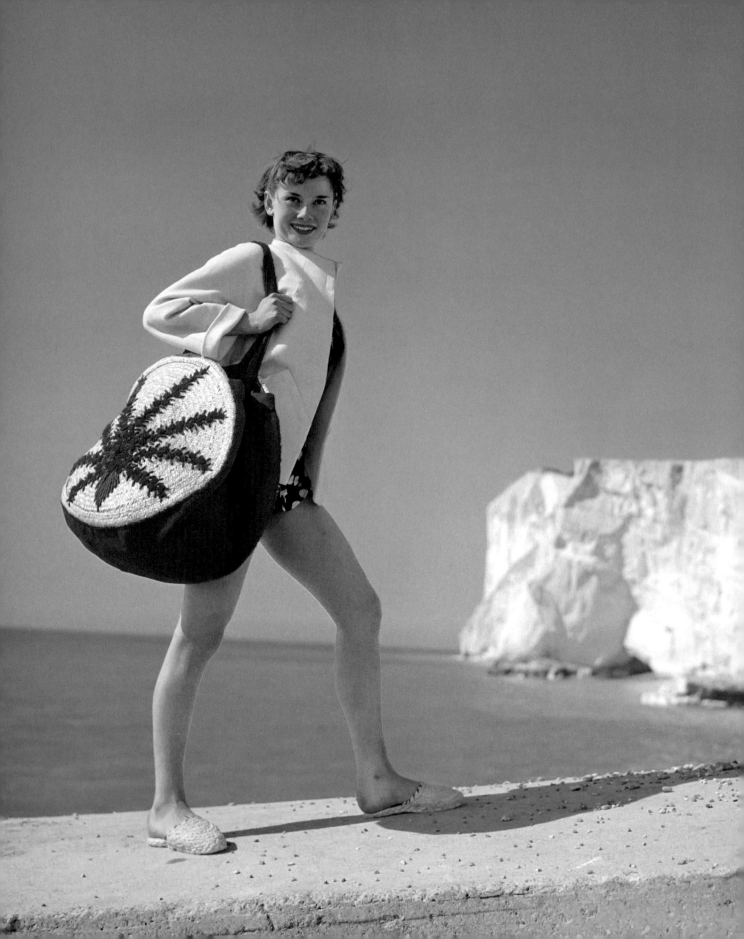

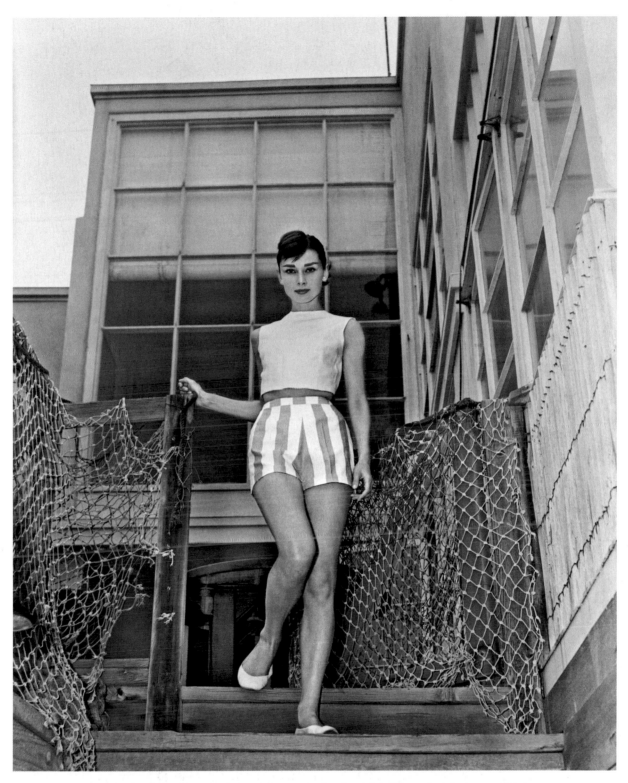

SUN IN THE AFTERNOON: (ABOVE) Audrey Hepburn in Malibu, California, 1956.
Photo by Bill Avery. (OPPOSITE) Hepburn on the beach at Rottingdean, East Sussex,
England, circa 1951.

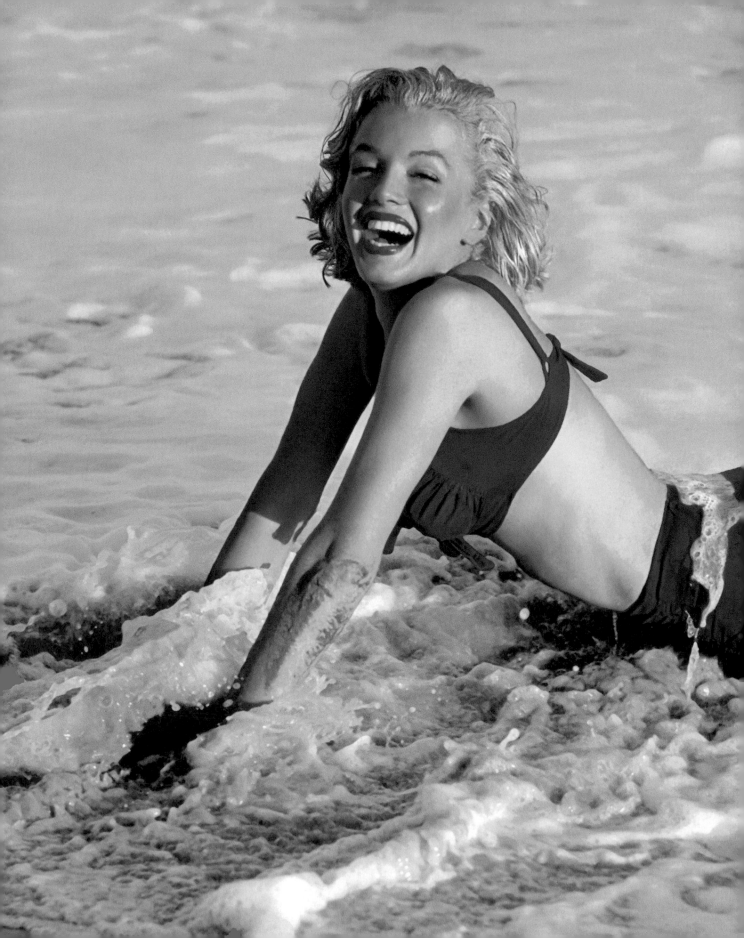

Marilyn Monroe in *Clash by Night* (1952).

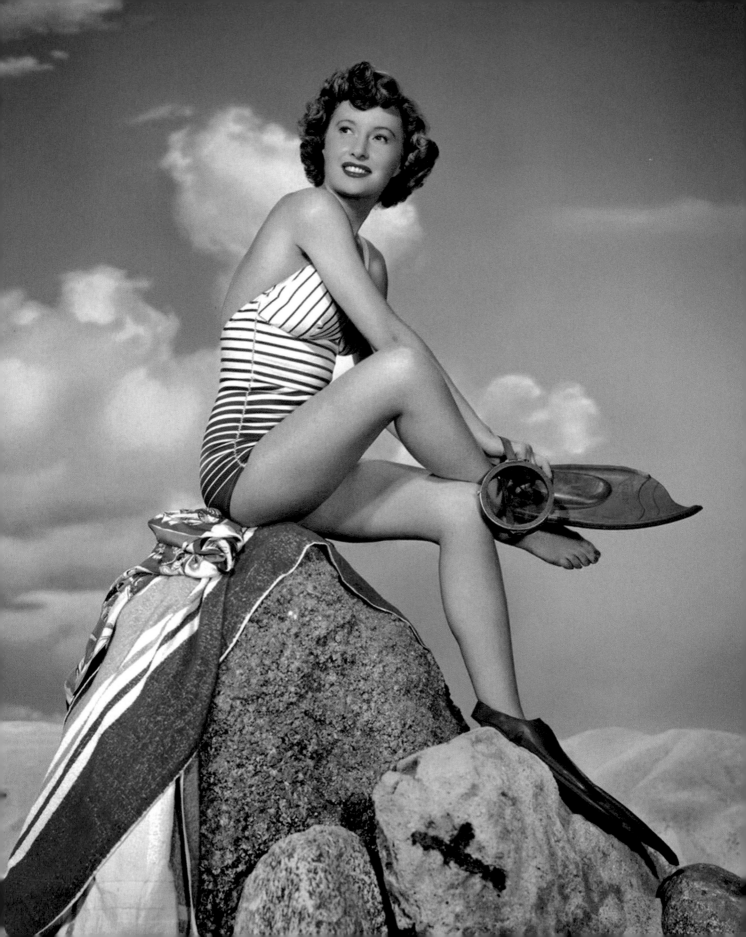

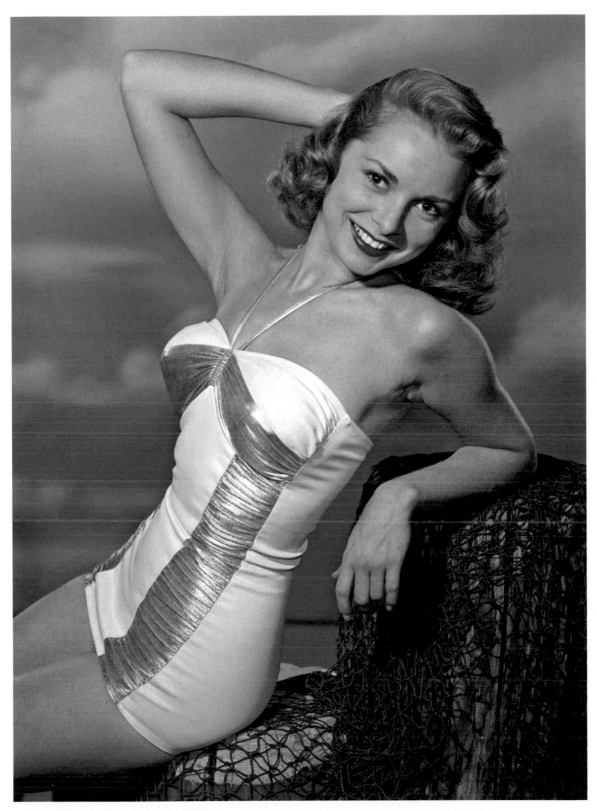

(ABOVE) Janet Leigh, wearing the "Gilded Lily" bathing suit by Cole of California, circa 1950. (OPPOSITE) Barbara Stanwyck, 1950.

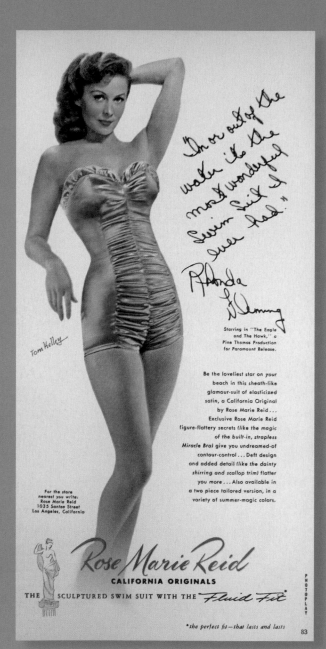

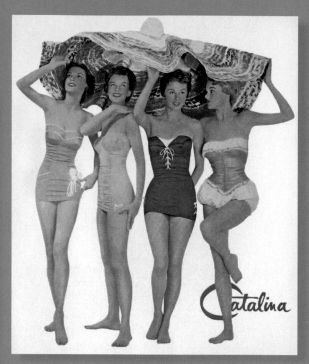

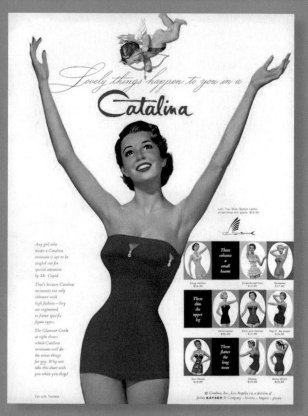

(ABOVE LEFT) Rhonda Fleming for designer Rose Marie Reid, 1950. (TOP RIGHT) Catalina, 1954. (BOTTOM RIGHT) Catalina, 1955. (OPPOSITE TOP LEFT) Cole of California, 1953. (OPPOSITE BOTTOM LEFT) Lastex, 1951. (OPPOSITE RIGHT) Skol Suntan Lotion, 1950.

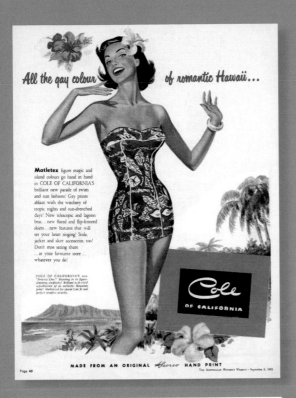
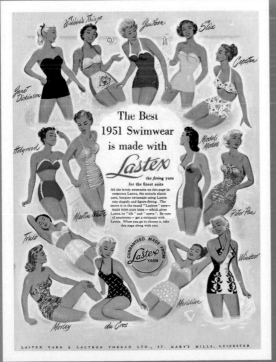
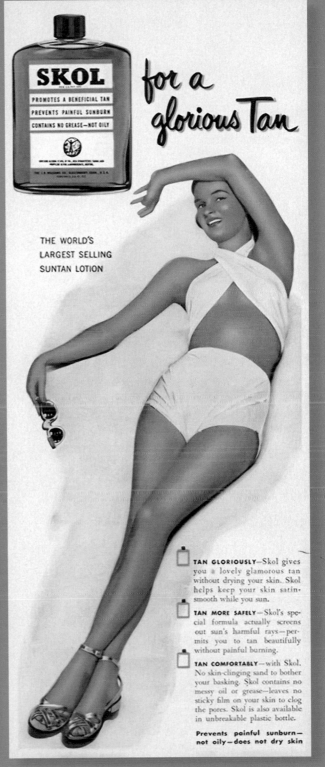

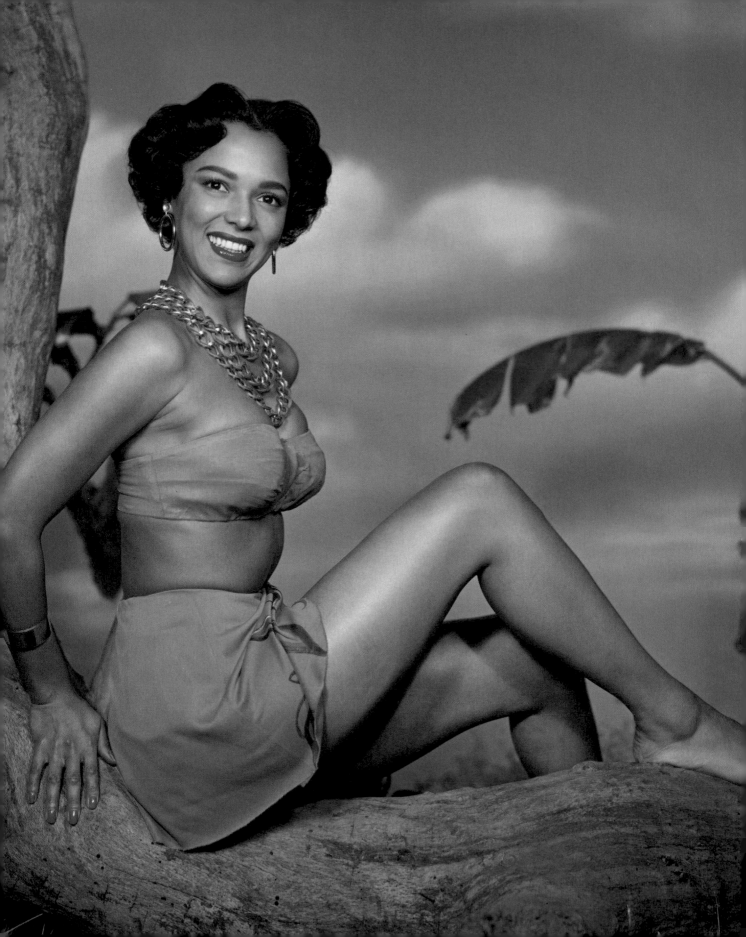

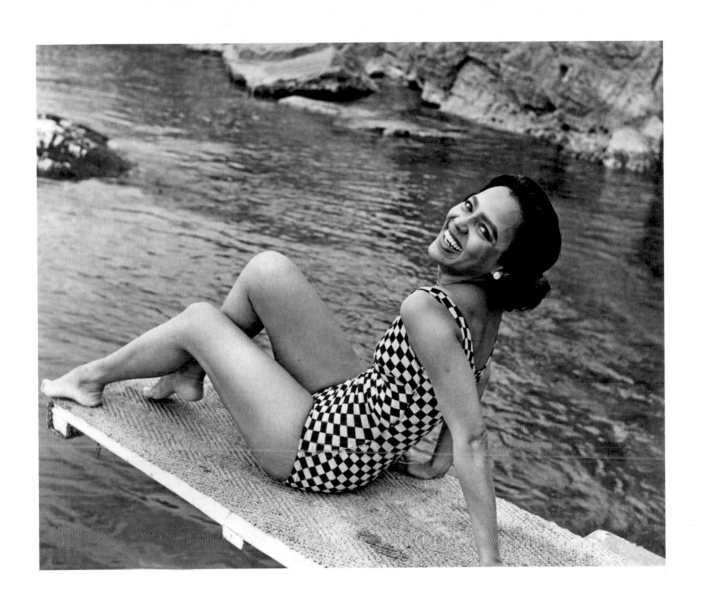

ISLAND IN THE SUN: (ABOVE) Dorothy Dandridge, early 1950s. (OPPOSITE)
Dandridge as Melmendi, Queen of the Ashuba, in *Tarzan's Peril* (1951).

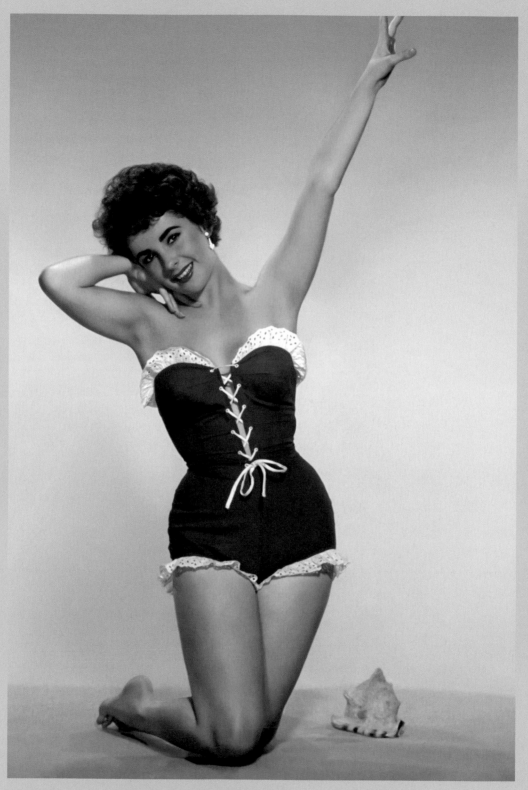

BEACHED AT THE STUDIO: (ABOVE) Elizabeth Taylor, 1950.
(OPPOSITE) Kim Novack, 1952.

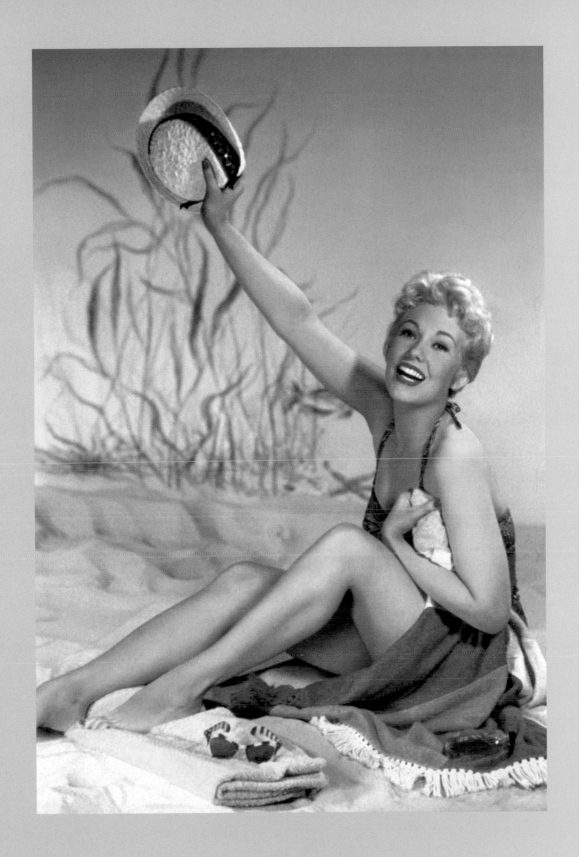

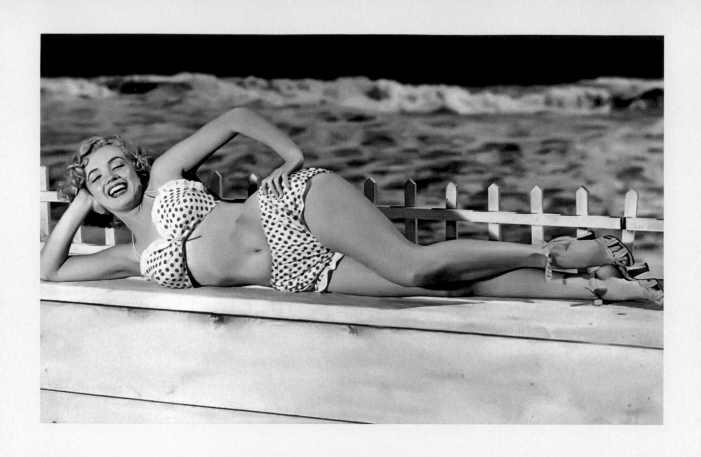

(ABOVE) Marilyn Monroe in *Love Nest* (1951). (OPPOSITE) Marilyn Monroe, 1950.

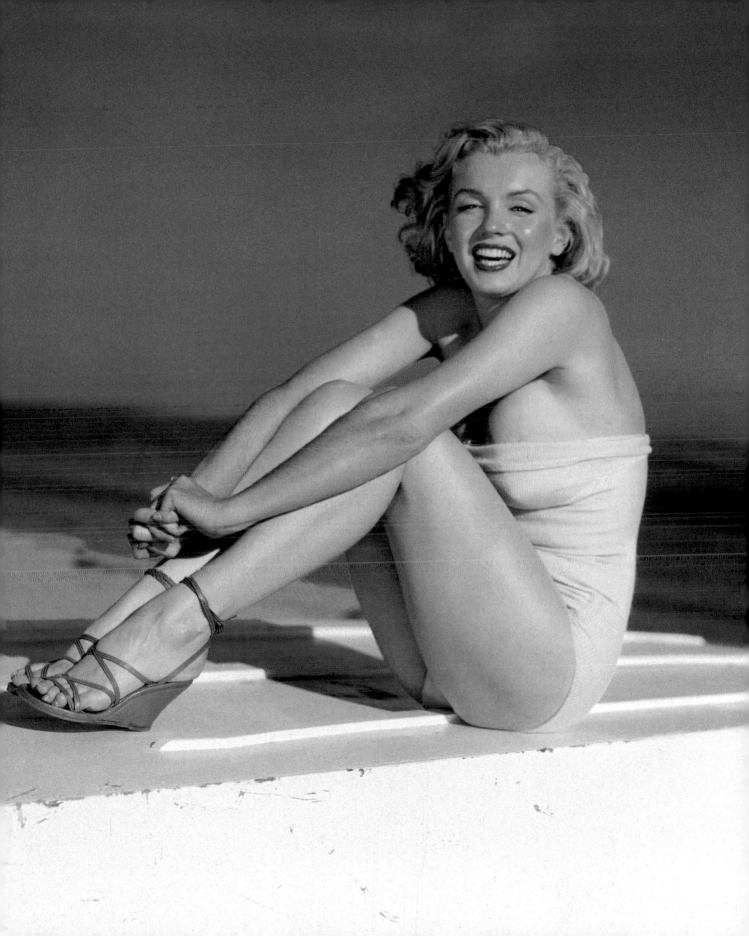

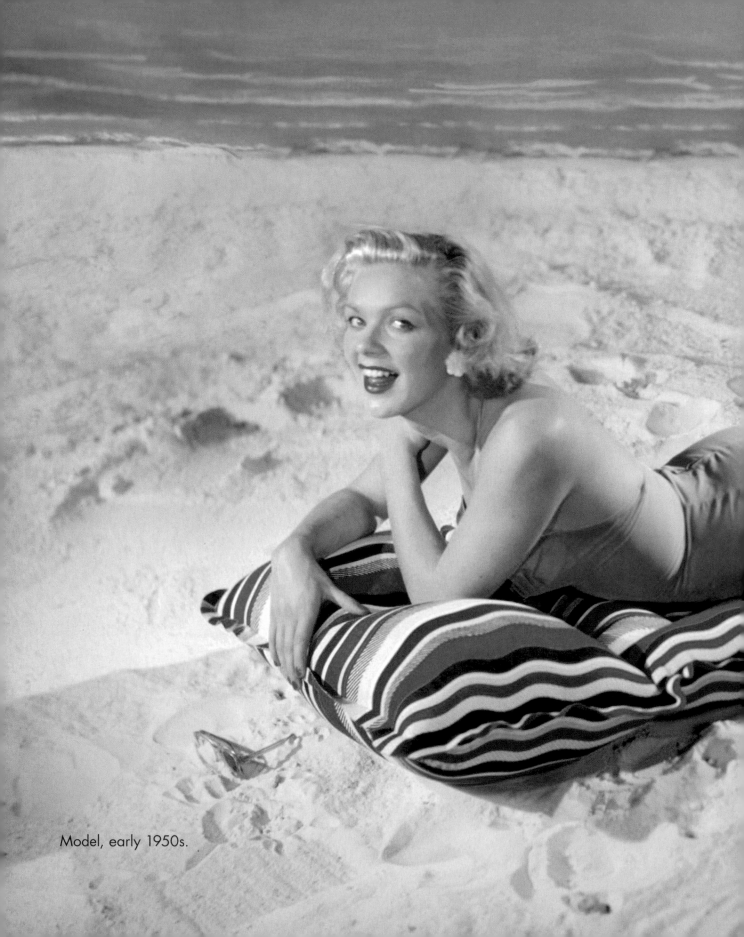

Model, early 1950s.

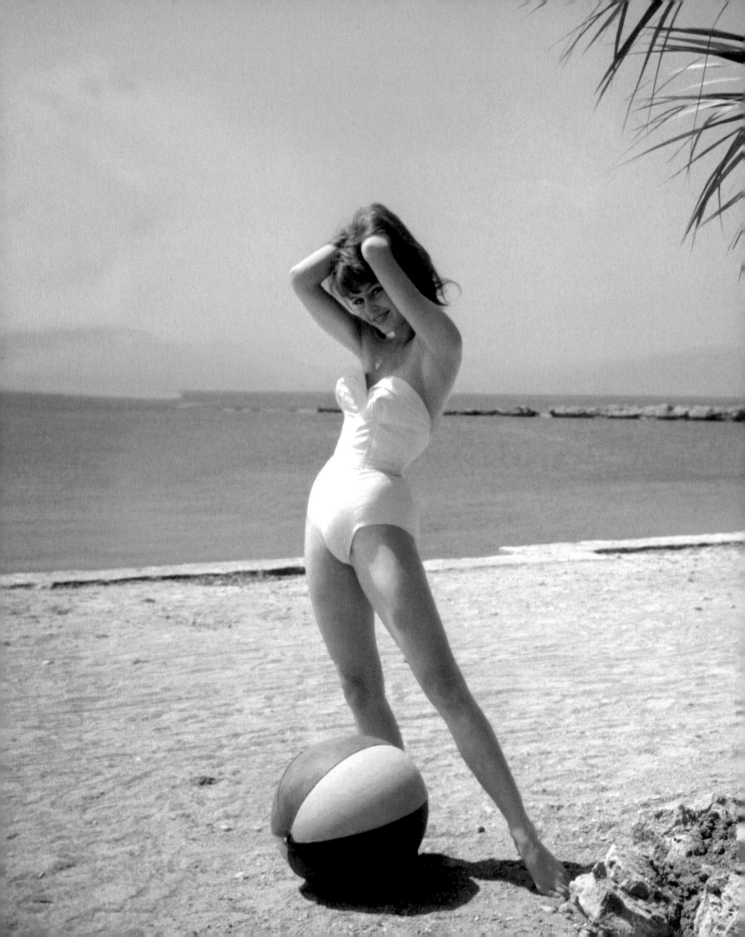

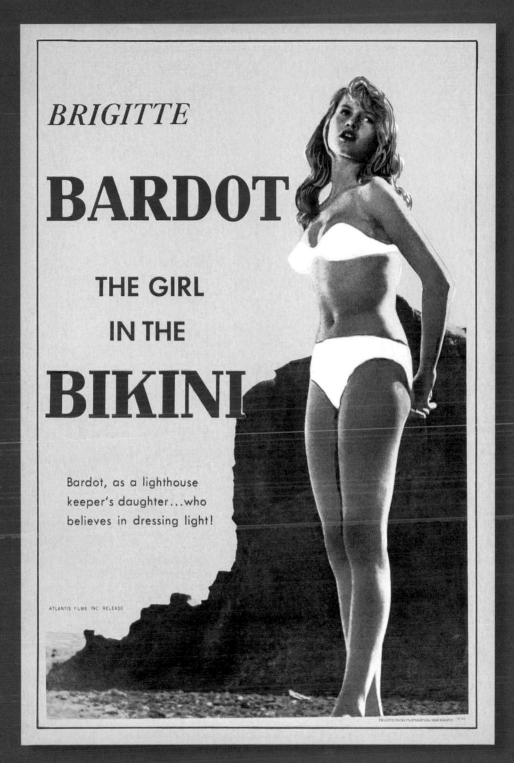

AND GOD CREATED BARDOT: (ABOVE) Movie poster featuring a very young Brigitte Bardot in *The Girl in the Bikini* (1952). (LEFT) Bardot in Cannes, 1953. Photo by Kary Lasch.

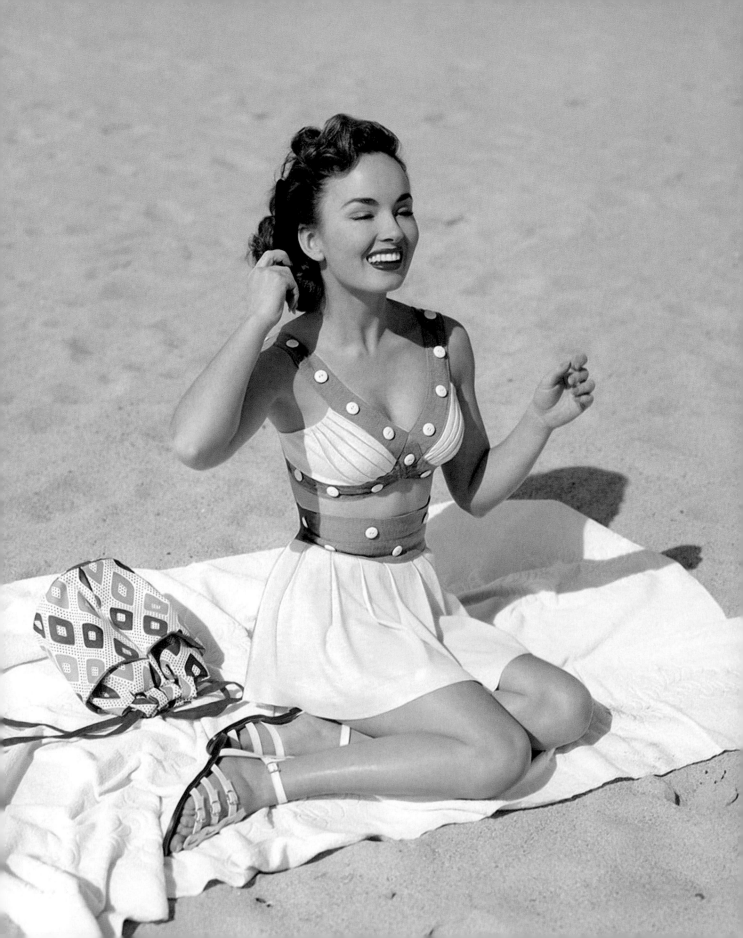

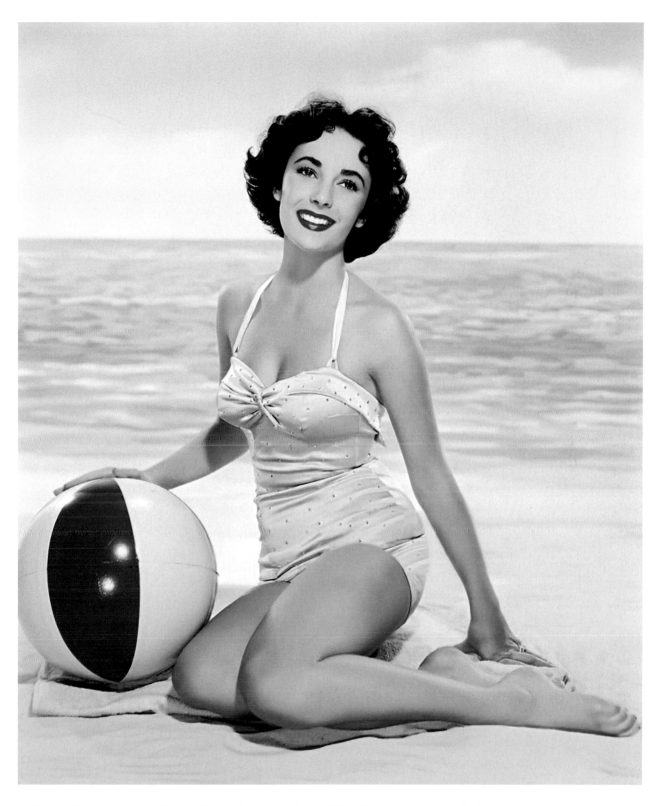

PLACES IN THE SUN: (ABOVE) Elizabeth Taylor, 1950. (OPPOSITE) Ann Blyth, 1952.

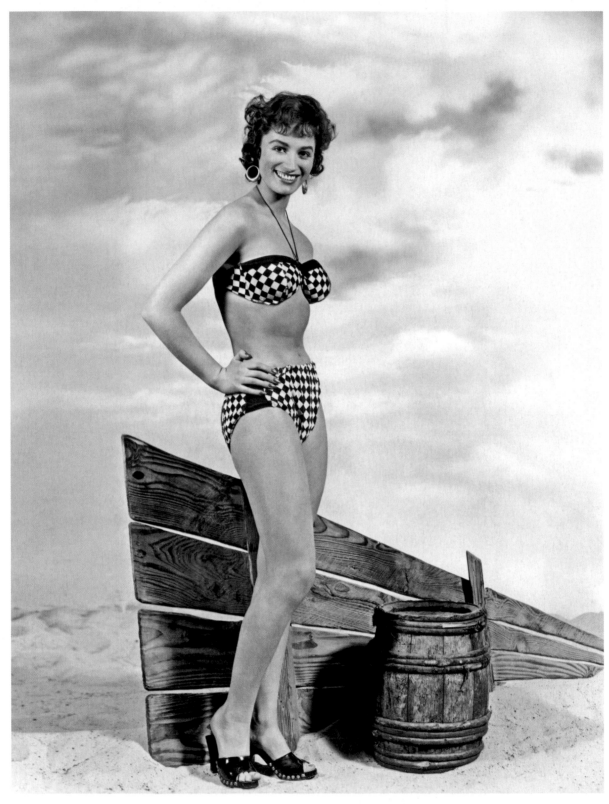

SUN SISTERS: (ABOVE) Jackie Collins in *For Better, for Worse* (1954). (OPPOSITE) Joan Collins, mid-1950s.

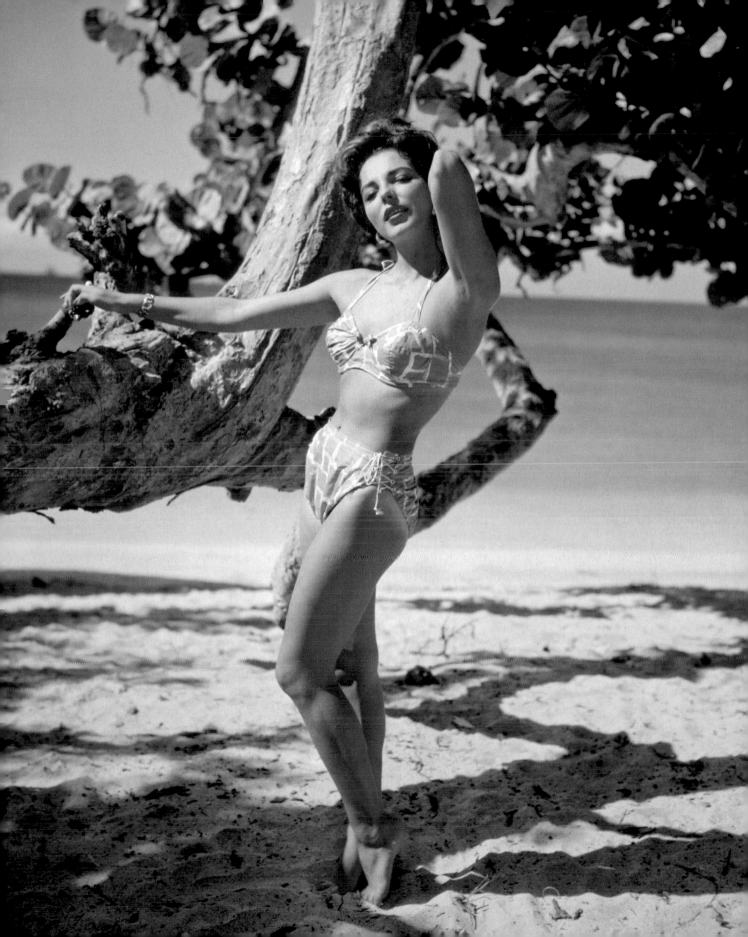

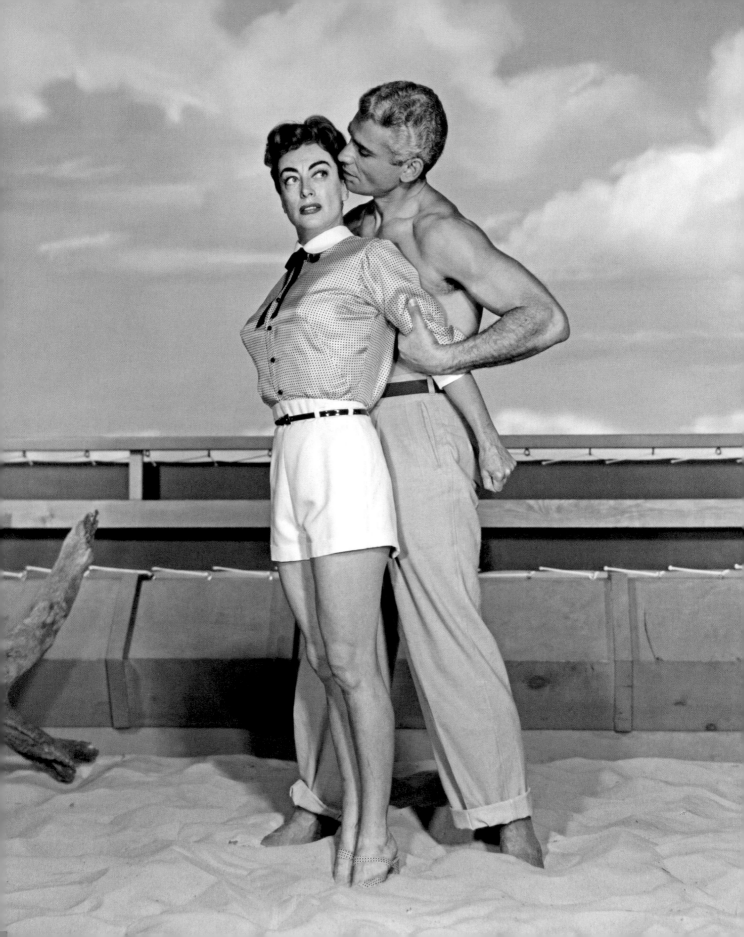

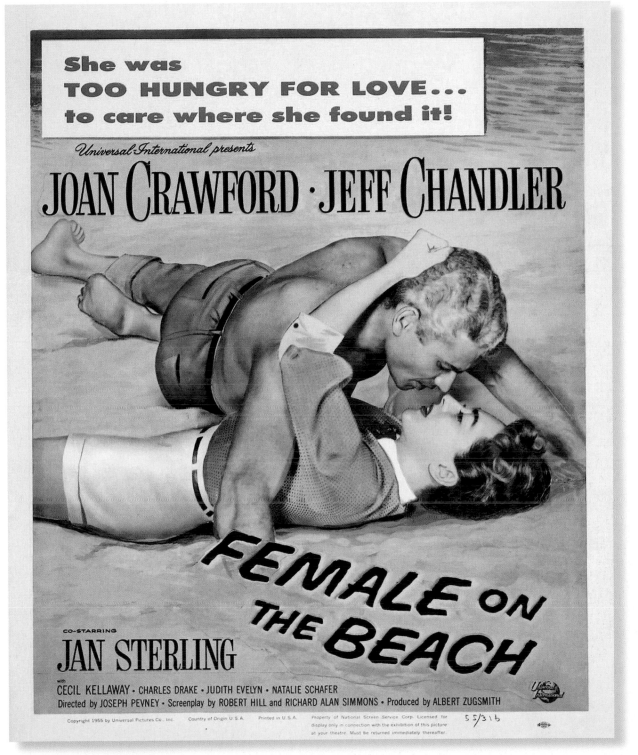

(ABOVE) Movie poster featuring Joan Crawford and Jeff Chandler in *Female on the Beach* (1955). (OPPOSITE) Crawford as Lynn Markham and Chandler as unscrupulous man candy Drummond Hall in *Female on the Beach* (1955).

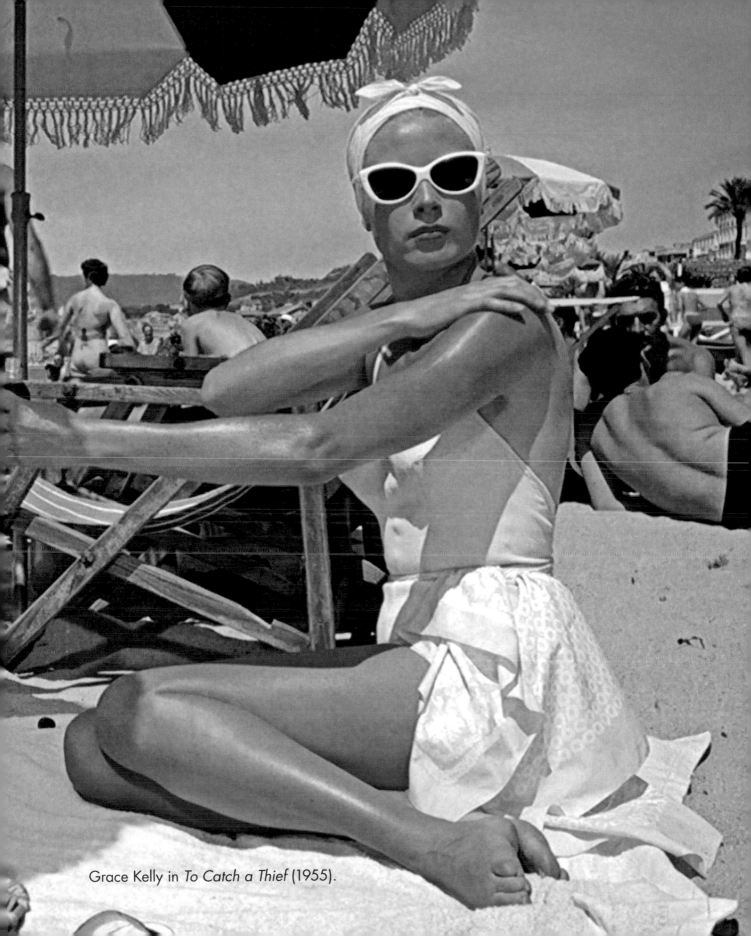

Grace Kelly in *To Catch a Thief* (1955).

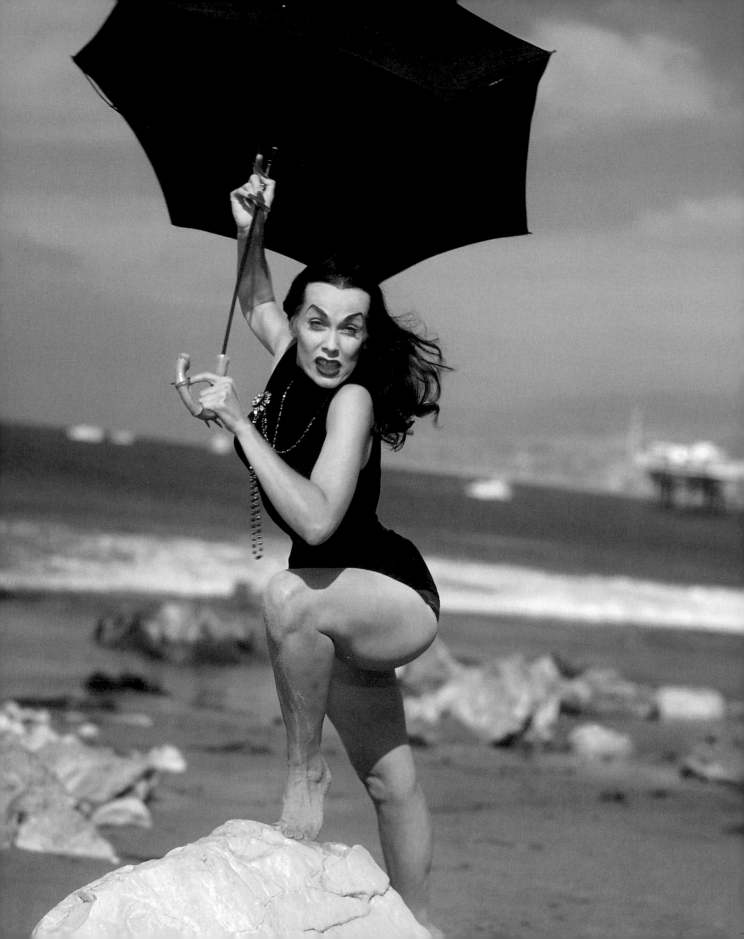

"In the time of Marilyn Monroe and the absolute supremacy of the hourglass physique, Nurmi starved, steamed and self-mutilated her way to a 17-inch waist, then built her bust-line with handmade enhancements designed to mimic the look and feel of real breasts."

R.H. GREENE, Author and documentary filmmaker on
MAILA NURMI a.k.a. VAMPIRA.

EVIL UNDER THE SUN: Vampira (Maila Nurmi), 1954.
Photo by Bruno Bernard/Bernard of Hollywood.

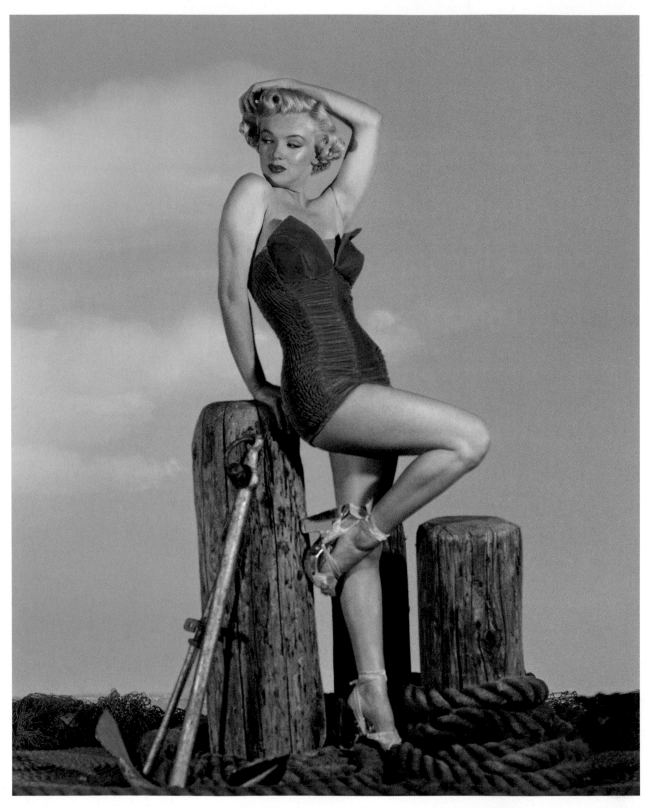

NAUTI-GIRL: (ABOVE) Marilyn Monroe, 1951. Photo by Cashman. (OPPOSITE) Marilyn Monroe, 1953.
Photo by Bert Reisfeld.

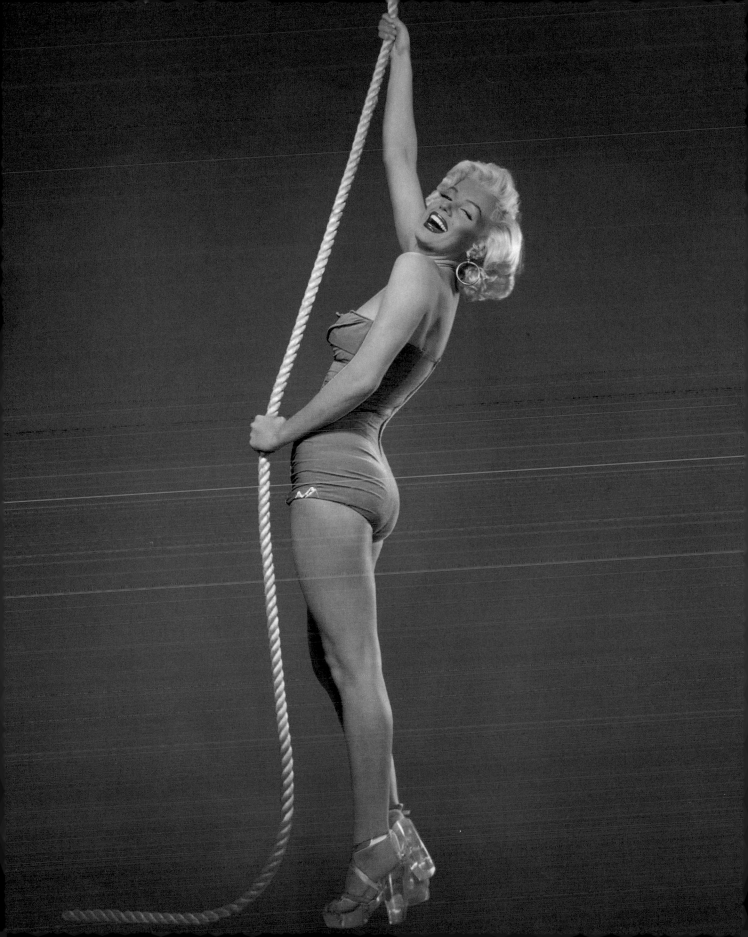

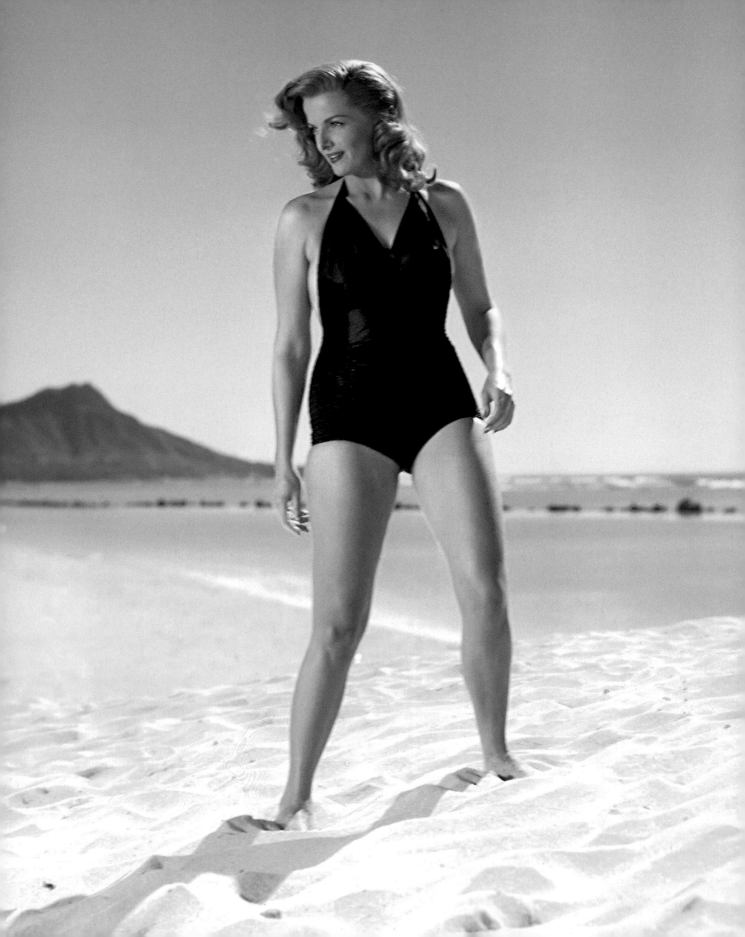

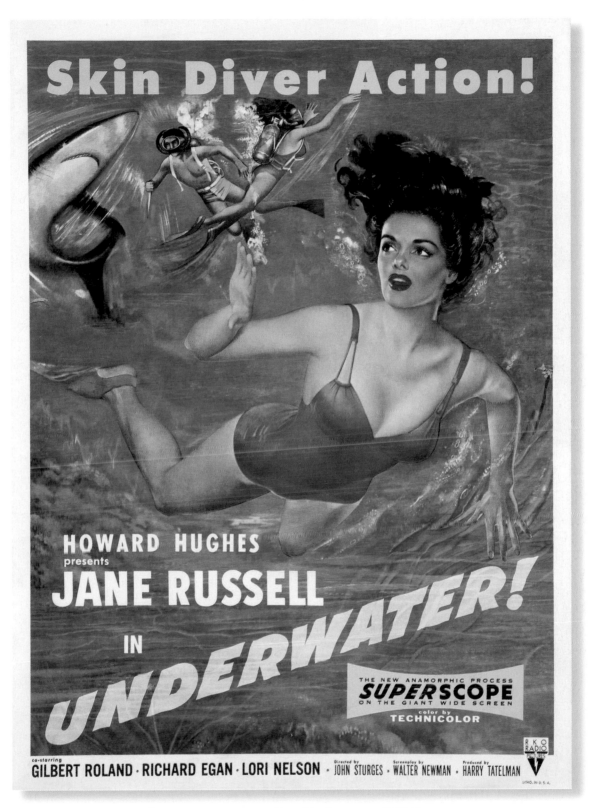

(ABOVE) Movie poster featuring Jane Russell in *Underwater* (1955).
(OPPOSITE) Jane Russell in *The Revolt of Mamie Stover* (1956).

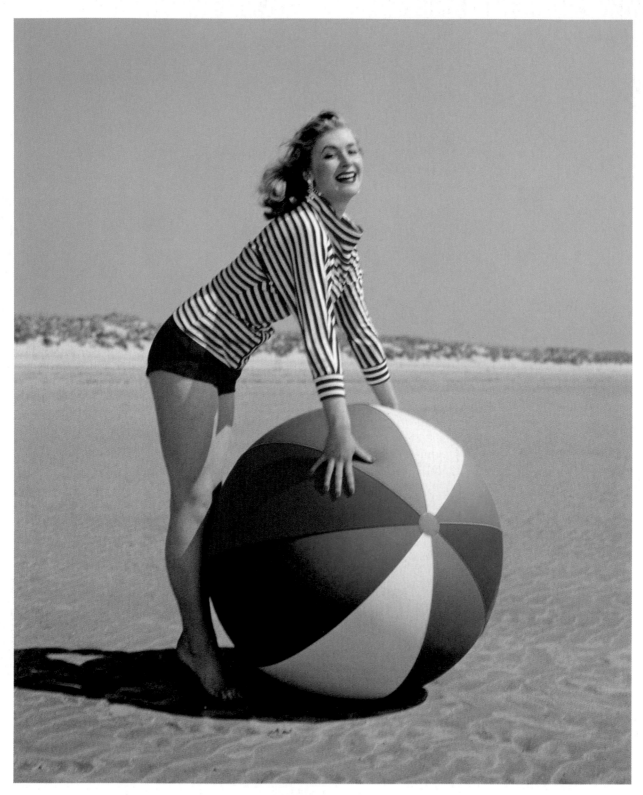

HAVING A BALL: (ABOVE AND OPPOSITE) Mid-1950s.

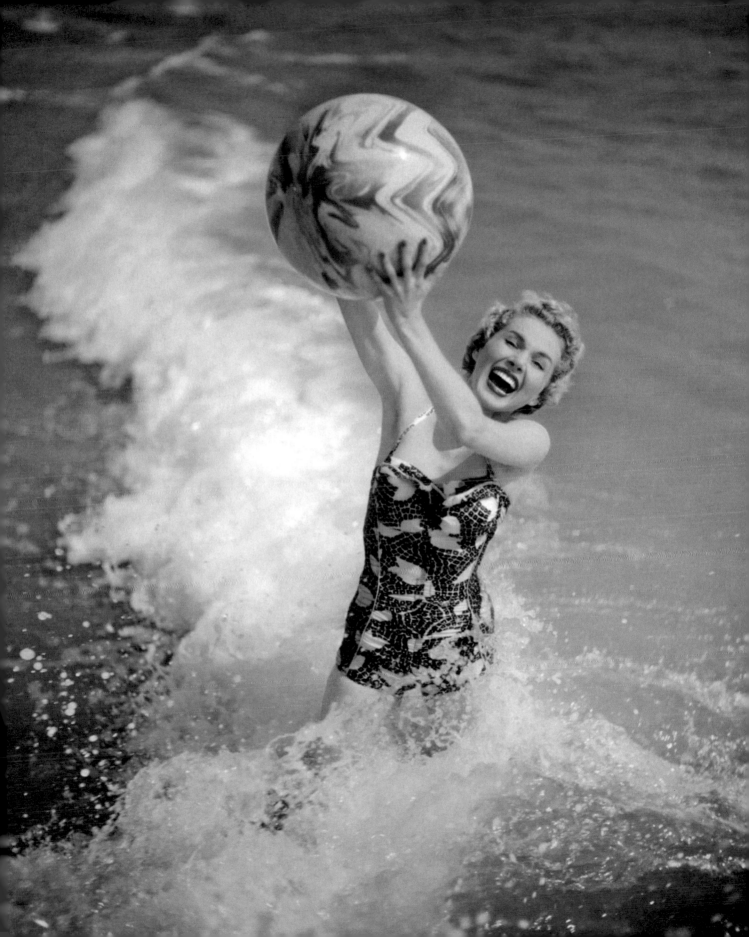

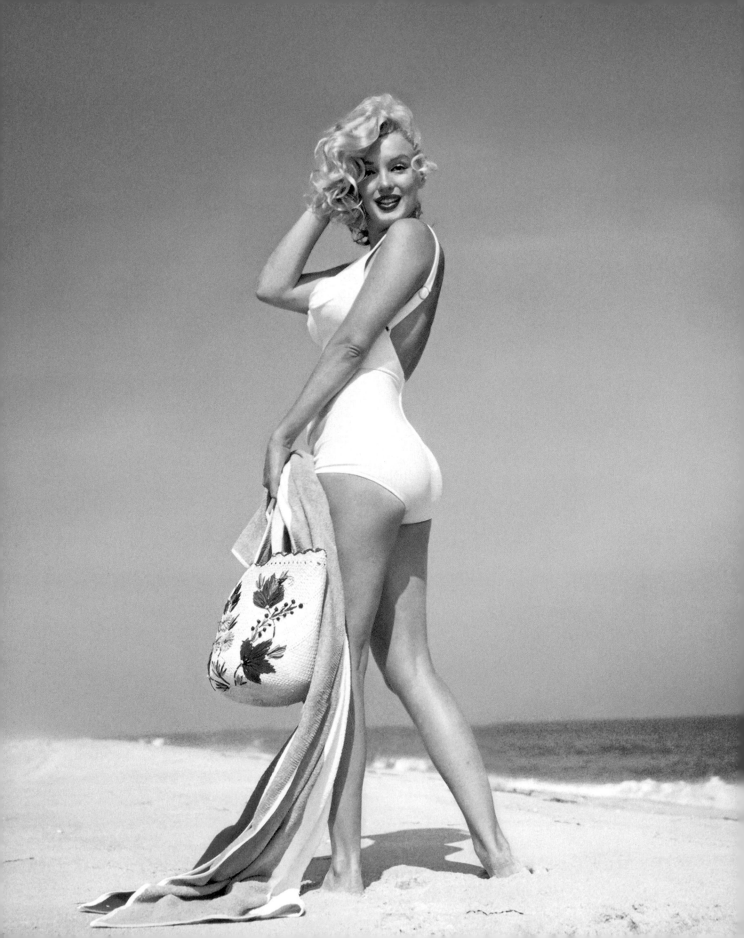

"Girdles and wire stays should never have been invented. No man wants to hug a padded bird cage."

MARILYN MONROE

Marilyn Monroe, Amagansett Beach, Long Island, New York, 1957.
Bathing suit by Catalina. Photo by Sam Shaw.

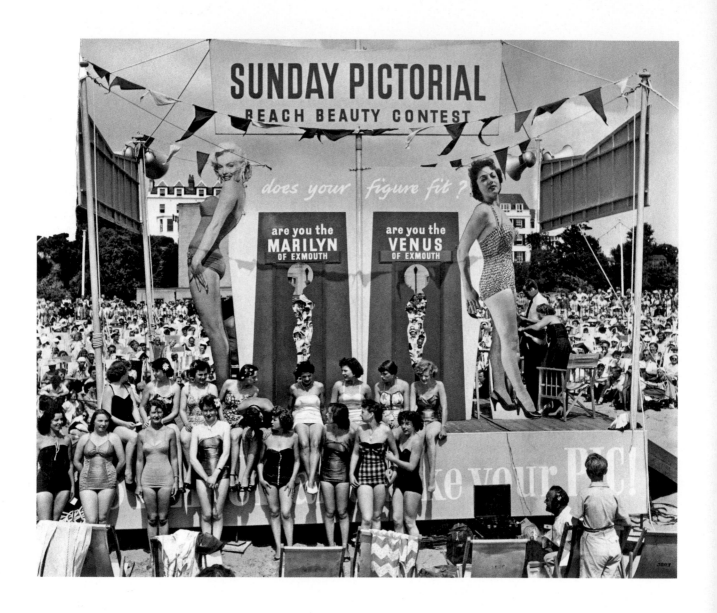

(ABOVE) In an unexamined (at the time) display of objectification, competitors wait their turn to be judged at the *Sunday Pictorial* Beach Beauty Contest, Exmouth, England, July 1955.
(OPPOSITE) A dancer at the shore, early 1950s.

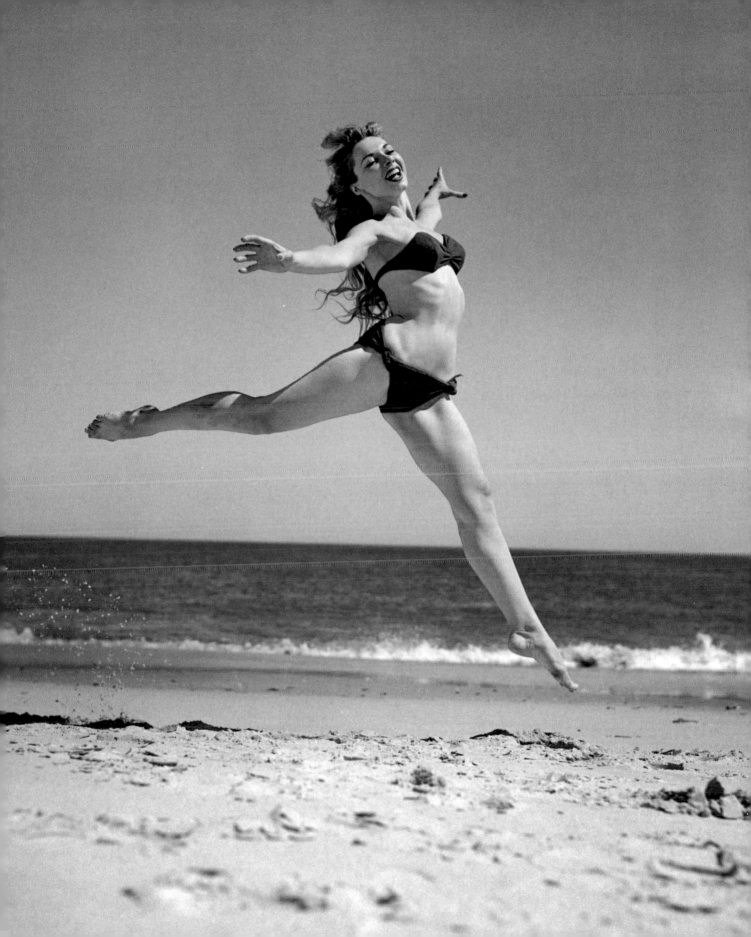

"I was the first home-grown sex symbol, rather like Britain's naughty seaside postcards. When Marilyn Monroe's first film was shown here (*The Asphalt Jungle,* 1950), a columnist actually wrote, 'How much like our Diana she is.' "

DIANA DORS

UNDRESSED TO KILL: Diana Dors in a silver lamé bathing suit worn at the beach in *The Unholy Wife* (1957).

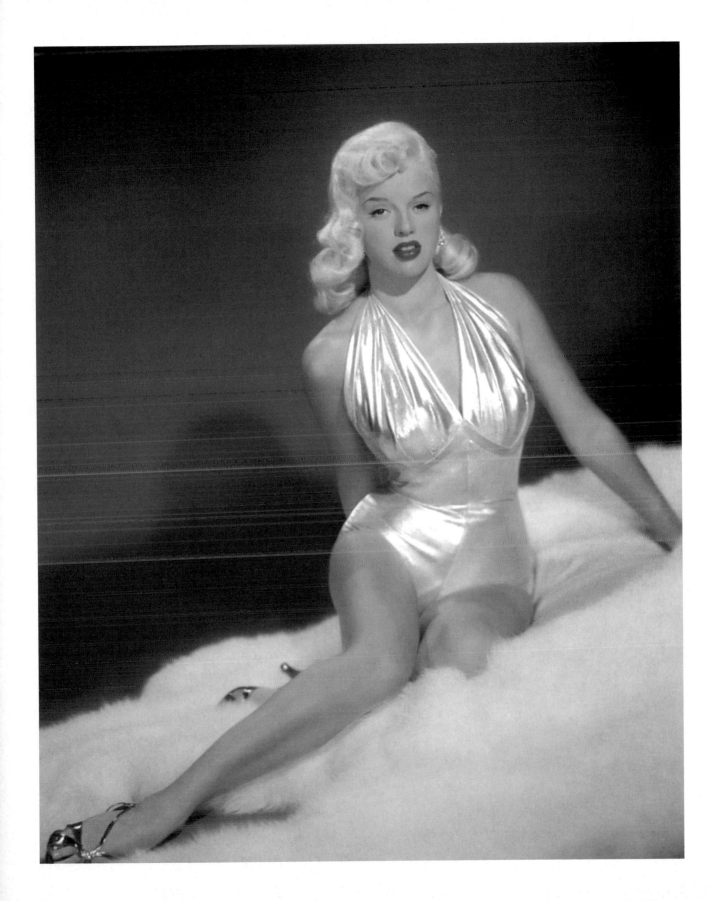

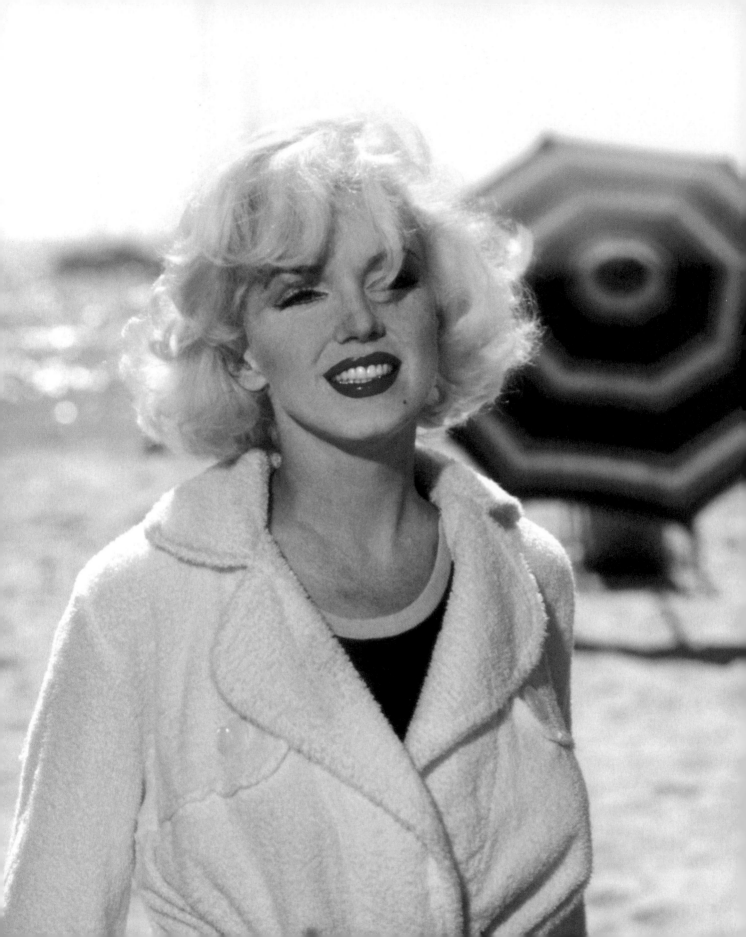

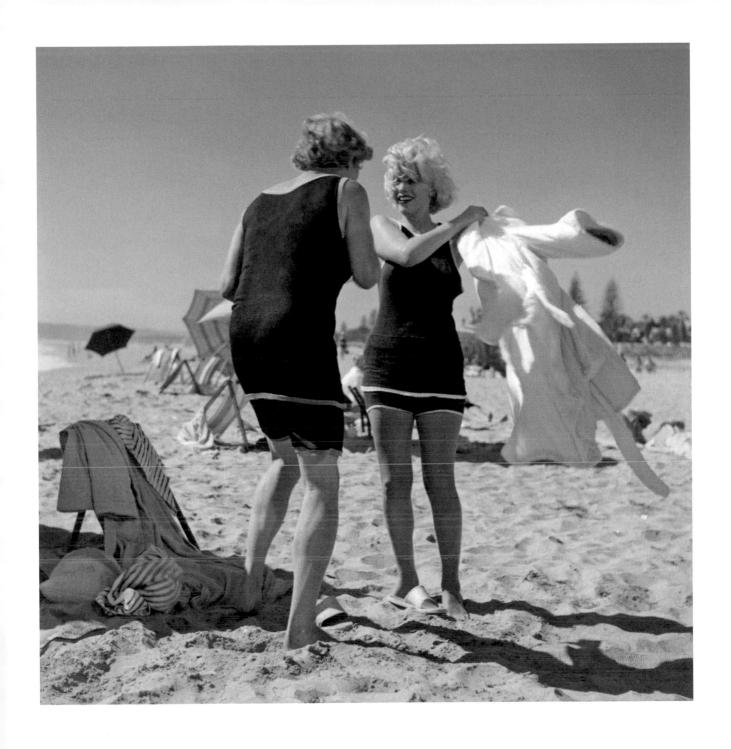

BOSOM BUDDIES: (OPPOSITE) Marilyn Monroe as Sugar Kane Kowalczyk in *Some Like It Hot* (1959). (ABOVE) Monroe and Jack Lemmon in *Some Like It Hot* (1959).

The One They're All Talking About!

SAM SPIEGEL
PRESENTS

ELIZABETH TAYLOR · KATHARINE HEPBURN · MONTGOMERY CLIFT

SUDDENLY, LAST SUMMER

...suddenly
last
summer
Cathy
knew
she
was
being
used
for
something
evil
!

CERTIFICATE
ADULTS ONLY
X

Based on the play by **TENNESSEE WILLIAMS**　Directed by **JOSEPH L. MANKIEWICZ**　Produced by **SAM SPIEGEL**

Written for the screen by GORE VIDAL and TENNESSEE WILLIAMS　Production Designer OLIVER MESSEL　A HORIZON BRITISH PRODUCTION　**A COLUMBIA** PICTURES RELEASE

SUMMER MADNESS: (ABOVE) Movie poster featuring Elizabeth Taylor in *Suddenly, Last Summer* (1959). (OPPOSITE) Taylor delightfully chums the waters as the ultimate man bait in *Suddenly, Last Summer* (1959).

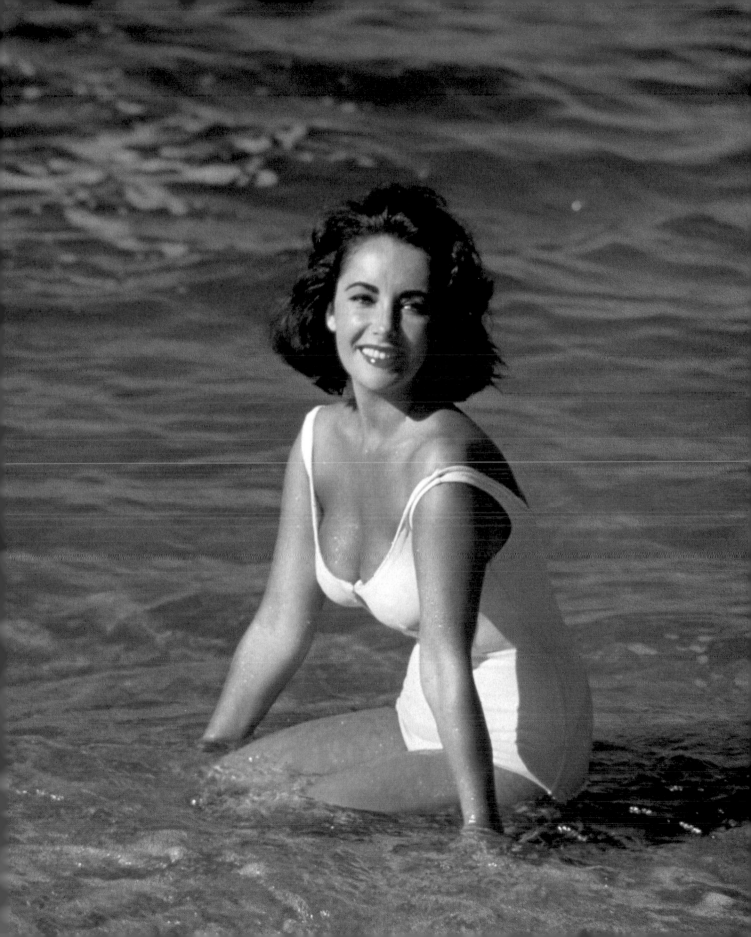

"What you really need is a new suit for sunning, last year's for swimming and an one extra just for fun. A wardrobe of three or four suits isn't at all unusual anymore . . . and some women buy 12 or 13 at a time."

ROSE MARIE REID, Designer of her eponymous line of swimwear.

Vogue, 1959. Photo by Louise Dahl-Wolfe.

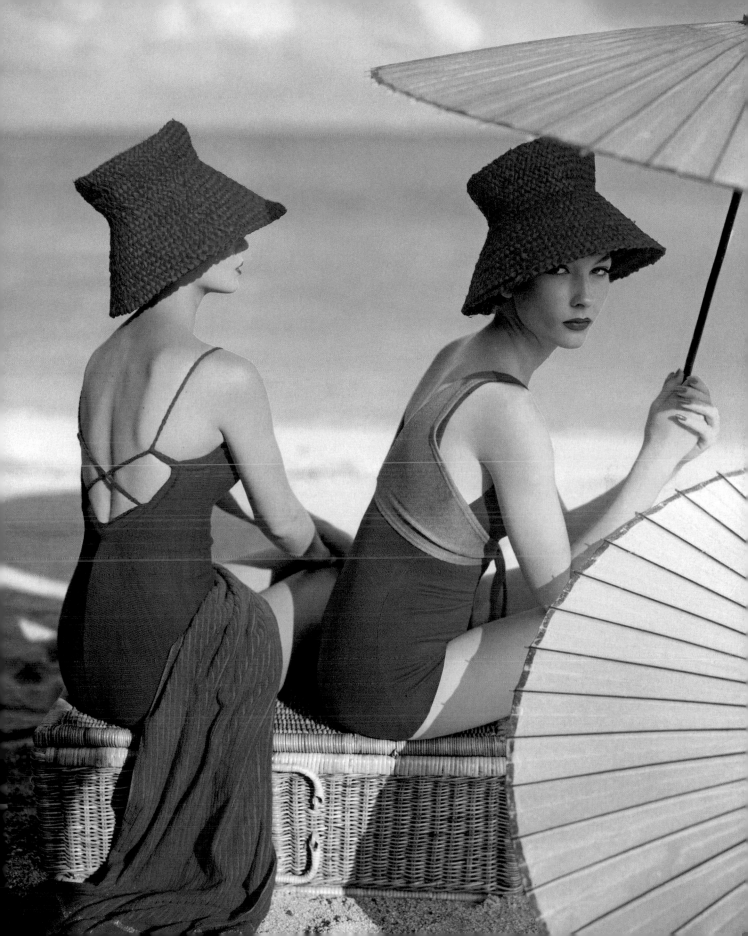

THE SIXTIES

"When she walks, she's like a samba
The swings so cool and sways so gentle . . ."

ORIGINAL LYRIC BY VINICIUS DE MORAES; ENGLISH LYRIC BY NORMAN GIMBEL—RECORDED BY ASTRUD GILBERTO

Modern Brazil suddenly came into sunny focus in the mid-1960s. The Rio renaissance—a seductive assault on the senses—was an awakening, a craze and a dance, to the smooth rhythms of the bossa nova, a hypnotic hybrid of samba and jazz. Antonio Carlos Jobim, and a few years later, Sergio Mendez & Brasil '66, provided the world a soundtrack it didn't know it wanted. Even Eydie Gormé wanted to "blame it on the bossa nova, with its magic spell." The girls of Copacabana and Ipanema seemed to be the most bikini-beautiful on the planet, the sighing admiration for one of them—her name was Heloisa—expressed by Jobim and his collaborators on the international hit referenced above.

The sea, the shore, the sand—all things coastal—captured the attention and the time of the young and the tannable. Hawaii had become the fiftieth state of the United States and brought with it an oceanic state of mind. TV and movie companies crossed both oceans to capture a bit of island sorcery. Tahiti was the site of the

location filming of Marlon Brando's *Mutiny on the Bounty* (1962); Tarita became a one-movie wonder, and was Brando's leading lady on and off the set. Ursula Andress, photographed by Bunny Yeager, undulated out of the Caribbean Sea, in a startling white bikini, her work uniform, to become the very first "Bond girl." In the Greek port city of Piraeus, Melina Mercouri as Ilya, plied her trade, but "never on Sunday." Director John Huston gathered Richard Burton, Ava Gardner, Deborah Kerr, and Sue Lyon to film *The Night of the Iguana* in 1964, on the western coast of Mexico. With Elizabeth Taylor along to keep an eye on Burton, the stars stirred the headlines, and in the process created out of the small unknown resort an international destination: Puerto Vallarta.

A youth explosion seemed to be on the horizon when *Where the Boys Are* hit the big screen in 1960. The spring break beaches of Fort Lauderdale, Florida, provided the backdrop, as they did five years later for Elvis Presley's *Girl Happy*. Elvis had already begun his long streak of featherlight comedy-romances with songs, some of which set their slight stories by the sea. *Blue Hawaii* (1960) unfolds in Honolulu and Hanauma Bay, while *Fun in Acapulco* (1963) is exactly that; *Clambake* (1967) is a panoramic postcard, taking place all over the Florida coast: Miami, Biscayne Bay, Lighthouse Point, the Keys, even the Everglades. The bevy of Hollywood beach beauties paired with "The King" included Paula Prentiss, Shelley Fabares, and Ursula Andress, fresh off Dr. No's Bahama isle.

The little rebel surfer girl, the semi-fictional *Gidget*, was the subject of two teen beach comedies, the first starring Sandra Dee, before turning up on TV in a sitcom with Sally Field. Gidget—from "girl" + "midget"—proved to be a feminist in utero, owning and carrying her own surfboard, hanging out with the guys, and holding her own in the waves. Field wore wholesome two-piece swimsuits, high-waisted, pastel, and bunny-cute. Major sequences of the first movie and the series were shot in Malibu, north of Santa Monica. The Malibu beach was considered, and still is, both more private and more photogenic, with its intimate coves and craggy rock formations. The coast of Southern California also beckoned Hollywood with the luxurious shore of Santa Barbara, the public beaches of Laguna, and the more exclusive retreat at La Jolla, just north of San Diego.

Gilligan's Island filmed its episodes on a tropically outfitted backlot lagoon in Studio City, California. The three female castaways were attired in enough resort wardrobe for a hundred three-hour tours. Sally Field returned to television in a preposterous concoction called *The Flying Nun*. Her beachwear, her every-wear, was her white novice habit, topped by an odd but airworthy cornette. The aerial shots of San Juan, Puerto Rico, and its coast, as Sister Bertrille "flew" on her missions, were almost worth a viewer's investment in the ridiculous proceedings.

Annette Funicello caught the surf wave at just the right moment,

starring with Frankie Avalon in a string of sandy comedies, "strictly for teenaged cats and jammers," as Robert Salmaggi began his review of *Muscle Beach Party* in the *New York Herald Tribune* in 1964. "Throw in three or four songs by Avalon and Annette, a couple more by Dick Dale and Little Stevie Wonder, some frenetic shimmies by . . . those attractive swimsuit babes, a few faked-in shots of some expert surfing and you've about got the picture." Annette was attractive, could sing a pleasant tune, and had a light touch on screen. But the draw, in those beach movies, was the way she wore a two-piece bathing suit. The final beach opus, *How to Stuff a Wild Bikini*, in 1965, showed her off in the sexiest swimsuit she ever put on: a maillot in white, with a low-cut "V," filled in with matching net. It was a fitting finale. The suit was perhaps a knock-off of the recent Cole of California line of bathing suits, called "The Scandal Collection," which featured the same "V," but with a sheer stretch-mesh panel, and shown in black.

The wave broke big; there was surf music, there were surf clothes and surf commercials, and surf movies, every weekend, like *Ride the Wild Surf* and *For Those Who Think Young*, both from 1964. Swimwear for women and men bloomed with large floral prints and tropic color. Even the Beatles stormed the beaches at Nassau for their spy caper *Help!* (1965), romping in the waves. The flick obliquely depicted an encounter between surf and mod—big color, youthful cut, and bold print animating both trends, one Pacific and one Atlantic.

The print master, Emilio Pucci, opened his resort boutique on Capri, the rocky island off the coast of Naples and the site of the Blue Grotto, later expanding to Rome. He introduced his bikini in 1965, each accompanied by a matching pareu, in his trademark geometric abstract prints in vivacious color. His "wearable art" attracted the attention of Monroe, Sophia Loren, and Jackie Onassis, the "Pucci" label becoming a jet set favorite. Audrey Hepburn's chic Riviera bathing suit in *Two for the Road* (1967) is mistakenly thought to be a Pucci design; the blue-green suit is actually by Ken Scott, a Pucci acolyte with a smaller price-point. The bikini, simmering on the back burner in America, finally found its sweet spot. Many stars and stars-to-be asked for the latest in an informal contest to see who could reveal the most without giving away the best. The well-endowed—but smoother figured than Annette—Barbara Eden, Pamela Tiffin, and Yvette Mimieux all appeared bikini-fied. The public beachgoers and poolsiders followed the example of these updated symbols of Hollywood glitz.

Starlet Raquel Welch boldly went where probably no one else would go, when the publicity campaign for her first star part rolled out. The 1966 movie *One Million Years B.C.* and its poster featured Welch in a doeskin bikini, lined with fur, astride a volcanic landscape. A sex symbol was birthed; La Raquel spent most of the rest of the decade costumed in some spectacular variation of Louis Réard's prized 1946 invention, including the hybrid of one-piece

and bikini that Theadora Van Runkle designed for *Myra Breckinridge* (1970). A larger-than-life likeness of Raquel in this red, white, and blue number, complete with white cowboy hat and boots, spun slowly, high above the Sunset Strip in West Hollywood for years.

On the cover of the June 1962 issue of *Playboy*, Hugh Hefner presented his magazine's first cover bikini. Bronzed and glowing in the sand, a female torso is clad in a knotted-at-the-sides black bikini bottom. The image is involuntarily arousing, but is completely objectified, dispensing with the model's head. A better—by far—image was the one chosen for the January 20, 1964, edition of *Sports Illustrated*. The sun-drenched photo features model Babette March in a white straight-cut bandeau bikini. March stands knee high in the surf for "A Skin Diver's Guide to the Caribbean," the sub-tagline promising "Fun in the Sun on Cozumel," the island resort off the eastern coast of Mexico on the Yucatán Peninsula. "By today's standards," Time.com pointed out in 2011, "the suit is hardly scandalous, but at the time March's bikini caused a sensation." The success of this edition of the magazine led to its being referred to as the first *Sports Illustrated Swimsuit Issue*.

The timing was right and the beach towel was spread; the bikini would far surpass the one-piece maillots, practical tank suits, and tame two-piece suits—in popularity, comment, and attention—through the next decade. But more reveal was to come.

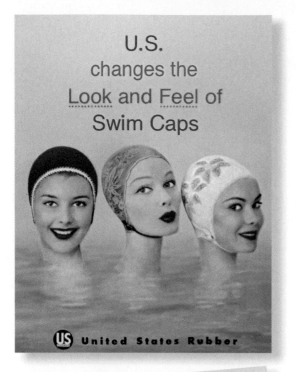

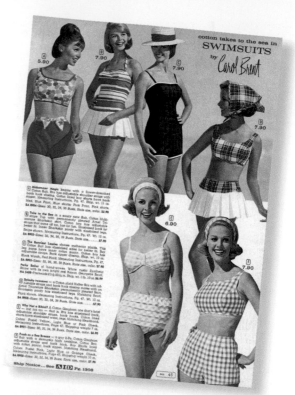

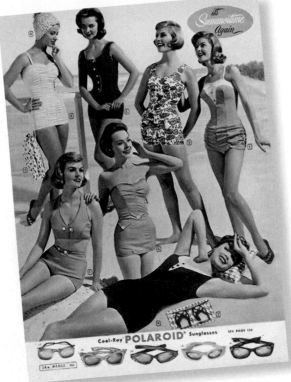

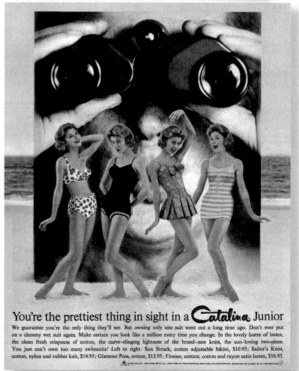

(ABOVE, CLOCKWISE FROM TOP LEFT) Advertisements for United States Rubber swim caps, early 1960s; Carol Brent swimsuits, early 1960s; Catalina Junior swimsuits, 1960; and Polaroid sunglasses, 1961.

and bikini that Theadora Van Runkle designed for *Myra Breckinridge* (1970). A larger-than-life likeness of Raquel in this red, white, and blue number, complete with white cowboy hat and boots, spun slowly, high above the Sunset Strip in West Hollywood for years.

On the cover of the June 1962 issue of *Playboy*, Hugh Hefner presented his magazine's first cover bikini. Bronzed and glowing in the sand, a female torso is clad in a knotted-at-the-sides black bikini bottom. The image is involuntarily arousing, but is completely objectified, dispensing with the model's head. A better—by far— image was the one chosen for the January 20, 1964, edition of *Sports Illustrated*. The sun-drenched photo features model Babette March in a white straight-cut bandeau bikini. March stands knee high in the surf for "A Skin Diver's Guide to the Caribbean," the sub-tagline promising "Fun in the Sun on Cozumel," the island resort off the eastern coast of Mexico on the Yucatán Peninsula. "By today's standards," Time.com pointed out in 2011, "the suit is hardly scandalous, but at the time March's bikini caused a sensation." The success of this edition of the magazine led to its being referred to as the first *Sports Illustrated Swimsuit Issue*.

The timing was right and the beach towel was spread; the bikini would far surpass the one-piece maillots, practical tank suits, and tame two-piece suits—in popularity, comment, and attention— through the next decade. But more reveal was to come.

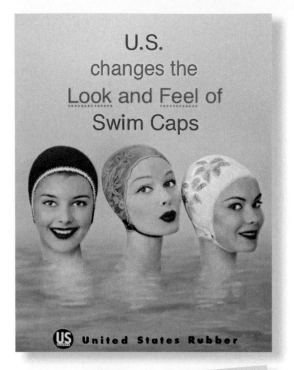

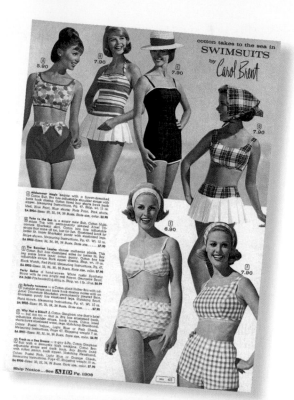

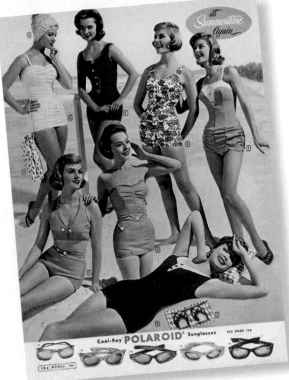

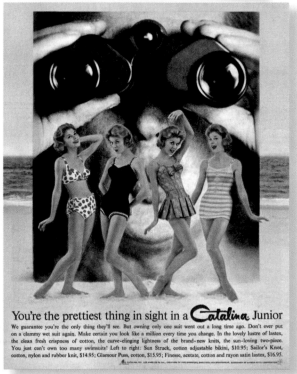

(ABOVE, CLOCKWISE FROM TOP LEFT) Advertisements for United States Rubber swim caps, early 1960s; Carol Brent swimsuits, early 1960s; Catalina Junior swimsuits, 1960; and Polaroid sunglasses, 1961.

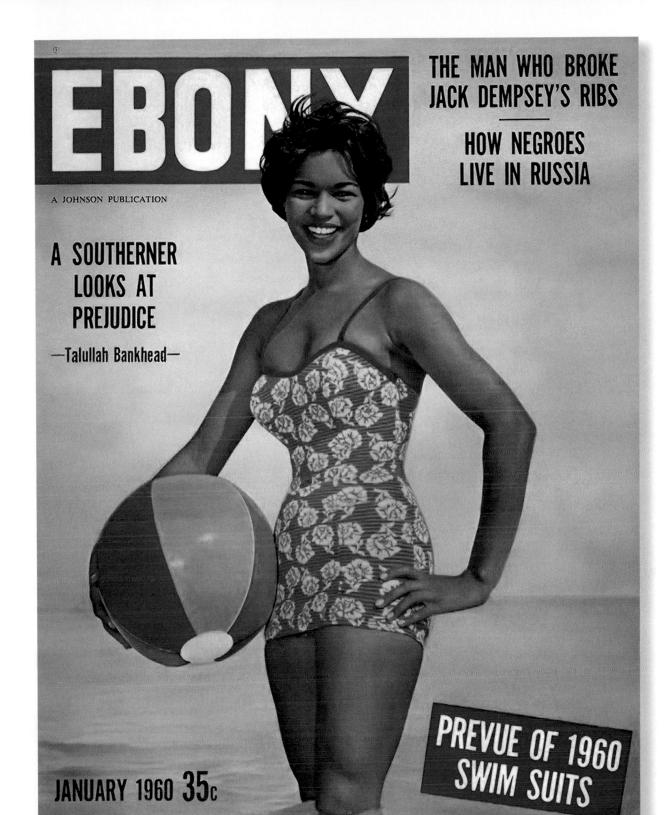

Jill St. John, 1967. Photo by Pierluigi Praturlon.

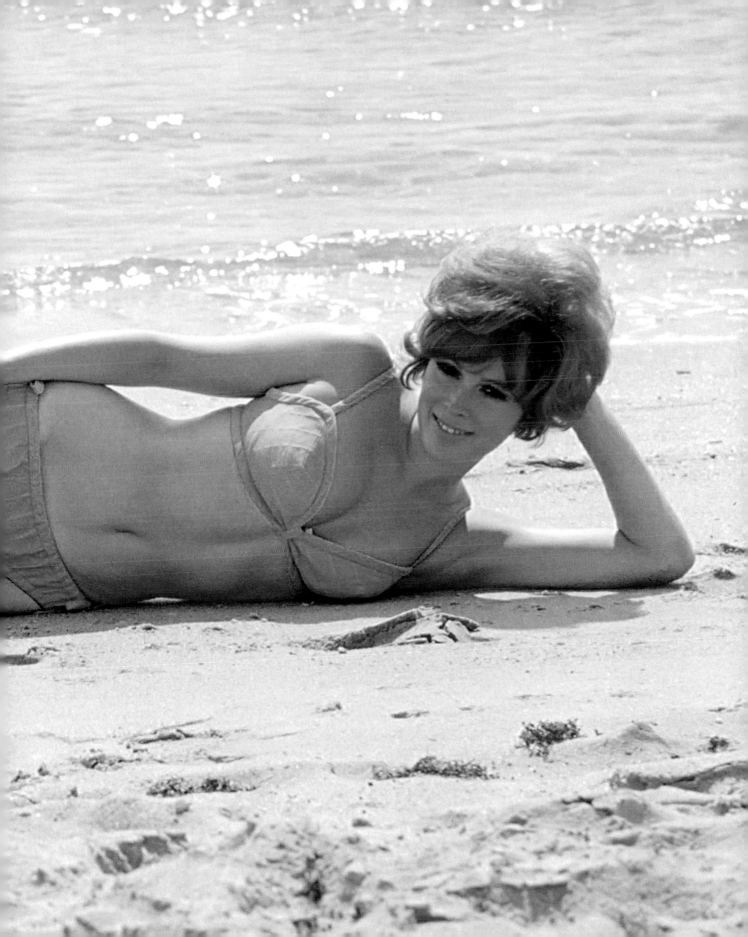

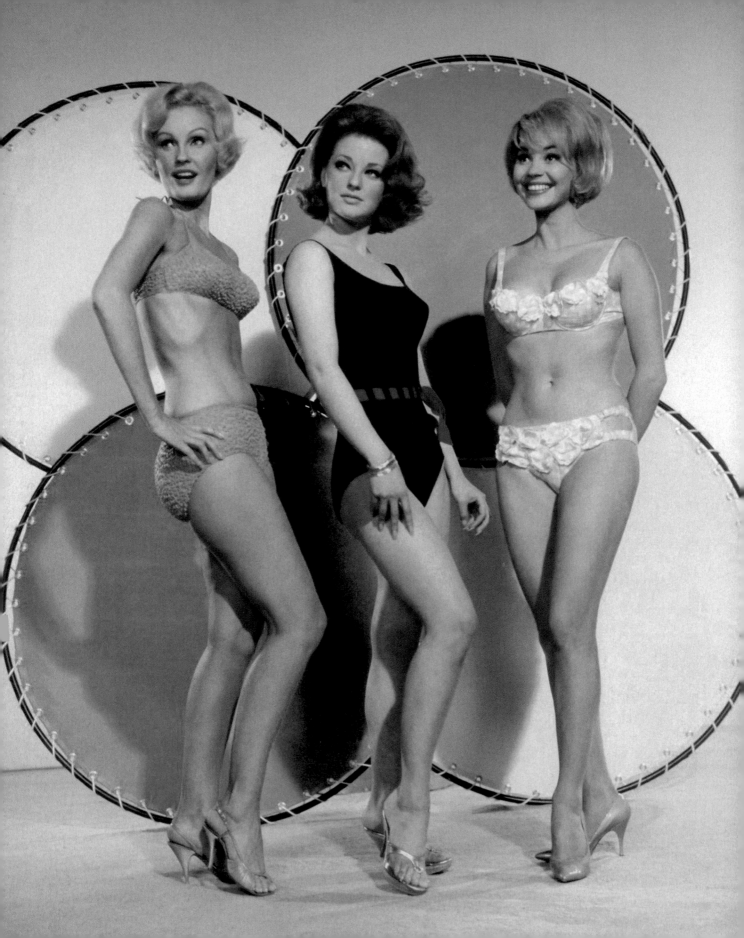

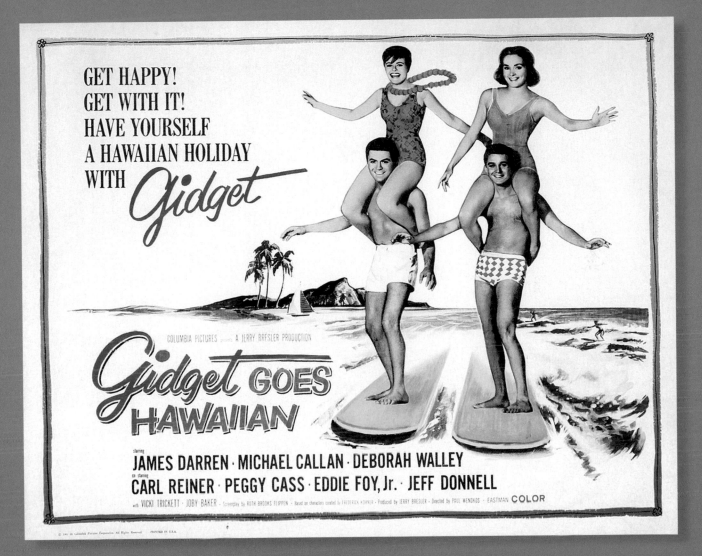

(ABOVE) Movie poster featuring Deborah Walley as the title character in *Gidget Goes Hawaiian* (1961). Based on Frederick Kohner's 1957 novel, *Gidget, the Little Girl with Big Ideas*, Gidget was originally played by Sandra Dee in 1959, and then perhaps most memorably by Sally Field in the 1965/66 television sitcom. (OPPOSITE) Pamela Curran, Rusty Allen, and Gail Gilmore strike a pose for Elvis Presley in *Girl Happy* (1965).

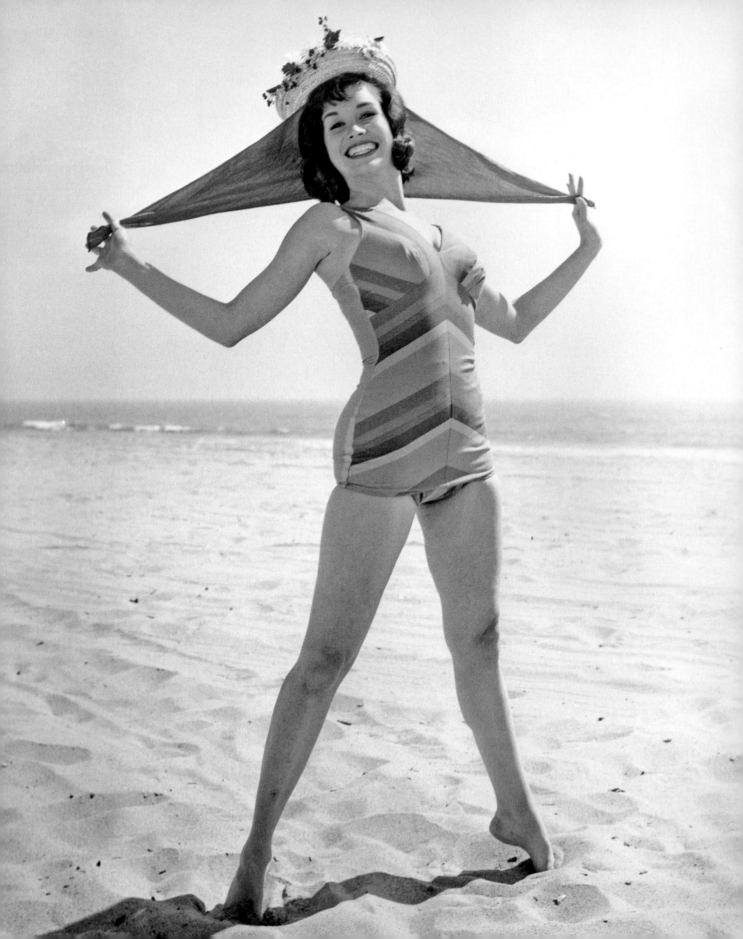

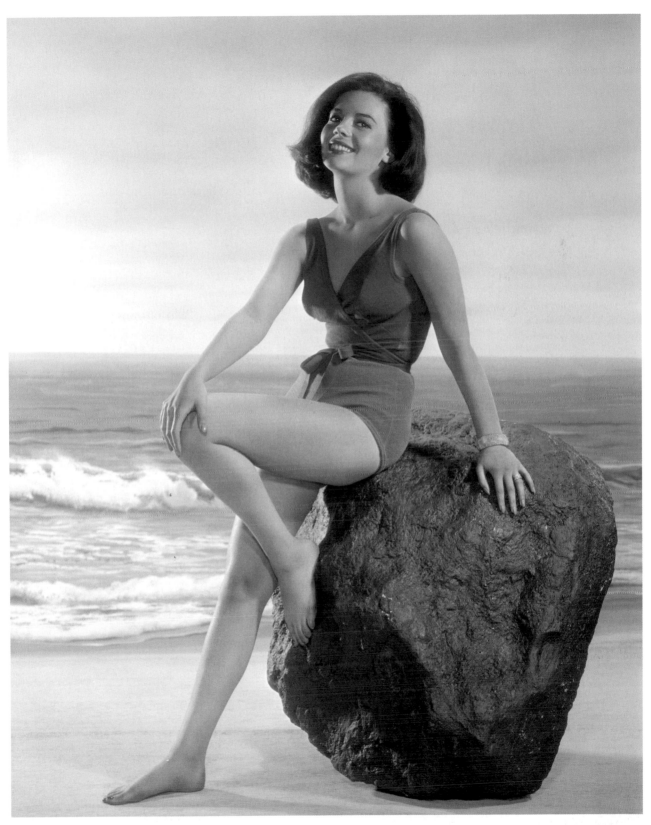

SPLENDOR IN THE SUN: (OPPOSITE) Mary Tyler Moore, circa 1964. (ABOVE) Natalie Wood, 1961.

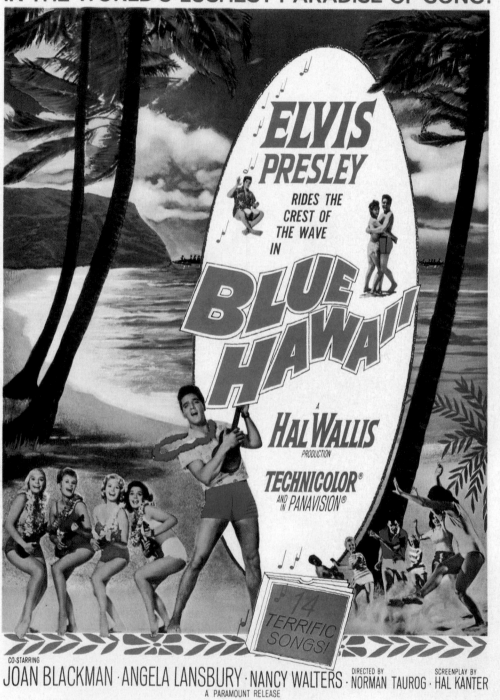

GIRLS! GIRLS! GIRLS!: (ABOVE) Movie poster featuring Elvis Presley in *Blue Hawaii* (1961). (RIGHT) Elvis, pearl diving, in *Clambake* (1967).

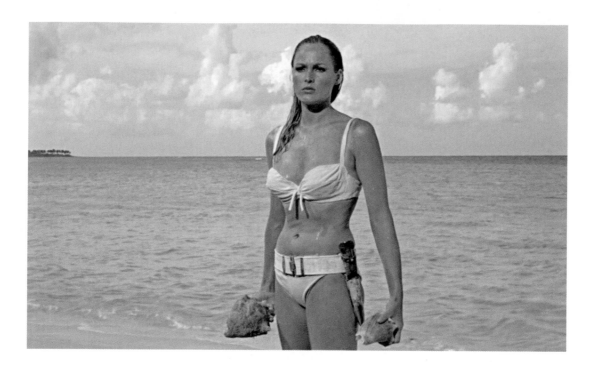

"This bikini made me a success. My entrance in *Dr. No* wearing the bikini on that beautiful beach now seems to be regarded as a classic moment in cinema, and made me world famous as 'The Bond Girl.'"

URSULA ANDRESS

(ABOVE AND OPPOSITE) Ursula Andress as Honey Ryder, the original Bond Girl, emerges from the Caribbean waves in *Dr. No* (1962). The scene would be homaged decades later by Halle Berry in *Die Another Day* (2002), and again by Daniel Craig in *Casino Royale* (2006).

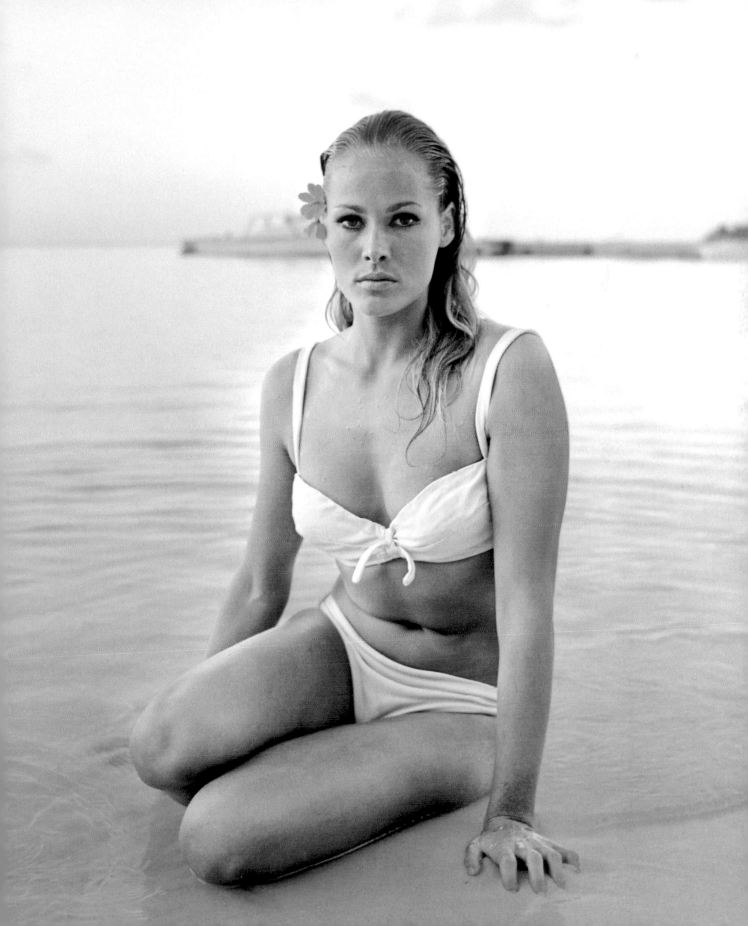

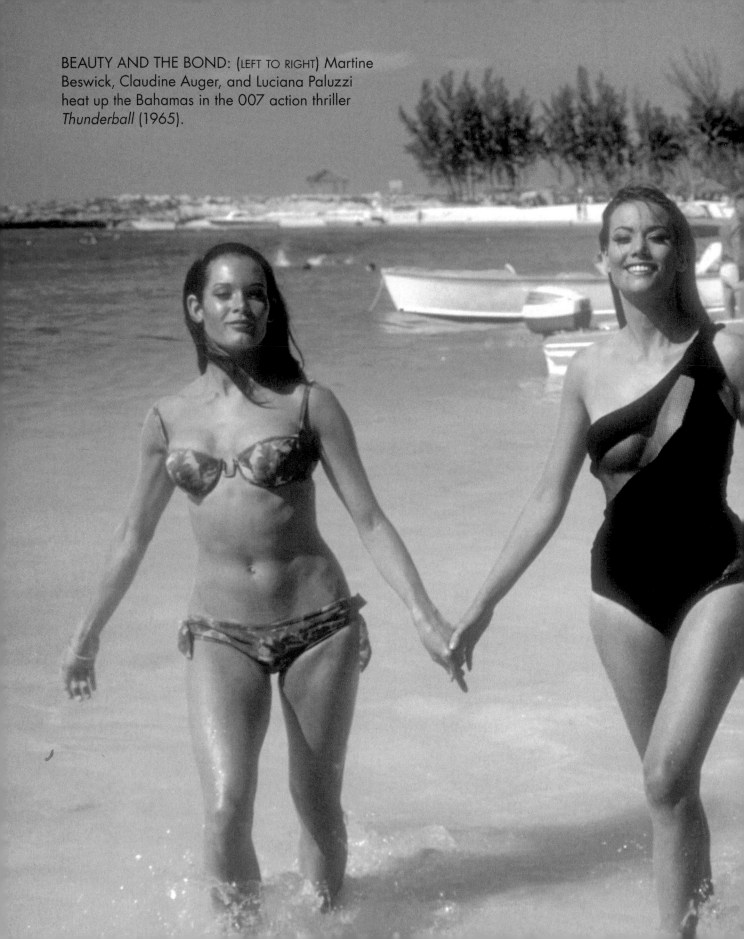

BEAUTY AND THE BOND: (LEFT TO RIGHT) Martine Beswick, Claudine Auger, and Luciana Paluzzi heat up the Bahamas in the 007 action thriller *Thunderball* (1965).

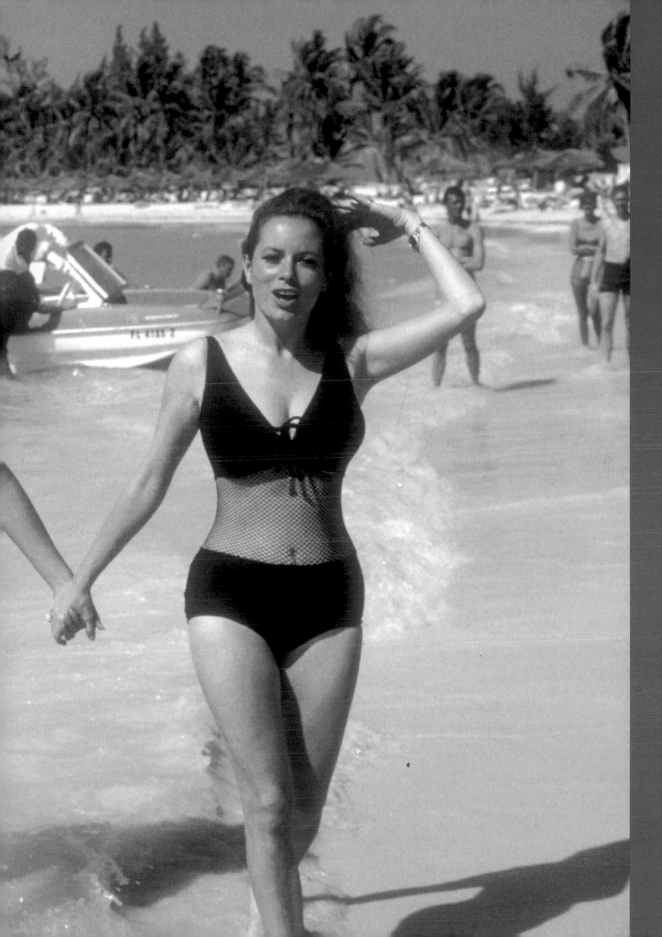

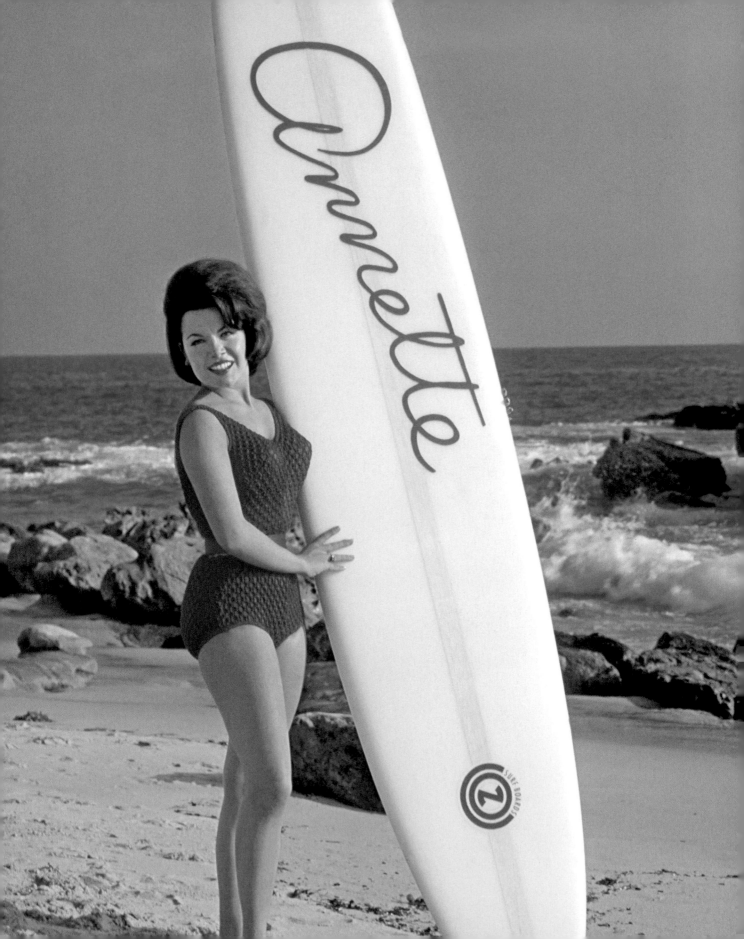

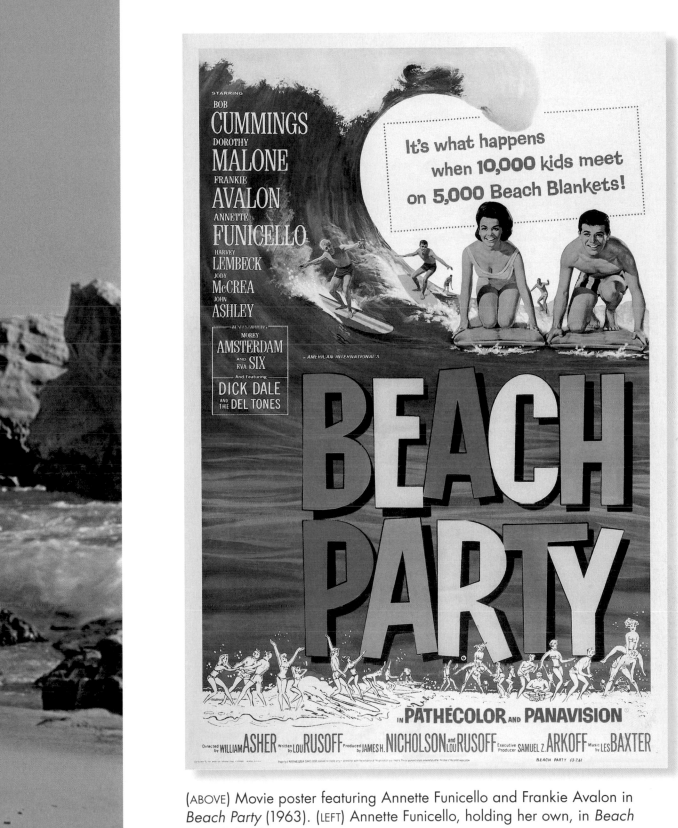

(ABOVE) Movie poster featuring Annette Funicello and Frankie Avalon in *Beach Party* (1963). (LEFT) Annette Funicello, holding her own, in *Beach Party* (1963).

BEACH MANIA: Movie posters for (TOP) *Beach Blanket Bingo* (1965); (RIGHT) *Muscle Beach Party* (1964); and (OPPOSITE) *Bikini Beach* (1964).

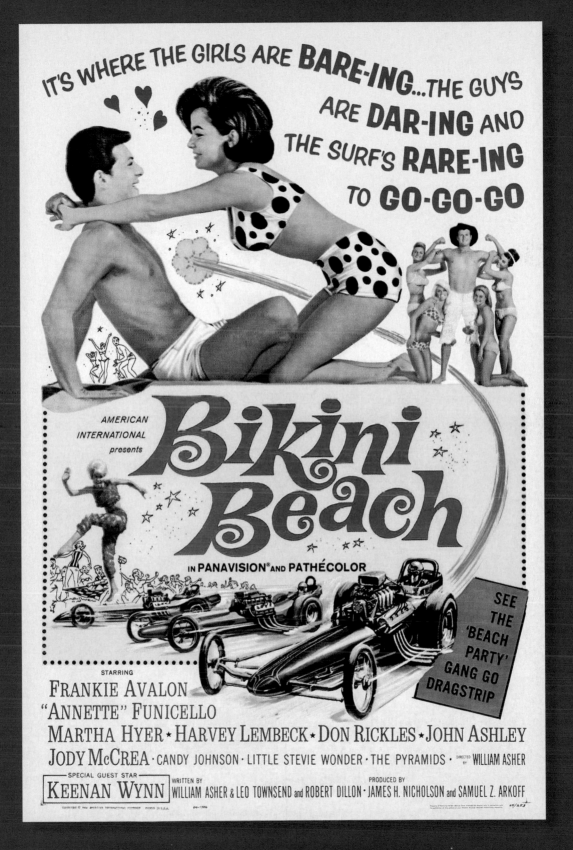

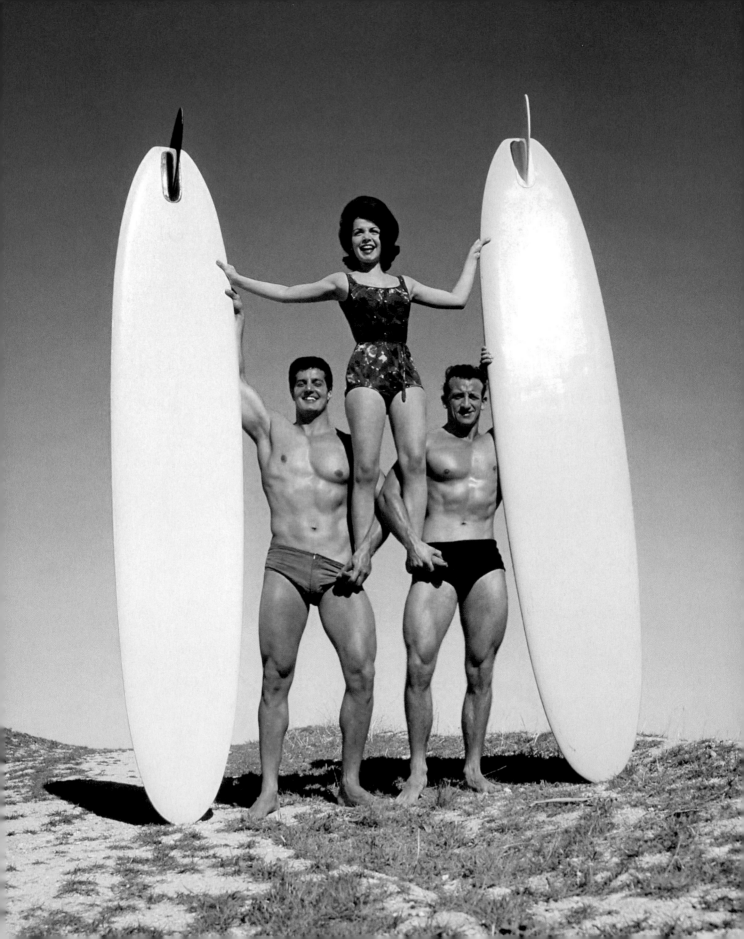

BALANCING ACTS: (ABOVE) Annette Funicello and Frankie Avalon in *Beach Party* (1963). (OPPOSITE) Funicello as Dee Dee with (on left) bodybuilder Peter Lupus as Flex Martian in *Muscle Beach Party* (1964).

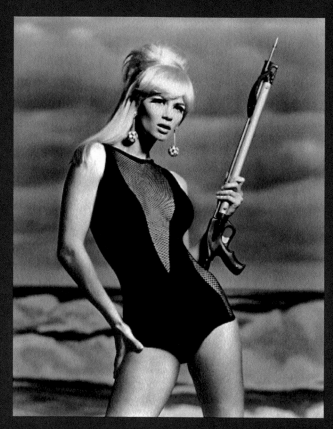

"Never in the history of mankind has so little done so much for so many."

COLE OF CALIFORNIA, Advertising tagline, 1964

(ABOVE) Cole of California's "Great Scandal Suit," 1964. A one-piece of nylon knit, the enormously popular swimsuit was the first to utilize stretch mesh. (RIGHT) Veruschka wearing a black wool knit maillot by Rudi Gernreich. Itapoã, Brazil, 1968. Photo by Franco Rubartelli.

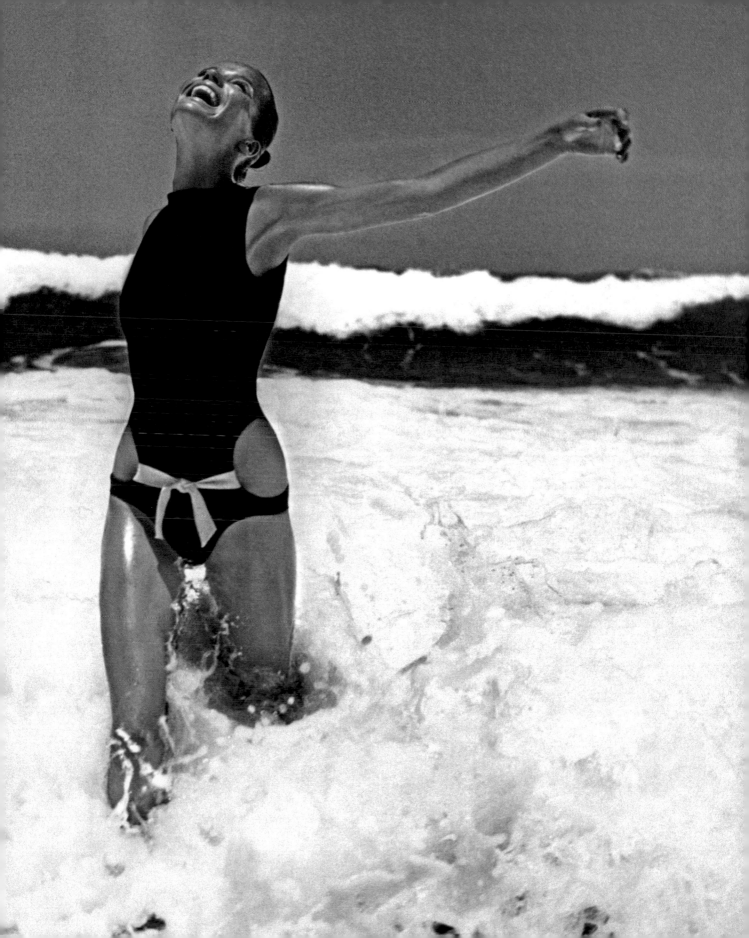

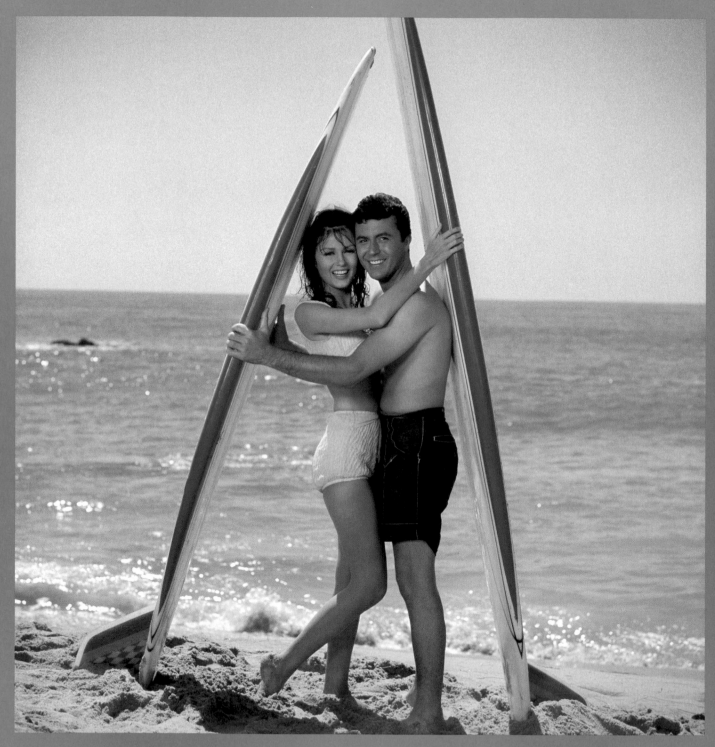

ALL ABOARD: *For Those Who Think Young* (1964). (TOP) Pamela Tiffin as Sandy Palmer and James Darren as Gardner "Ding" Pruitt III. (OPPOSITE) Tina Louise as Topaz McQueen.

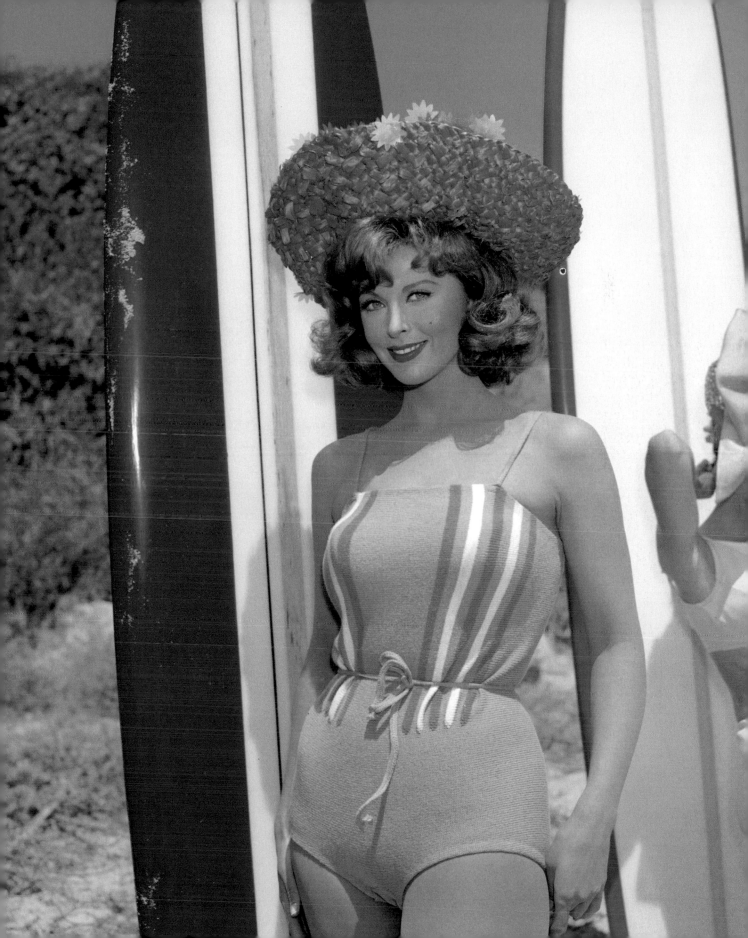

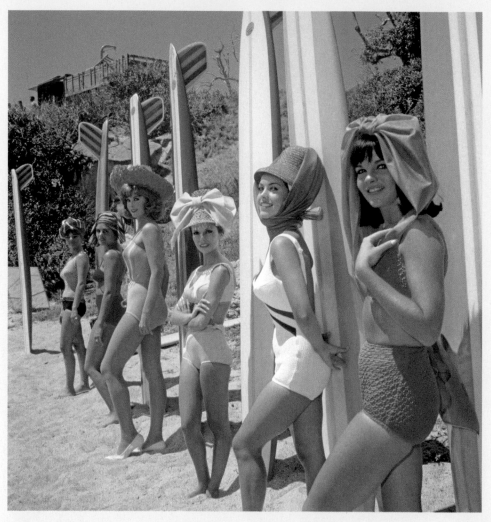

(ABOVE) Tina Louise and Nancy Sinatra in *For Those Who Think Young* (1964). (RIGHT) Nancy Sinatra as Karen Cross in *For Those Who Think Young* (1964).

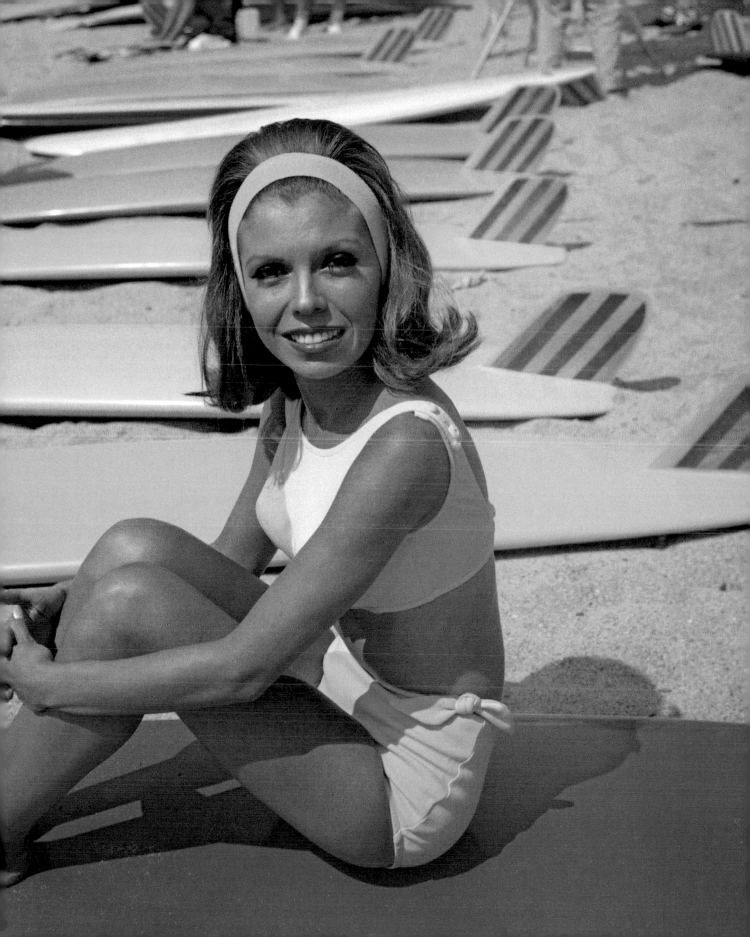

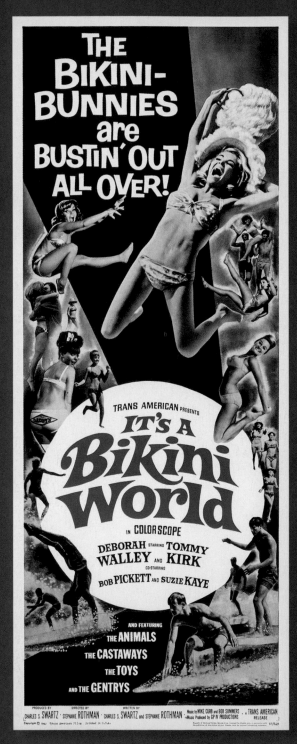

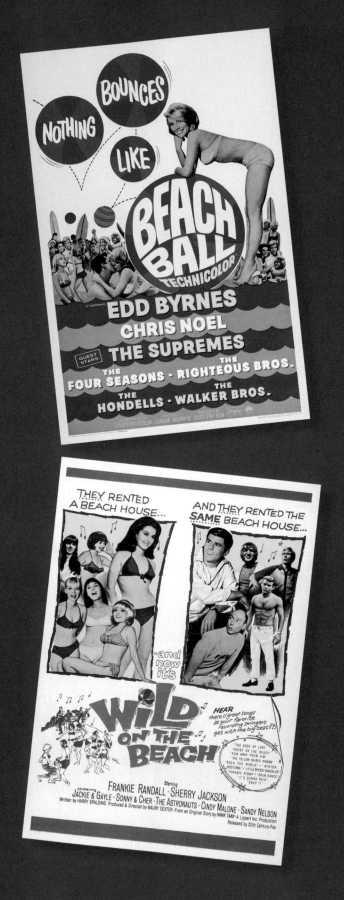

CHEAPER BY THE DOZEN: Movie posters for (ABOVE LEFT) *It's a Bikini World* (1967); (TOP RIGHT) *Beach Ball* (1965); (BOTTOM RIGHT) *Wild on the Beach* (1965); and (OPPOSITE) *Girls on the Beach* (1965).

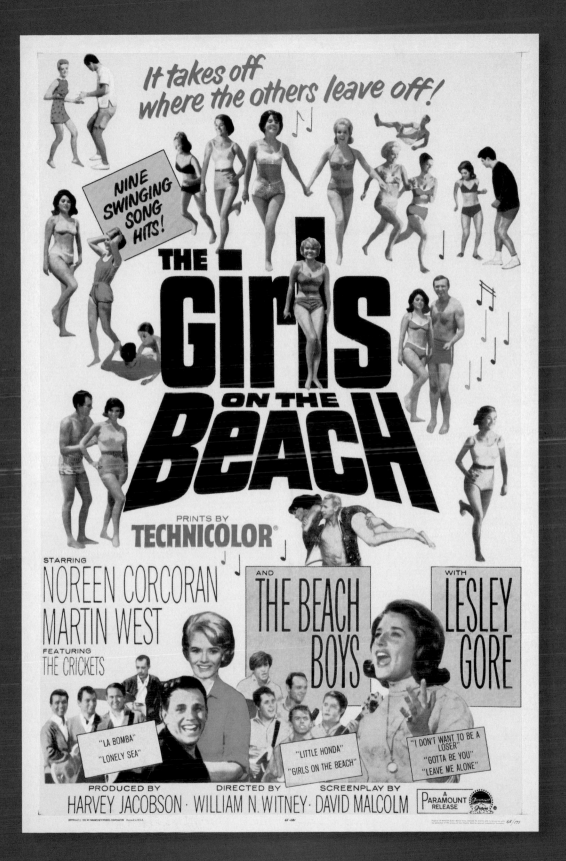

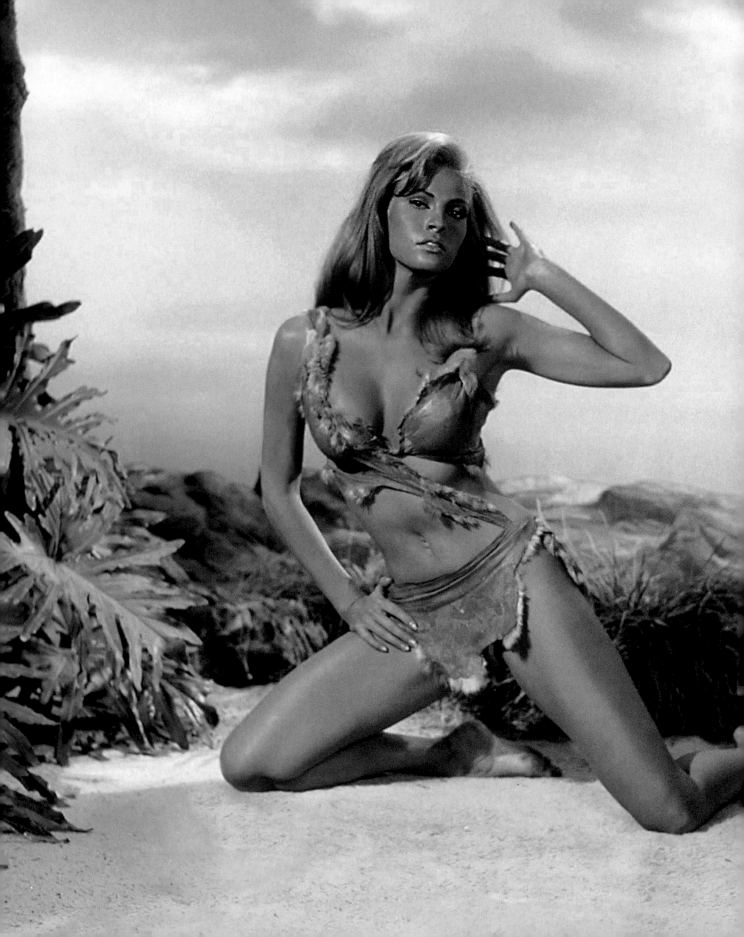

"The indelible image of a woman as queen of nature. She was a lioness: fierce, passionate and dangerously physical."

CAMILLE PAGLIA ON RAQUEL WELCH

Raquel Welch, suffering for her art, in *One Million Years B.C.* Welch bikinied her way to superstardom in the 1966 fantasy, and would parlay similar wardrobe to spectacular effect in *Fathom* (1967), *Bedazzled* (1967), *The Biggest Bundle of Them All* (1968), and *Myra Breckinridge* (1970).

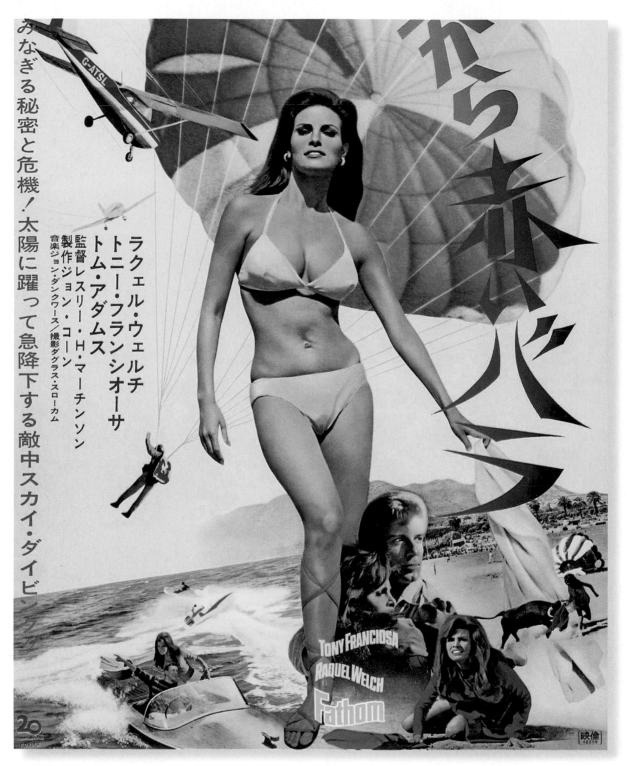

A GIRL IN UNIFORM: (ABOVE) Japanese movie poster featuring Raquel Welch in *Fathom* (1967). (RIGHT) Welch, circa 1966.

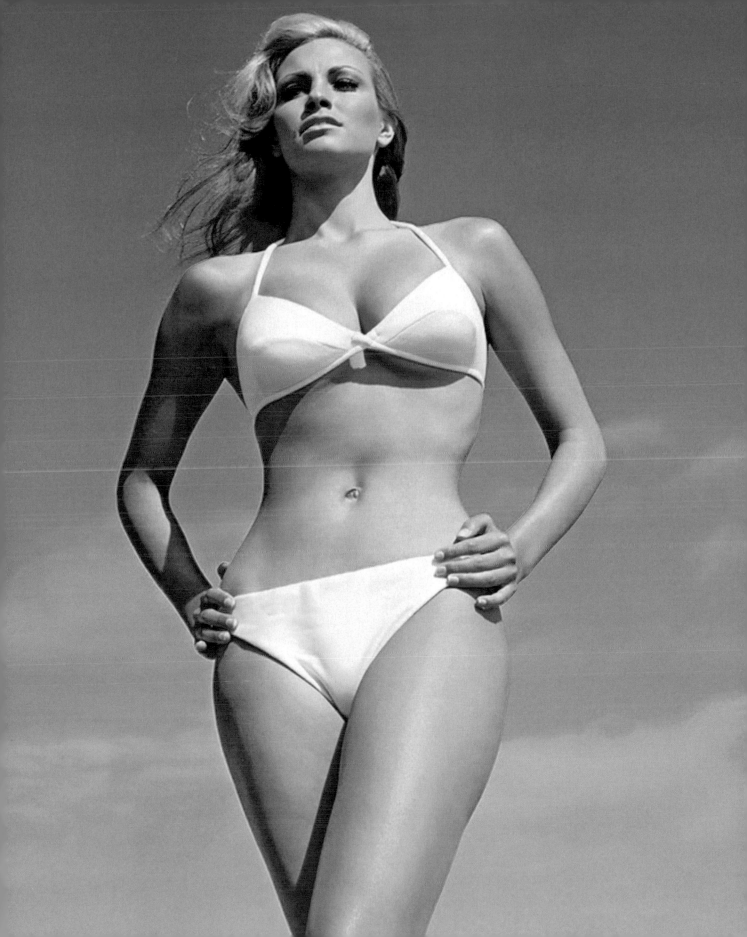

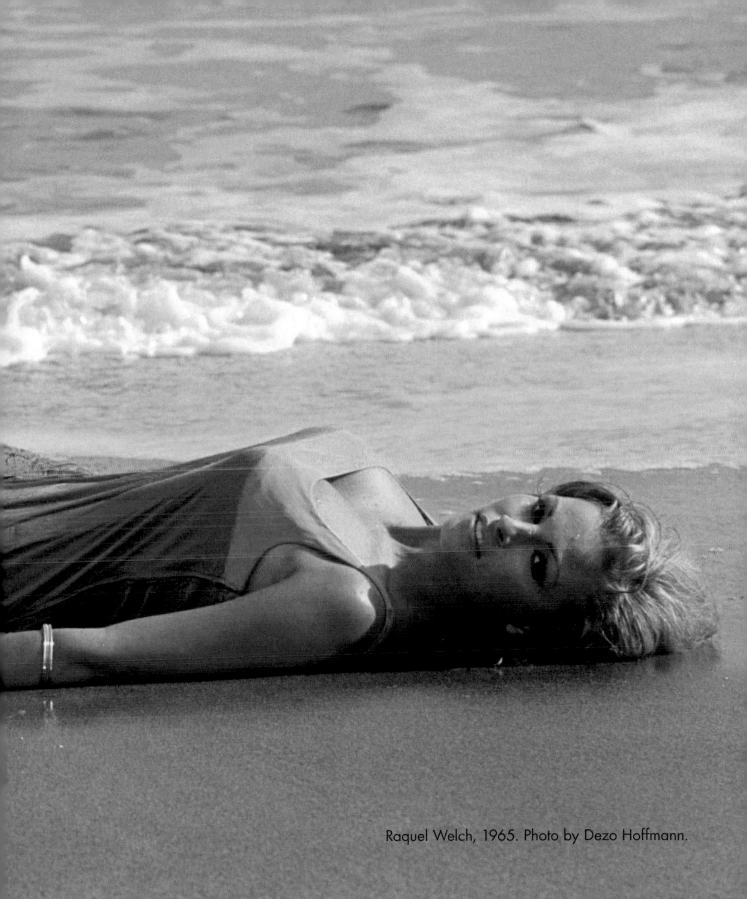

Raquel Welch, 1965. Photo by Dezo Hoffmann.

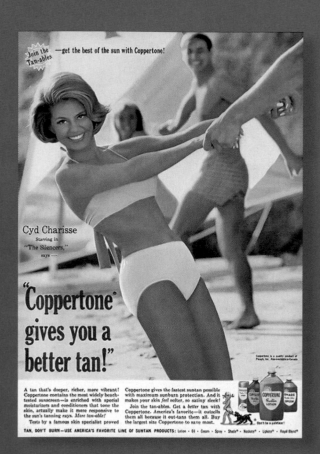
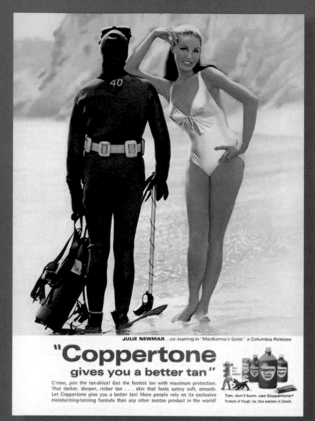
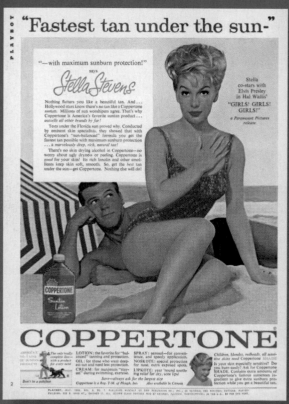
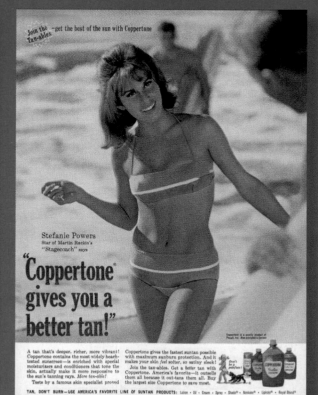

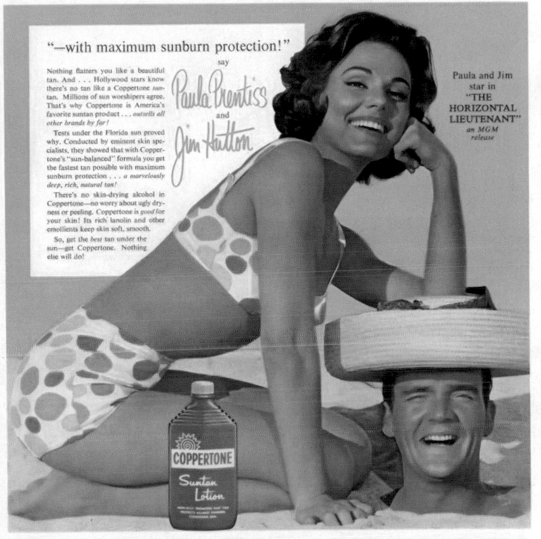

BAKING BEAUTIES: (ABOVE) Advertisement for Coppertone Suntan Lotion featuring Paula Prentiss, 1962. (OPPOSITE, CLOCKWISE FROM TOP LEFT) Advertisements for Coppertone Suntan Lotion featuring Cyd Charisse, 1966; Julie Newmar, 1969; Stefanie Powers, 1966; and Stella Stevens, 1962.

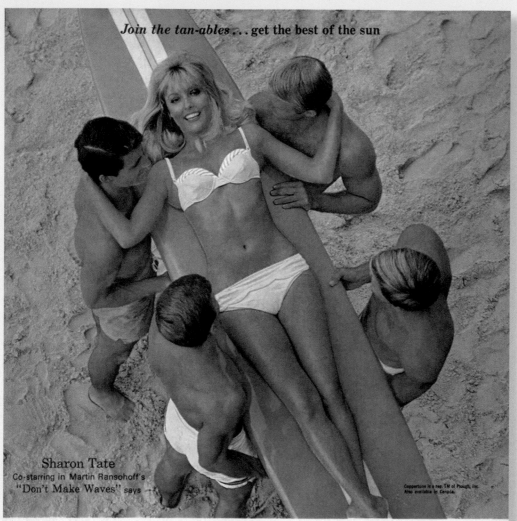

Join the tan-ables . . . get the best of the sun

Sharon Tate
Co-starring in Martin Ransohoff's
"Don't Make Waves" says

Coppertone is a reg. TM of Plough, Inc.
Also available in Canada.

"Coppertone gives you a *better* tan"

(—it's enriched to give extra protection, too!)

You *do* get a better tan with Coppertone. The fastest tan possible with maximum sunburn protection . . . plus extra safeguards against skin dryness. Coppertone contains the most widely beach-tested sunscreen. It's also enriched with lanolin, cocoa butter and other moisturizers that make your skin more tan-able . . . keep your skin soft and satiny sleek.

So join the tan-ables. Get a better tan . . . deep, dark, superbly smooth. Coppertone outsells them all because it out-tans them all! Get the best of the sun with enriched Coppertone. Save on large size,

Don't be a paleface!

TAN, DON'T BURN—with America's most popular, most complete line of suntan products: Lotion, Oil, Cream, Spray, Shade®, Noskote®, Lipkote®, Royal Blend®. Also new Baby Tan® for young children and Royal Blend Soap.

17

MAKING WAVES: (ABOVE) Advertisement for Coppertone Suntan Lotion featuring Sharon Tate, 1967. (RIGHT) Sharon Tate as Malibu in *Don't Make Waves* (1967). Malibu Barbie, produced by Mattel in 1971, was inspired by Tate's character in the film.

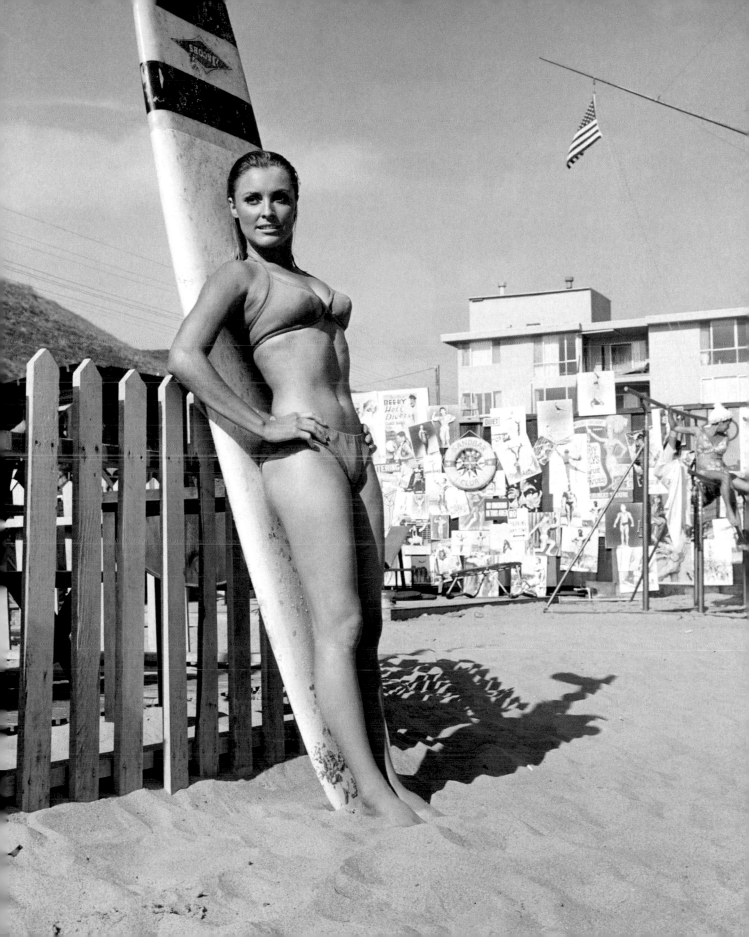

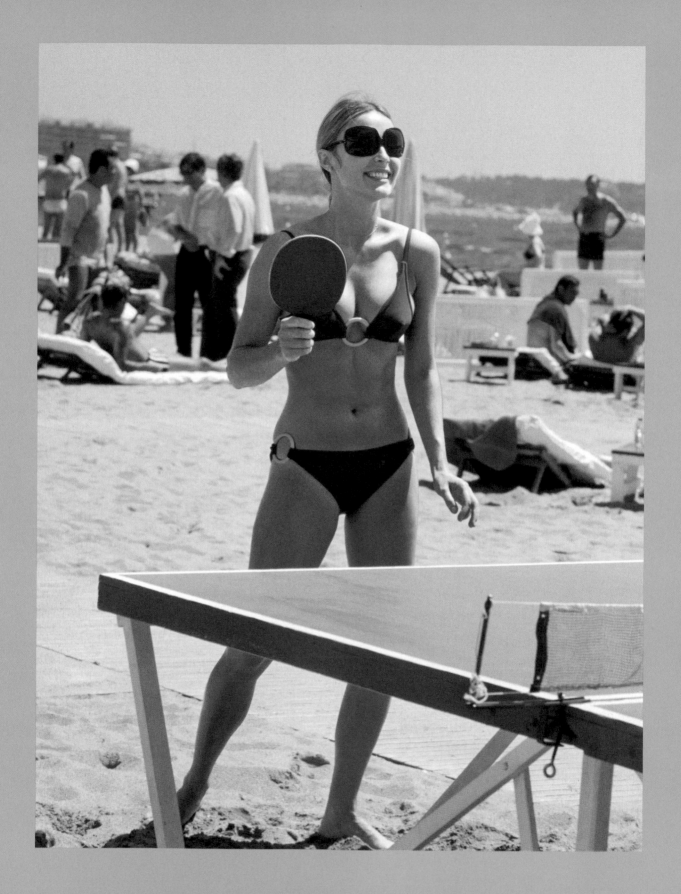

"Sharon Tate has transcended her career in the 60's to become one of the great fashion and style icons of the twentieth century and beyond. A designer's dream, and one of the few actresses of her time to blur the line between movie star and fashion model in the pages of *Vogue* and *Bazaar*, she looked equally as dynamic in haute couture as she did in a bikini."

TRINA TURK, DESIGNER ON SHARON TATE

Sharon Tate enjoys some beach Ping-Pong at the Festival de Cannes, May 1968. Photo by Jack Garofalo.

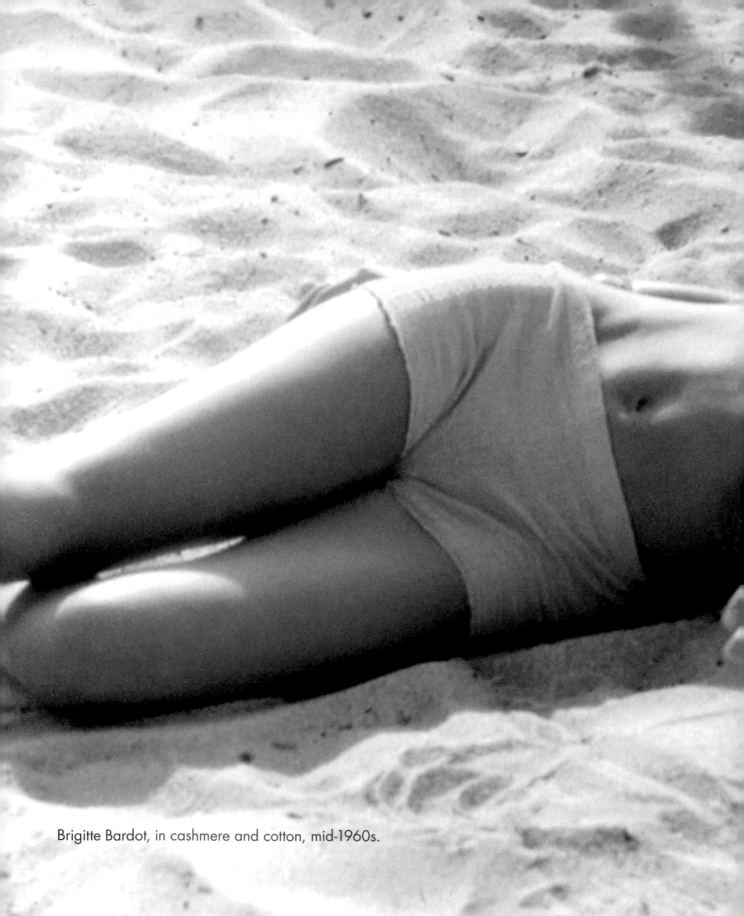

Brigitte Bardot, in cashmere and cotton, mid-1960s.

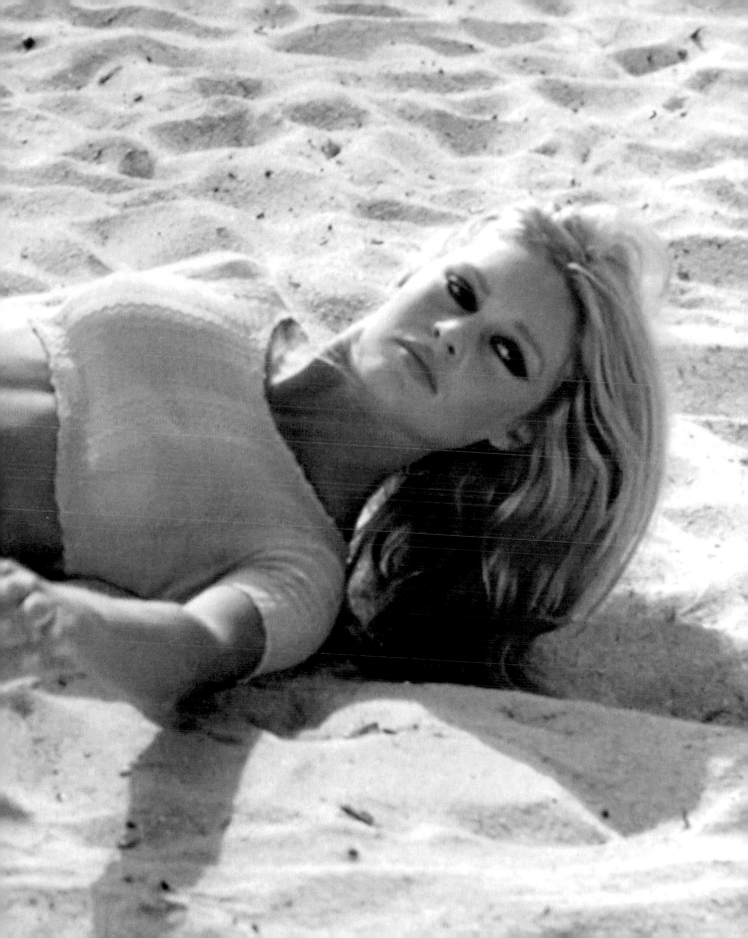

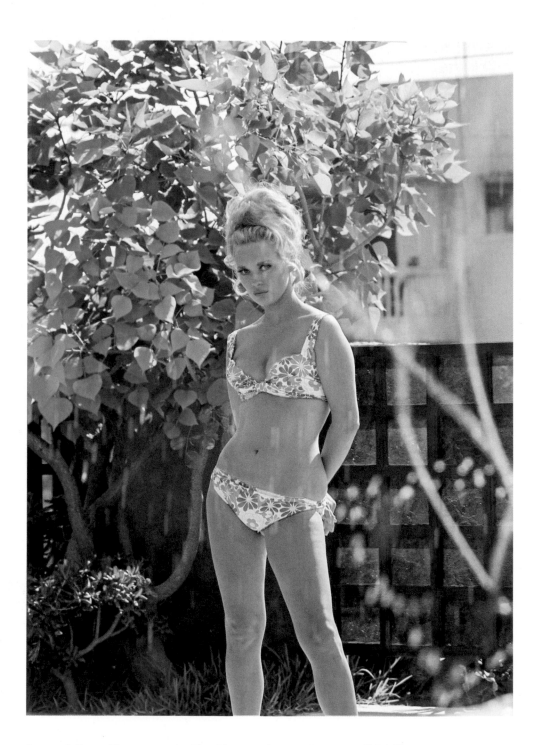

(ABOVE) Faye Dunaway in *The Extraordinary Seaman* (1969).
Photo by Pierluigi Praturlon. (RIGHT) Dunaway in *The Happening* (1967).

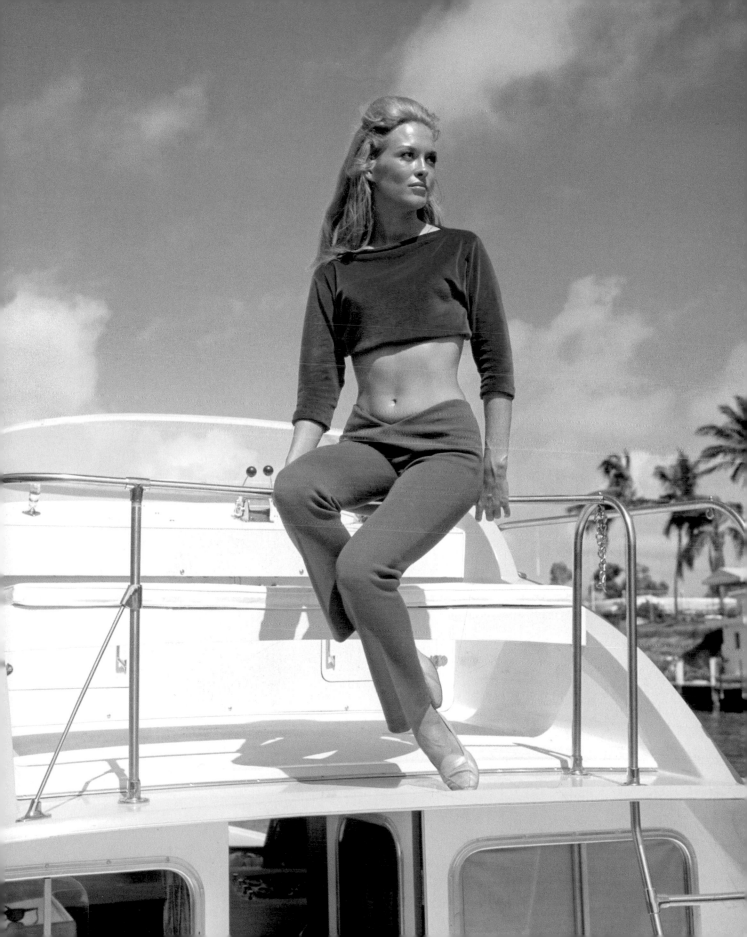

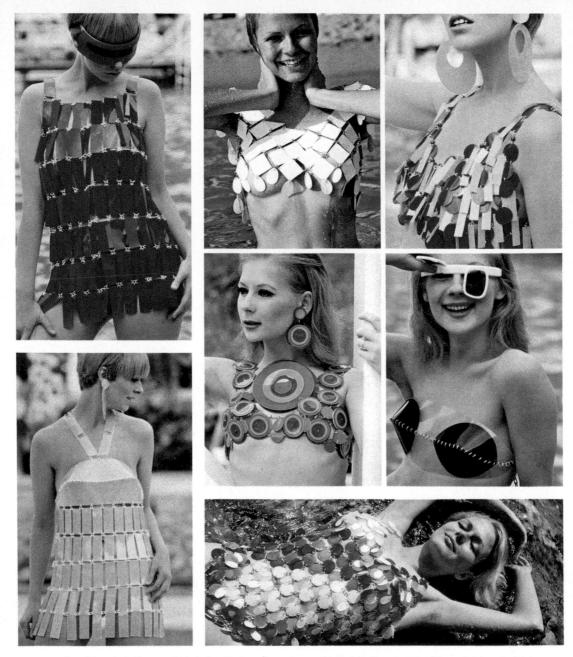

Paco Rabanne's starkly geometrical plastic swimsuits employ contemporary materials with a classic simplicity, conjuring up timeless images. Rabanne's modern mail-female approach is most apparent in air-conditioned outfit, above right, designed to show and shield a fair lady. The girl in the center wears a bolero of disks emblazoned with concentric circles, suggesting the armor of Attic warriors. The lass on her left, peering through one of Paco's opulent optics, is shielded by breastplates that further delineate a common interest of ancient and modern times. The linked plastics can be paired with similar accessories. Paco has used his link principle in creations ranging from sandals with linked-plastic straps to wedding outfits with plastic veils. Additional information about them may be obtained directly from Paco Rabanne in Paris.

148

(ABOVE) Paco Rabanne swimsuits featured in *Playboy* magazine, November 1966.
(OPPOSITE) Ann-Margret, circa 1966.

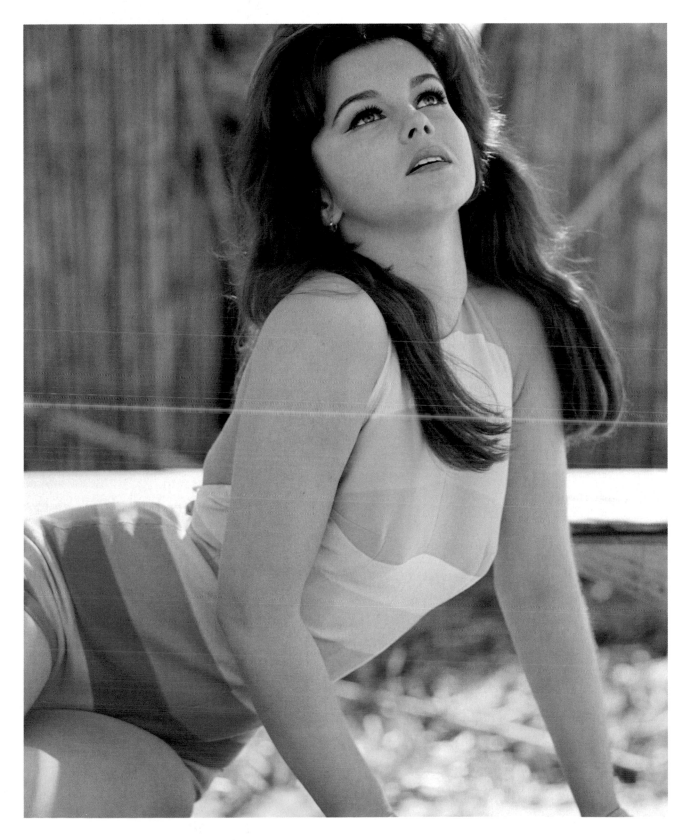

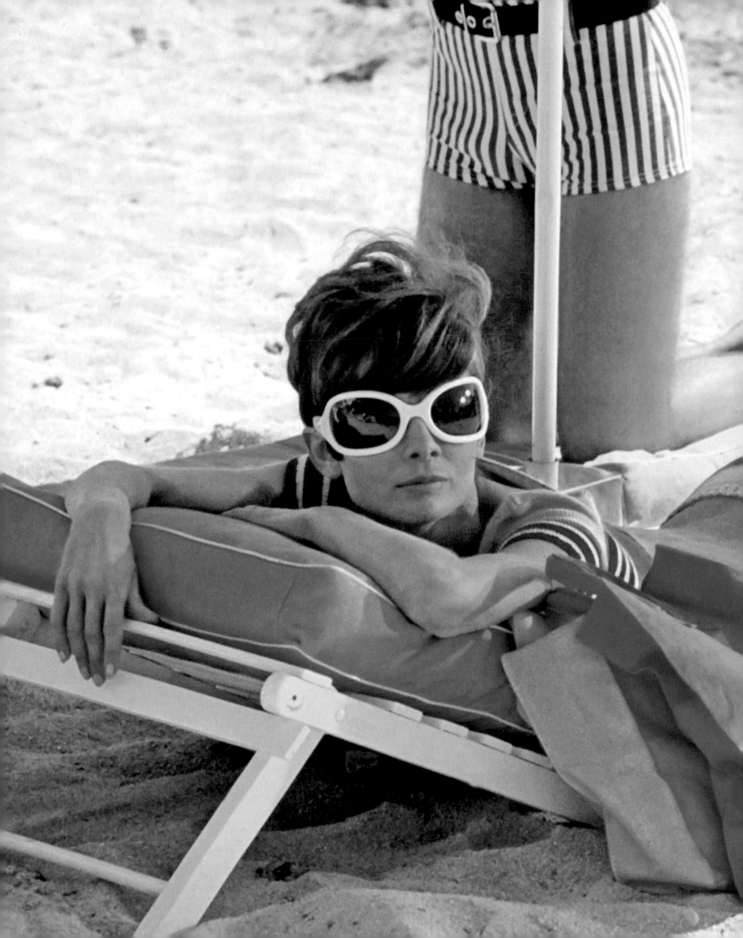

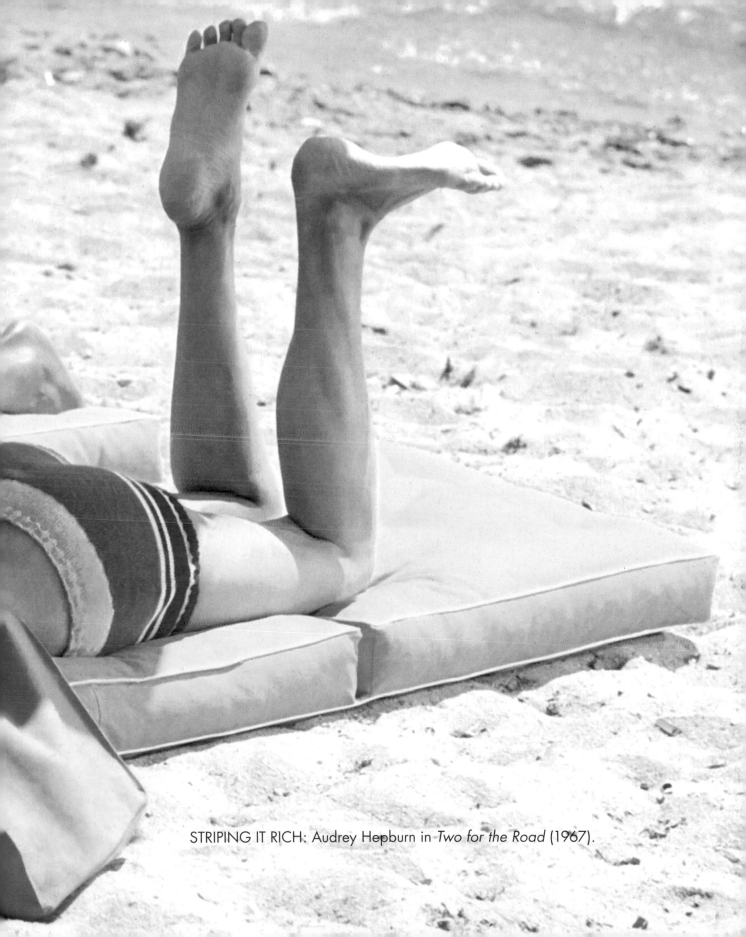

STRIPING IT RICH: Audrey Hepburn in *Two for the Road* (1967).

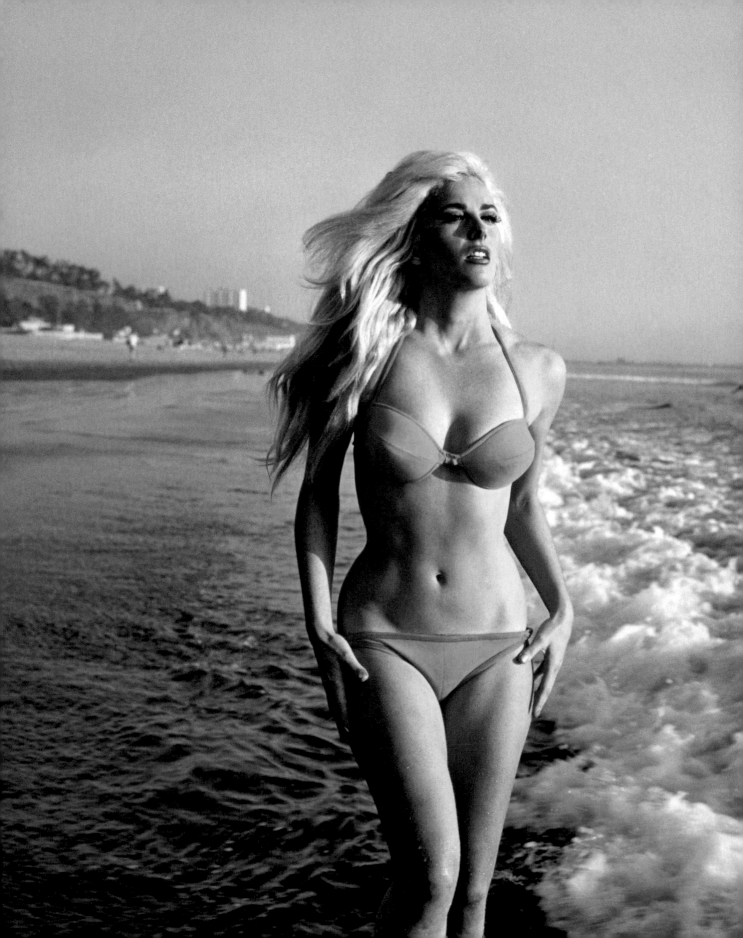

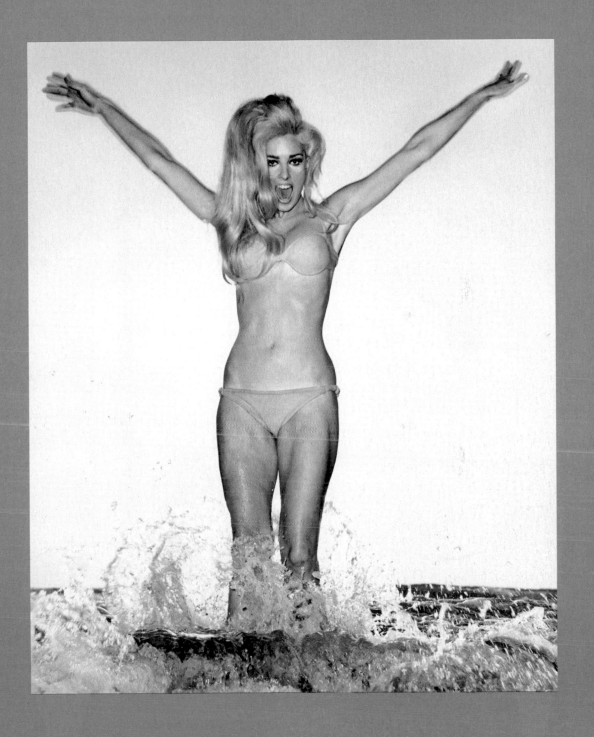

(ABOVE AND LEFT) HOW TO STUFF A WILD BIKINI: Edy Williams, 1968. Often dubbed "The Last Starlet," Williams popularized a Southern California hybrid: the bikini-gown. Comprising a standard bikini—and in Williams' case usually in crochet or crushed velvet—the design featured flanks of matching fabric attached to the base of the bikini top which fell mini or maxi length.

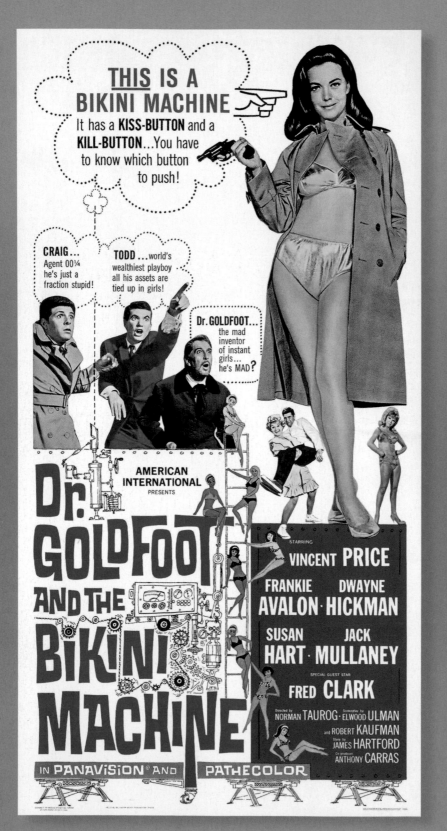

(ABOVE) Movie poster for *Dr. Goldfoot and the Bikini Machine* (1965). (OPPOSITE) *The Trip* (1967).

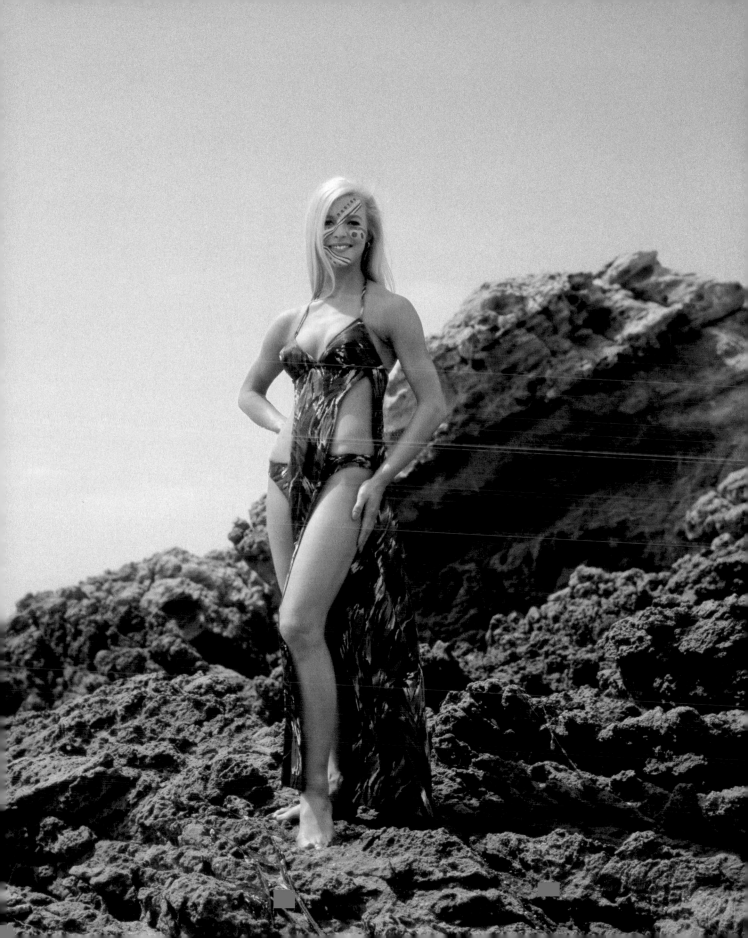

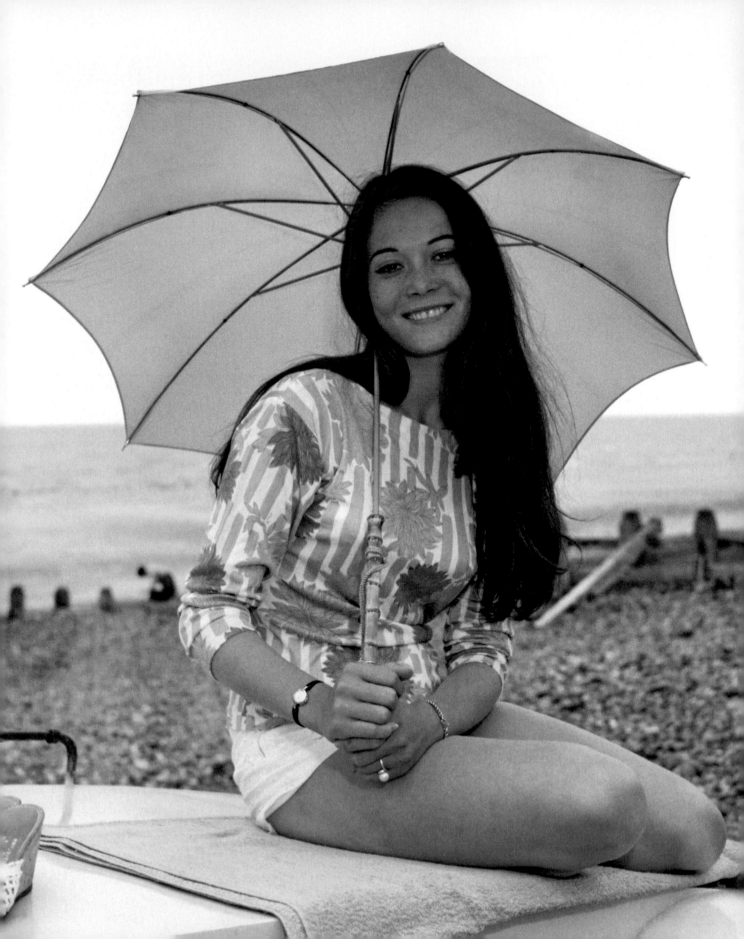

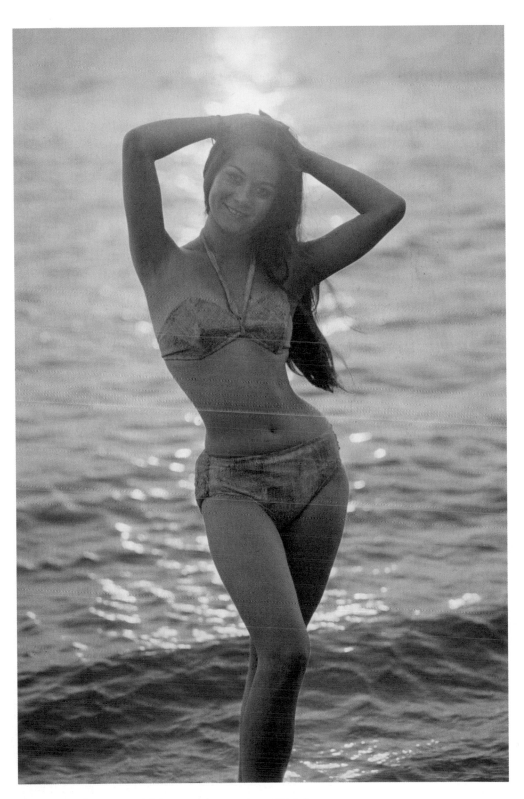

(ABOVE and OPPOSITE) Nancy Kwan, circa 1966.

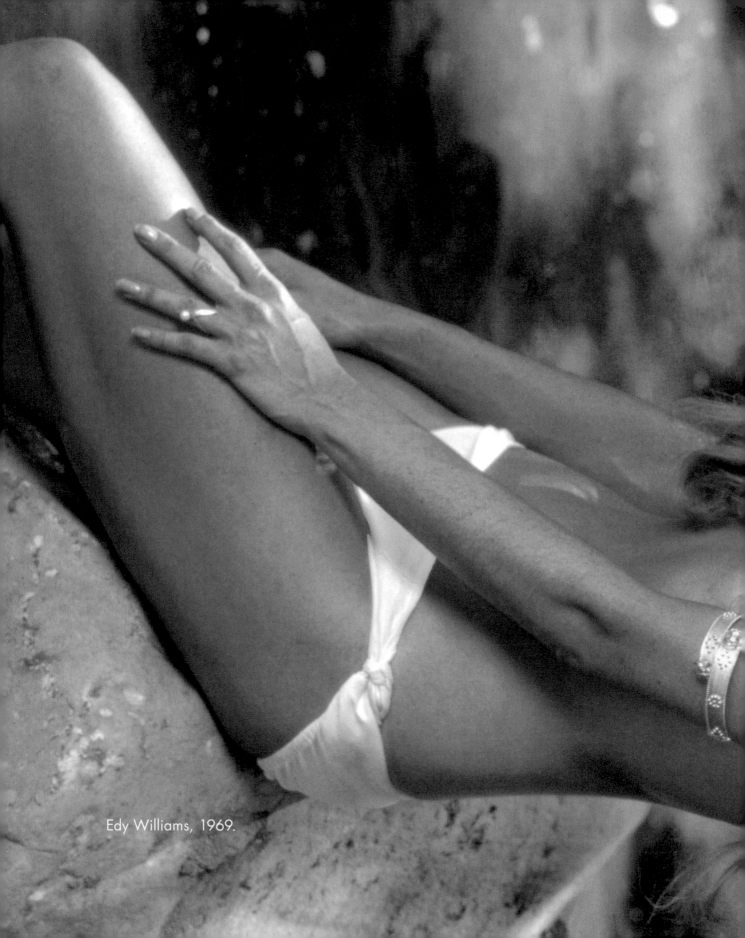

Edy Williams, 1969.

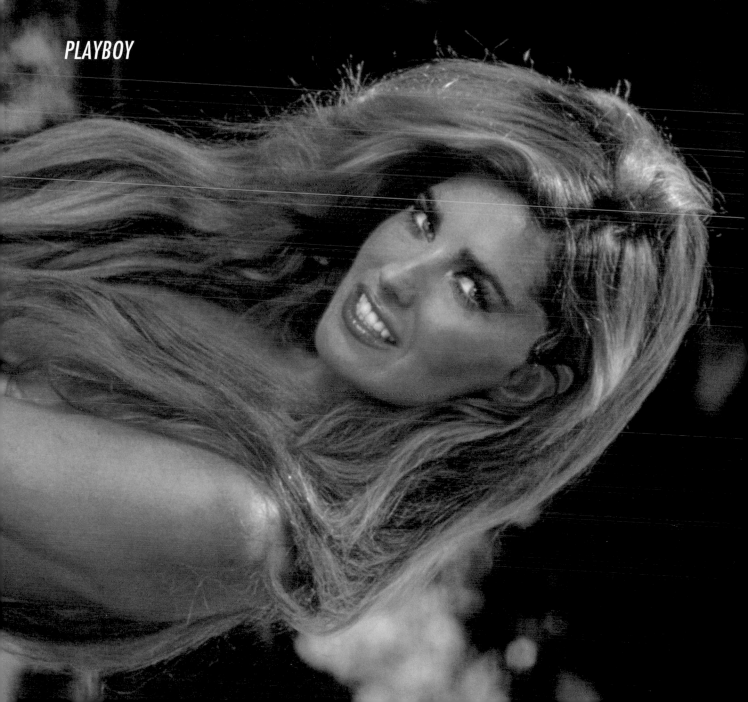

"We salute the panty bikini which, after a decade of continental exposure, is finally finding its place in the U.S. sun."

PLAYBOY

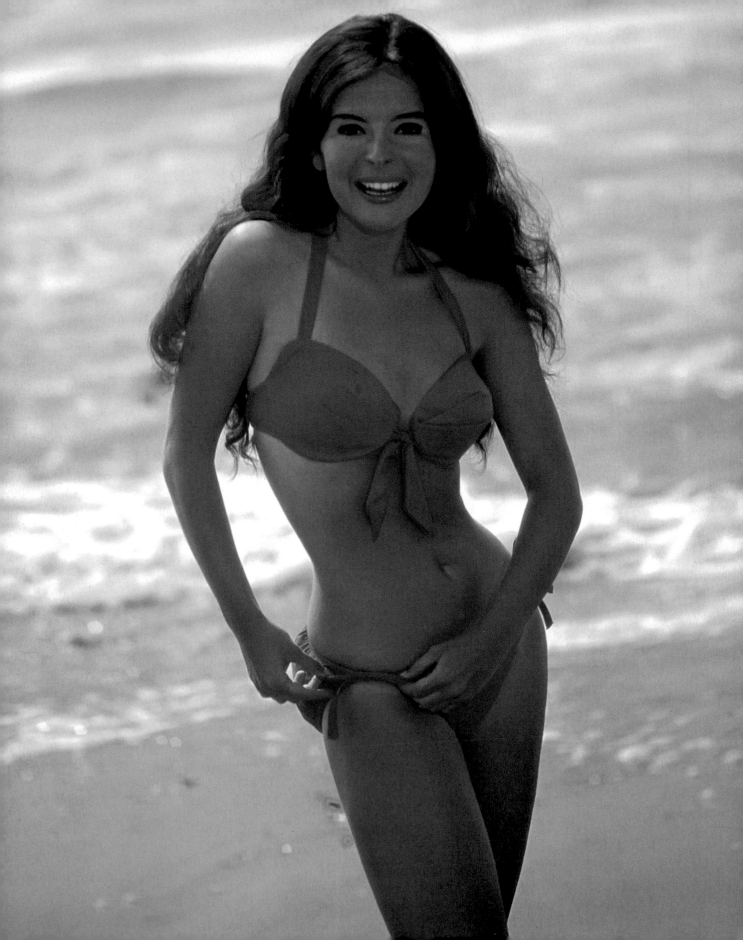

"[The bikini] was a 'swoonsuit' that exposed everything about a girl except her mother's maiden name."

DIANA VREELAND
Editor-in-chief of *Vogue*, 1963–71.

Susan Bernard, 1970. Photo by Bruno Bernard/Bernard of Hollywood.

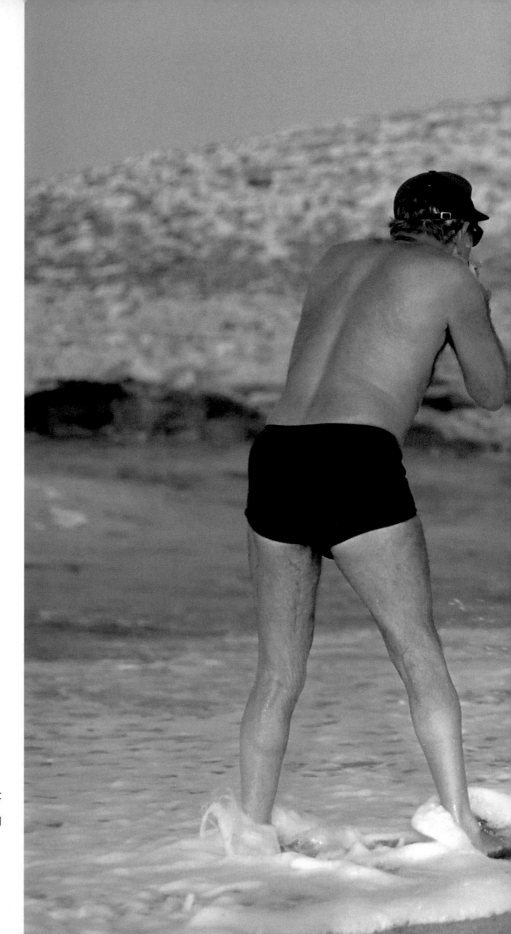

Bruno Bernard/Bernard of
Hollywood photographing
models, Majorca, 1971.

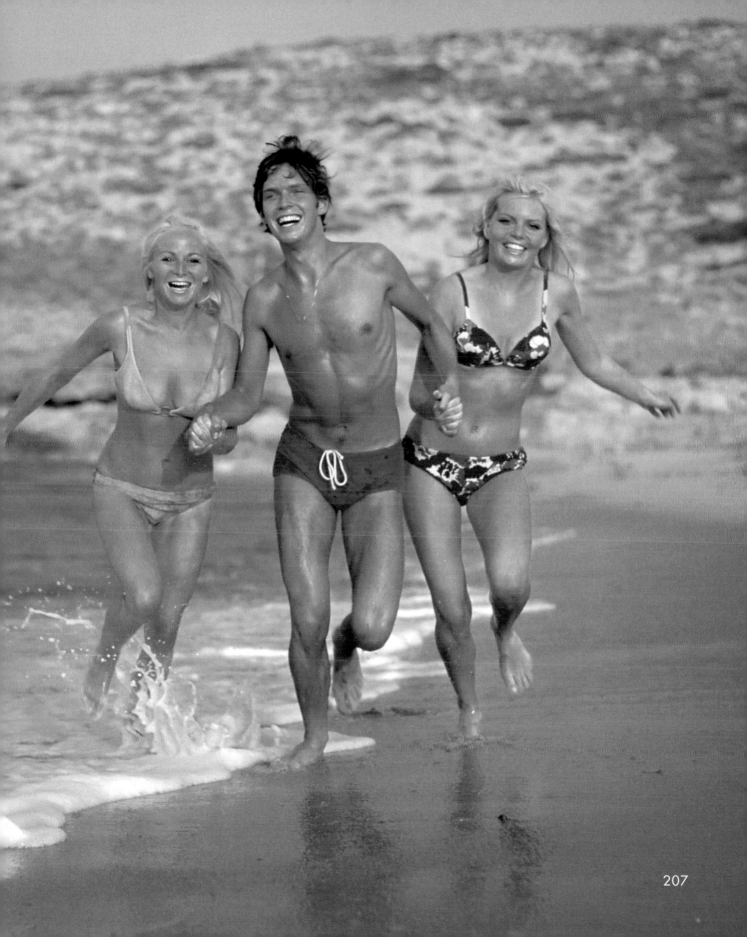

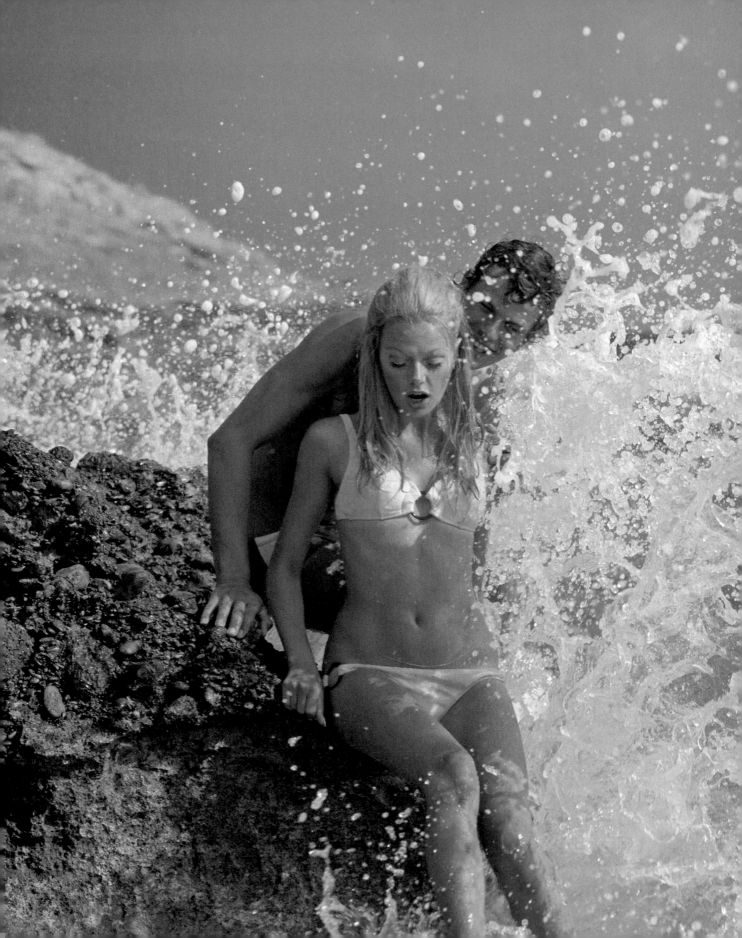

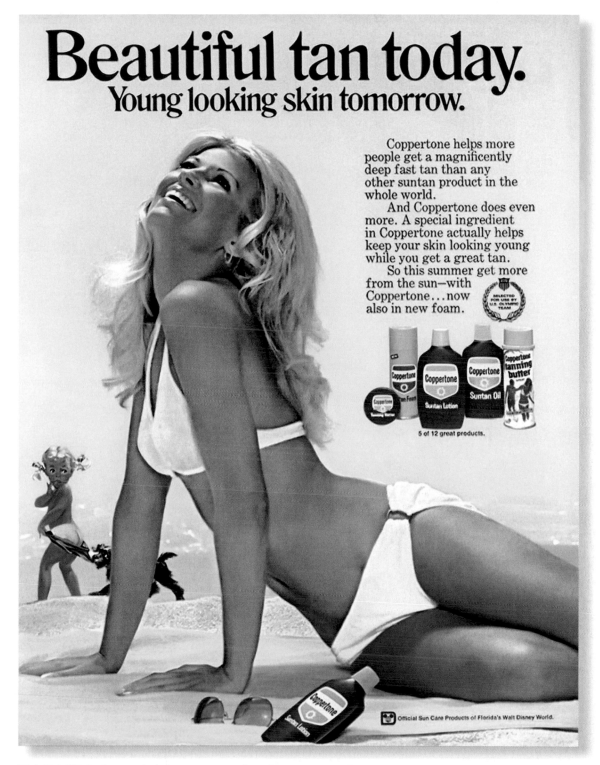

TANFASTIC: (ABOVE) Advertisement for Coppertone Suntan Lotion, circa 1970. (LEFT) Heidi Mann and Peter, Majorca, 1970. Photo by Bruno Bernard/Bernard of Hollywood.

Lord Brothers
Holidays

Majorca
Canary Islands
Tunisia
Around-the-World
Cyprus
South Africa
India
East Africa
USA

1970-71
WINTER
SUNSHINE

(ABOVE) Advertisement for Lord Brothers Holidays, 1970–71. (RIGHT) Susan Bernard, 1970. Photo by Bruno Bernard/Bernard of Hollywood.

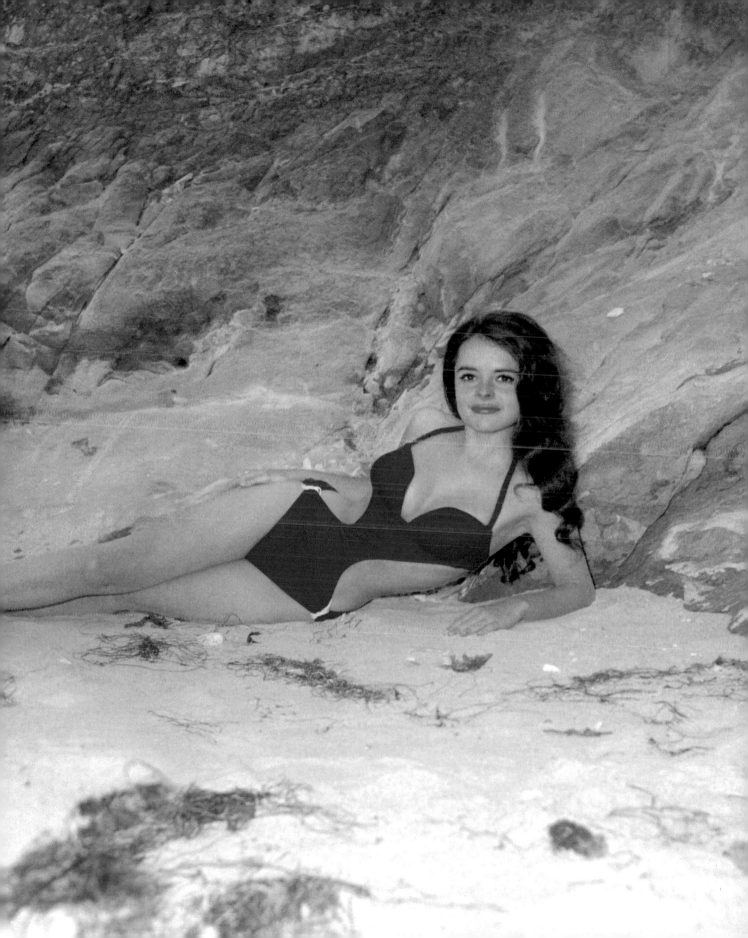

AFTERWORD

"In the summertime when the weather is hot
You can stretch right up and touch the sky.
When the weather's fine
You got women, you got women on your mind . . ."

LYRIC BY RAY DORSET—RECORDED BY MUNGO JERRY

Women in the workforce, feminism on the march, the Equal Rights
Amendment on the national agenda: the 1970s placed women
center stage. On American television, Mary and Rhoda, *Maude*,
Wonder Woman, *The Bionic Woman*, and *Police Woman* made
the case for visibility and validity, at home, in the workplace, and
everywhere a bra could be burned.

At the beach, women had more choices than ever: cover up,
show a little, show a lot, and in select venues, bare it all. Swimwear
became softer, less constructed, more touchable. The big three—
Jantzen, Cole, Catalina—continued to set trends, but more often
followed them. Rudi Gernreich, not done innovating, in 1974
designed a one-piece thong, not topless, cut very high over hips,
with a narrow strip of fabric disappearing between the buttocks—a
suit to free the body. That same year, Diane Von Furstenberg topped
the bikini panty with a bosom bandeau, gathered at the center

with halter strings, to lift without lining or foundation. These American designs took some specific inspiration from the free-spirited *lindas raparigas* of Brazil, who had begun wearing the *tanga*—the thong bikini—exposing still more of the breasts and derriere. The string bikini, the next big thing, was on its way to Copacabana and Ipanema.

On the Continent, Italian designer Ada Masotti began featuring the bikini in her collections for La Perla in 1971. The same year, Fred Prysquel launched Vilebriquin, out of St. Tropez, with surf-inspired swimwear, in fabrics developed to dry quickly in the sun. A move from Hungary to Tel Aviv prompted Lea Gottlieb to abandon her raincoat business in favor of a new swimwear line, Gottex. The label's palette was inspired by Gottlieb's new surroundings: "the aqua of the Mediterranean, the golden yellow of the desert, the blue of Lake Tiberius, the pink of Jerusalem stone, and the greens of the Galilee." Gottlieb is said to be the first to employ spandex in bathing suits, her success cuing Pierre Cardin and Yves Saint Laurent to seek deals to manufacture Gottex swimwear under their names.

Down Under, the MacRae Knitting Mills, based in Sydney, Australia, made socks and hosiery during World War I, before sidestepping to the knitting of competitive swimwear. The renamed Speedo Company, with its boomerang symbol, has maintained a long history with the Olympics, becoming

the official licensee for the summer games at Montreal in 1976. Speedos for both genders—tank suits with a french-cut leg and racer-back suits for women, the bikini for men—have been sported by the swimmers and volleyballers at Bondi Beach (from the Aboriginal "boondi," meaning "water breaking over rock"). Bondi Beach was a flashpoint for outrage over the brevity of the average Speedo. Two-piece suits were forbidden until 1961, when restrictions were relaxed, but still stipulated that "bathers must be clad in a proper and adequate bathing costume." By the 1980s, taking the sun topless was common, especially at Bondi's southern end.

Other sea resorts began "making waves" on the Hollywood and "beautiful" people radar: the uncrowded Seychelles Islands off Africa's eastern coast; exotic Turtle Island in Fiji; Anguilla and the Saints—Martin, Barts, and Kitts—in the Caribbean; Cabo San Lucas at the very tip of Baja California Sur; the resorts on Maui and Kauai; the mythic Bora Bora, one of the Society Islands making up French Polynesia; the Maldives in the Indian Ocean; and the Florida Keys, dotting the ocean off southern Florida. Controversy clung to the beaches at Cape Town, on the southern edge of Africa, "the divide between the icy Atlantic and the warm Indian oceans." Apartheid divided the country just as the Cape delineated the seas. Change was coming, but slowly, as evidenced by the evolutions in the U.S. Jane Hoffman-Davenport was not the first African-American *Cosmo* girl, but definitely the first to appear on the cover of *Cosmopolitan*

magazine in a swimsuit, for the May 1971 issue. With a certain palpable joy, she wears a "patchwork pouf," multicolor bikini with a string halter, stylistically related to the trend for crochet and macramé: ethnic authenticity mixed with a coy show of skin.

Cancun, "Mexico's Splashy New Resort," as *Sports Illustrated* called it, was the setting for Cheryl Tiegs' first outing as the magazine's cover girl, for the swimsuit issue in January 1975. Her halter bikini, by Anne Collins for Bobbie Brooks, just covers what we are not supposed to see, but her eyes-wide-shut smile assure us that she is the All-American girl at play in the waters of the resort. It also suggests that a super-slender clotheshorse need not apply for *S.I.* swimsuit royalty; healthy curves are required.

Jacqueline Bisset displayed some healthy curvage in *The Deep* in 1977. Clad in a bikini bottom with a white, wet T-shirt and scuba mask, Bisset redefined the possibilities of the Hollywood pinup. The 8x10 glamour glossies distributed to G.I.s in WWII, and other interested parties, were suddenly vintage souvenirs. Bisset, somehow more nude than if she were wearing nothing, was enlarged to postersize and subsequently taped or tacked to one hundred thousand bedroom walls.

One iconic pinup poster selling twelve million copies; one top ten TV season of *Charlie's Angels*: these two colliding circumstances produced one very big international star. The poster was an inexpensive improvisation—the backdrop, the swimsuit and hair, the

head-back smile, the laid-back photographer—that fell into place in a moment, even though there were many takes. The bathing suit, a simple red tank, allowed, shall we say, her nipples to breathe; the colorful Mexican blanket draped behind was suggestive of a weekend on the coast of Baja California, and Coronas with a twist of lime.

Those who take to the beach today have a different relationship to the sun than their counterparts of three, four, and five decades ago. The tanning preparations long ago were to enhance skin tone, then they were to protect from burning, and then they were expected to do both. And they were supposed to be aromatic, suggestive of coconuts and sea breezes. The self-tanners and the bronzers promised a natural glow, but turned orange. There were tanning beds and spray tans, and then the alphabet soup of sunblock letters on a label. It's been complicated, but the true, lustrous tan from a week in the waves, a Sunday in the sun, is still desirable, as long as it is safe and sane.

A mellow bronze glow is what Bo Derek as Jenny, the titular dream girl in *10*, is after on her honeymoon at the Las Hadas resort near Puerto Vallarta. The 1979 comedy—both articulate and slapstick—examines one man's midlife crisis, as he encounters his "10" and temporarily upends his life to pursue her. Derek's slo-mo jog on the sizzling Mexican beach was instantly iconic; her tank suit—cut very high at the hip—was an insinuation of nudity, its color a match for Derek's tanned flesh. Fashion commentator Hal

Rubenstein declared that Derek's "perfect score has never been beaten."

Also in 1979, *Sports Illustrated* introduced a very young Christie Brinkley to its swimsuit issue cover, wearing a very low "V"-cut one-piece, bedazzled on sheer black lace mesh. She was "Getting Away From It All In The Seychelles." The magazine arrived for sports columnist Robb Murray, who was then ten years old. "On the cover? The most beautiful woman I'd ever seen. . . . [She] captured my imagination. Look at her. Perfect smile, golden hair—so much golden hair, in fact, that she can grab a handful and pull it up and still have plenty left to cascade lovingly off her tan shoulders and down her arched back. In one image, she changed my life."

This travel-cade is a memory book of sunlight and starlight, a photographic sampling of all the Hollywood beaches in the world where notable women have played and tanned and posed, and been rendered younger and more beautiful than they really are. The Hollywood fantasy is the gift that keeps on living.

There's one more opinion to pass on; it's from Nora Ephron: "Oh, how I regret not having worn a bikini for the entire year I was 26. If anyone young is reading this, go, right this minute, put on a bikini, and don't take it off until you're 34."

This book is dedicated to Caloundra.

PHOTO CREDITS

Colorization by Olga Shirnina (https://klimbim2014. wordpress.com): Back cover, pages 98–99.

David Wills: Cover, back cover, pages 18, 24, 24–25, 27, 30, 32, 33, 36–37, 37, 42 (top), 49, 52, 54, 60–61, 62, 63, 64, 66–67, 67, 68, 69, 70, 71, 72, 73, 76, 77, 79, 80–81, 82, 83, 84, 85, 86, 96, 98–99, 100, 101, 102, 103, 105, 108, 109, 113, 114, 115, 119, 120–121, 124, 125, 127, 135, 137, 138, 148, 149, 152, 153, 156, 158, 163, 164, 165, 167, 168, 174, 175, 176–177, 178, 178–179, 182, 183, 184, 184–185, 192, 193, 196–197, 197, 198, 202–203, 209, 210.

Everett: Pages 16–17, 19, 22–23, 26, 34–35, 38, 39, 40–41, 53, 55, 59, 87, 95, 110–111, 112–113, 116, 128, 129, 132, 133, 188–189, 218–219.

Getty Images: Pages 56–57, 141, 168–169, 186.

Independent Visions / MPTV (mptvimages.com): Pages 9, 15, 30–31, 42 (bottom), 43, 74–75, 97, 104, 118, 136, 139, 155, 156–157, 159, 160–161, 162–163, 170, 171, 172, 173–173, 190–191, 198–199, 200–201, 201.

Photofest (photofestnyc.com): Pages 28–29, 117, 126, 154.

Rex / Shutterstock: Pages 21, 50, 51, 58, 78, 89, 106, 107, 150–151, 166, 180–181, 190, 194–195.

Sam Shaw / Reproduced with kind permission of Shaw Family Archives (shawfamilyarchives. com): Pages 4–5, 130.

Susan Bernard / Bernard of Hollywood Publishing / © Renaissance Road, Inc. Los Angeles (bernardofhollywood.com): Pages 122, 204, 206–207, 208–209, 210–211.

REFERENCES

BOOKS

Ava: My Story, Ava Gardner. Bantam Books, New York, 1990.

The Bikini: A Cultural History, Patrick Alac. Parkstone Press Ltd., New York, 2002.

The Bikini Book, Kelly Killoren Bensimon. Assouline, New York, 2006.

Dressing the Decades: Twentieth Century Vintage Style, Emmanuelle Dirix. Yale University Press, New Haven CT, 2016.

Fifty Fashion Looks that Changed the Fifties, Paula Reed. Design Museum / Conran / Octopus, London, 2012.

Hollywood Glamour Portraits: 1926-1949, John Kobal, ed. Dover Publications, New York, 1976.

Hollywood Surf and Beach Movies: The First Wave, 1959-1969, Thomas Lisanti, foreword by Aron Kincaid. McFarland & Co., Inc., Jefferson NC, 2005.

Key Moments in Fashion, Emily Evans. Hamlyn, London, 1999.

Movie Star Portraits of the Forties, John Kobal, ed. Dover Publications, New York, 2011.

The Pin-Up: A Modest History, Mark Gabor. Universe Books, New York, 1972.

Screen Dreams: The Hollywood Pin-Up, Tony Crawley. Putnam Publishing Group, New York, 1982.

Sharon Tate: Recollection, Debra Tate. Running Press, Philadelphia PA, 2014.

Striking Poses, Richard Schickel. Stewart, Tabor & Chang, New York, 1987.

Sunkissed: Swimwear and the Hollywood Beauty, 1930-1950, Joshua James Curtis. Collectors Press, Portland OR, 2003.

The Swimsuit: A History of Twentieth Century Fashions, Sarah Kennedy. Carlton Books, Ltd., London, 2010.

The Swimsuit: Fashion from Poolside to Catwalk, Christine Schmidt. Berg, London, 2012.

WEBSITES

bfi.org.uk
cnn.com
dvdbeaver.com
elle.com
elvicities.com
fashionencyclopedia.com
glamoursurf.com
googleimages.com
harpersbazaar.com
huffingtonpost.com
imdb.com
independent.co.uk
latimes.com
manakatofreepress.com
nationalgeographic.com

nypl.org
nytimes.com
salon.com
slate.com
tcm.com
telegraph.co.uk
thehairpin.com
time.com
travelchannel.com
travelsquire.com
vintagefashionguild.com
vogue.com
wikipedia.org
youtube.com

ACKNOWLEDGMENTS

Sean Newcott, Paula Szafranski, Lynn Grady, Susan Kosko, Richard Aquan, Nyamekye Waliyaya, Jeanne Reina, Melanie Bedor, and the team at HarperCollins Publishers

Stan Corwin

Evan Macdonald

Susan Bernard

Manoah Bowman, Andrew Howick, Melissa Stevens, Kim Goodwin, Howard Mandelbaum, Mark Bishop, Todd Ifft, Glenn Bradie, Lindsay E. Potenza, Laura Watts, Peter Oyegun, Adam Cruz

Russell Adams, Lin Bloomfield, Alex Cherry, Luca Dotti, Amanda Erlinger, Michael Erlinger, Jeffrey Felner, Jim Gibb, Sean Hepburn Ferrer, Helene Galen, Jamie Kabler, Glenn Kawahara, Giuseppe Longo, Jeffrey McCall, Geri McNeil, Mauricio Padilha, Roger Padilha, Gisèle Roman, Madan Saranya, Loretta Schmidt, Reynold Schmidt, Edie Shaw Marcus, Meta Shaw Stevens, Nancy Sinatra, Ramona Sliva, Debra Tate, Damon Taylor, Veruschka, Raquel Welch, Edy Williams, Fay Wills, Ralph Wills

Special thanks to Stephen Schmidt for his wonderful cover and case design.

Special thanks to Independent Visions for all the photographs they generously provided for this book.

Special thanks to Olga Shirnina for the beautiful colorization of Marilyn Monroe that appears on the back and in the interior of this book.

DEY ST.

Cover and case design by Stephen Schmidt (duuplex.com).

HOLLYWOOD BEACH BEAUTIES. Copyright © 2018 by David Wills. All rights reserved. Printed in the United States of America. No part of this book may be used or reproduced in any manner whatsoever without written permission except in the case of brief quotations embodied in critical articles and reviews. For information, address HarperCollins Publishers, 195 Broadway, New York, NY 10007.

HarperCollins books may be purchased for educational, business, or sales promotional use. For information, please email the Special Markets Department at SPsales@harpercollins.com.

FIRST EDITION

Designed by Paula Russell Szafranski

Library of Congress Cataloging-in-Publication Data has been applied for.

ISBN 978-0-06-284285-5

18 19 20 21 22 QVE 10 9 8 7 6 5 4 3 2 1

ABOUT THE AUTHOR

Australian-born DAVID WILLS is an author, independent curator, photographic preservationist, and editor who has accrued one of the world's largest independent archives of original photographs, negatives, and transparencies. He has contributed material to many publications and museums, including the Museum of Modern Art, the Metropolitan Museum of Art, the Palm Springs Art Museum, the Phoenix Art Museum, and the Academy of Motion Picture Arts and Sciences.

Wills has produced a series of photography exhibitions based on images from his archive. His shows include *Murder, Models, Madness: Photographs from the Motion Picture "Blow-Up"*; *Edie Sedgwick: Unseen Photographs of a Warhol Superstar*; *Blonde Bombshell*; *James Bond*; *Women with Issues: Photographs from the Motion Picture "Valley of the Dolls"*; and *Warhology*.

Wills's books include Ara Gallant (2010); *Marilyn Monroe: Metamorphosis* (2011); *Audrey: The 60s* (2012); *Hollywood in Kodachrome* (2013); *Seventies Glamour* (2014); *Marilyn: In the Flash* (2015); *The Cinematic Legacy of Frank Sinatra* (2016); *Audrey: The 50s*; *Switched On: Women Who Revolutionized Style in the 60s*; and *Vegas Gold*. He is also the coauthor of *Veruschka* (2008).

His books and exhibitions have received major profiles in the *Los Angeles Times*, the *New York Times*, *Vanity Fair*, *American Photo*, *Vogue*, *Harper's Bazaar*, *Interview*, and *Time*. He has also written articles on photography and popular culture for publications including the Huffington Post, *V Magazine*, and *Palm Springs Life*.